Drawing
A Likeness

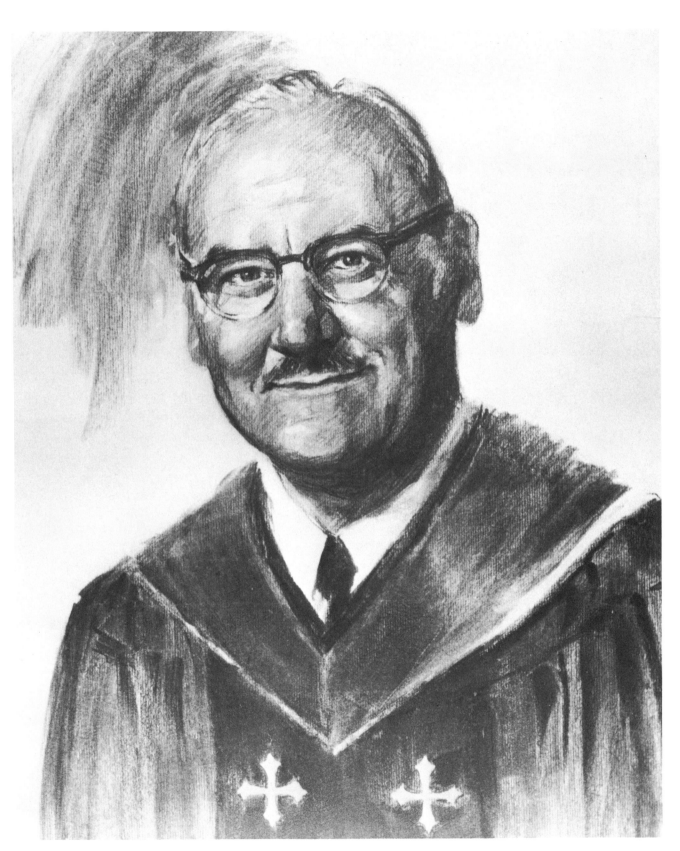

Dr. Loescher, Charcoal on Canson Ingres paper, 25″ x 15″ (64 x 38 cm), Collection of Mrs. Vernon Loescher. This is a preliminary study for a portrait painting. Since it had to be painted totally from various photographs, I had to develop a composite sketch that would both embody the spirit of the man and offer a plan for the values and drawing of the portrait.

Drawing A Likeness

BY DOUGLAS R. GRAVES

WATSON-GUPTILL PUBLICATIONS/NEW YORK

Paperback Edition
First Printing 1984

Copyright © 1979 by Watson-Guptill Publications

First published 1979 in New York by Watson-Guptill Publications,
a division of Billboard Publications, Inc.,
1515 Broadway, New York, N.Y. 10036

Library of Congress Catalog Card Number: 79-16472
ISBN 0-8230-1359-6
ISBN 0-8230-1358-8 pbk.

Distributed in the United Kingdom by Phaidon Press Ltd., Littlegate
House, St. Ebbe's St., Oxford

Manufactured in U.S.A.

3 4 5 6 7 8/88 87 86 85

Edited by Bonnie Silverstein
Production by Hector Campbell
Set in 12-point Palatino

TO MONTA

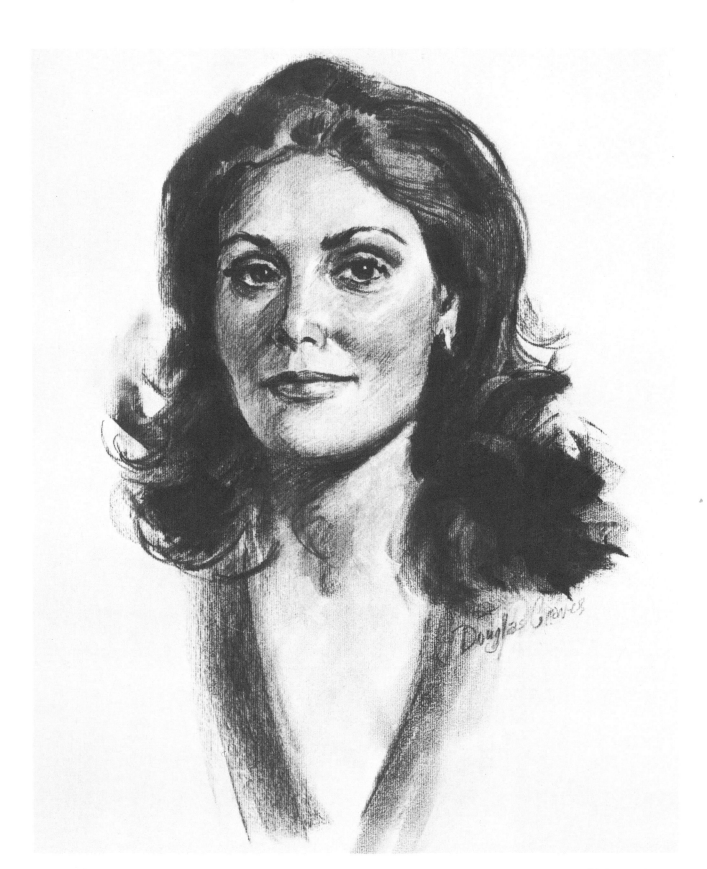

Kathryn, Charcoal on Canson Ingres paper, 25″ x 15″ (64 x 38 cm), Collection of Mr. and Mrs. Anthony Wauterlek. This is a study for a portrait of Kathryn, the woman drawn in the demonstration beginning on page 102. Comparing this one, which was done from life, to the other, done from a photograph, only adds fuel to the debate of which method is better, to work from life or from photographs. I personally find advantages to both.

Contents

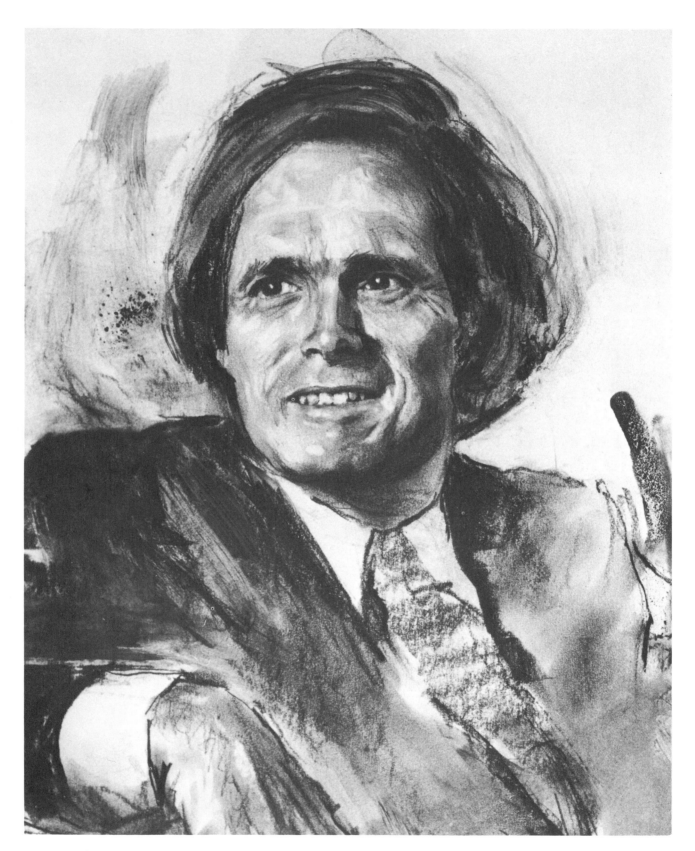

Bill, Powdered charcoal on illustration board, Detail of a three-quarter figure, 20″ x 30″ (51 x 76 cm), Collection of the artist. I wanted to experiment with powdered charcoal mixed into a liquid. I did this drawing on a smooth-surface illustration board. The technique offers a lot of possibilities for rendering tones and textures.

Introduction

Getting a likeness in a drawing or painting is not some mysterious ability given to only a few geniuses. It's simply the result of following a very logical procedure, a series of gradual steps from the general to more specific arrangements or placements of lines and tones. However, it's essential as you work that every step along the way is correct because, if you make a slip in drawing in the early stages, you'll soon lose that likeness, and it may be impossible to right this later on. Therefore, the purpose of this book is to take you very carefully through every precise move that I make in drawing a portrait, to show you exactly how I get (and keep) a likeness.

My previous book, *Drawing Portraits*, covered all the basic information necessary to know before drawing portraits: composition, value, drawing materials and how to use them, lighting, and the basic forms of the head—including the underlying bone structure and the forms and planes of each individual feature. But because the subject of drawing a portrait is so broad, I was forced to treat getting a likeness only generally, and the demonstrations there were, of necessity, limited to only a few steps each.

Realizing the subsequent gap, I was prompted to write this book as a sequel to *Drawing Portraits*, to supplement and augment it. In a way, the books are really a set. While *Drawing Portraits* contains all the information necessary to making a portrait, in this book, *Drawing a Likeness*, I have room to concentrate on a more advanced part of the subject of drawing portraits—getting a likeness—and do many more steps than is usual so that nothing is left out. Thus, by seeing exactly what I do, you can understand and follow my procedure completely.

The book is divided into three parts. In the first part, I describe in general some of the things to look for in your sitter as you begin to draw and I explain how individual characteristics differ from person to person. Then, in the second section, I do portrait sketches of three different people, with three different-shaped heads, showing you exactly how I progress in *forty-five* steps. Finally, in the last section, I show you how to handle six sketches in various drawing media. The procedure in the third section is the same but the steps here are condensed into ten per demonstration, though you'll clearly see the original forty-five steps in them.

Since you're not at my side as I draw, we'll have to refer to photographs instead of a live sitter. But I want you to imagine that you're looking over my shoulder as I draw from the photographs shown with each demonstration. When you're not drawing from life and therefore have only a limited knowledge of what each sitter really looks like, you'll have to copy the values and proportions in the photographs precisely, as I do here. However, in reality I often supplement a photograph with my personal knowledge of the sitter's characteristics and personality, and I suggest that you do the same.

I might also add that, in the privacy of my own commissions, I'll often skip steps or switch them around, and do all sorts of seemingly confusing things. But even so, every step I recommend here is in there somewhere. Anyway, I've tried a lot of different procedures before I found one that doesn't depend on something magical. But if you happen to have that extra gift of getting a likeness and can still follow this method, then so much the better.

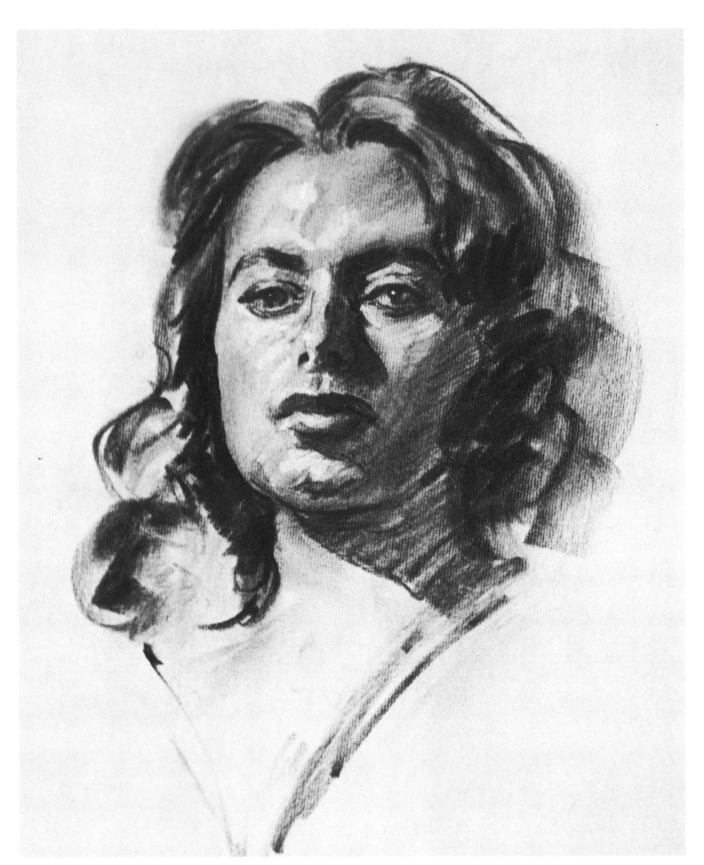

Alexandra, Charcoal on Canson Ingres paper, 25″ x 15″ (64 x 38 cm), Collection of the artist. I used a wide, chunky piece of charcoal to do this demonstration drawing for my students. The rendering is broadly handled in this quick thirty-minute sketch. You can get a likeness even in a short time span once your procedure has become automatic.

I.
Analysis of the Head

General Shape of the Head

Before you do anything, notice the general shape of the sitter's head. Is it oval, squarish, oblong, or triangular? Here are four fairly common head shapes. Bear in mind that they're not the only ones. You'll discover others as you begin to study various sitters.

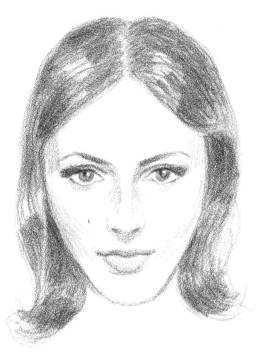

This woman's head appears to be triangular. The widest part of the triangle is across the skull; the point is at the chin.

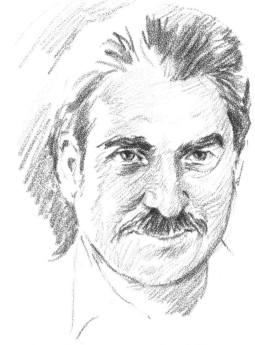

This man's head seems to be oval, a bit like an egg. This is probably the most common shape. As in the triangular head, the smaller part is at the bottom and the wider part is at the top.

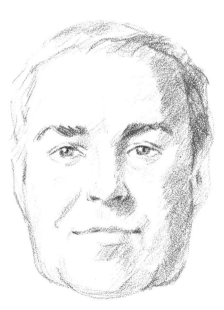

This head is rectangular, but looks almost square. It takes imagination to see the square shape because the corners are rounded.

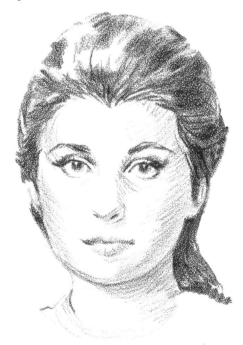

This girl's head has a circular appearance. Although it's rare for a head to be completely round, it's still much rounder than the typical egg shape. This shape doesn't seem to be as common as the others.

Variations Within the General Shape

Now that you have an impression of the basic shape, you can see that these shapes need further refining. For example, they may be more angular, rounded, or indented in various spots. But these variations are subtle and should all be kept within the context of the first general shape you observe.

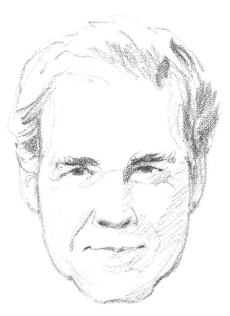

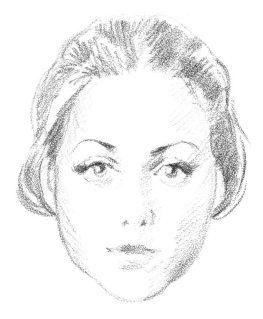

This is a somewhat oblong head with slight indentations at the temples. Next to the eyes there's a slight bulge in the contour of the head. As the edges drop they round somewhat, but one cheek has a tiny concavity, while the other is just a little more rounded. This is much more pronounced here than in the other heads. Also, the chin here is wider, and there's a cleft in the center.

The cheeks of this oval-shaped head round out then cut in quickly to form the prominent chin. The whole shape seems very symmetrical. Even under the hair, the skull appears nicely rounded.

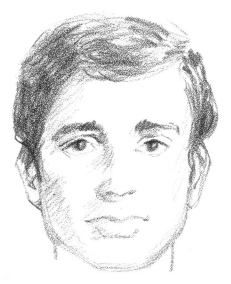

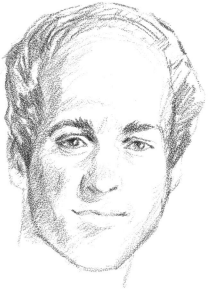

This man's head is boxlike, but unlike the next head, it widens at the skull. The jaw line has only one angle change, and there's a wide chin with no cleft. Notice carefully that the angle of the jaw differs on each side. One side is flatter, starts lower, and meets the chin slightly to the right.

This long head is partly rectangular and partly oval, with lots of variations. The skull is round at the top and drops down with a slight bulge on the right cheek. Also, the left side is more angular, with both jaw lines meeting the chin at the same angle that they meet the upper features.

Placement of the Eyes

If you're careful where you place the eyes, they can serve as points of reference for other features. All you need to do is rough in dark spots for their position. It's not difficult to place them. They generally line up about halfway between the top of the skull and the chin. Also, there's usually about a space of one eye between each eye. This is an elementary point that you'll find discussed in my book *Drawing Portraits.*

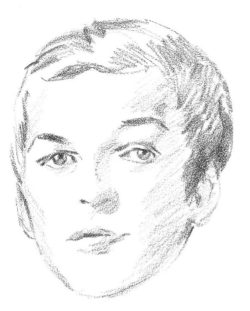

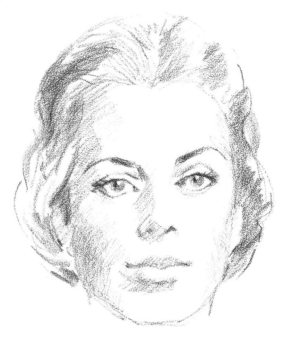

Even in a slightly turned head, the eyes are separated by more than the normal "eye-width" apart. The eye level is about center on the skull.

The eyes on this head don't line up evenly across the face; the right one is higher. The difference is very pronounced here, and you should now begin to realize that noting and recording this slight deviation is one of the keys to getting a likeness.

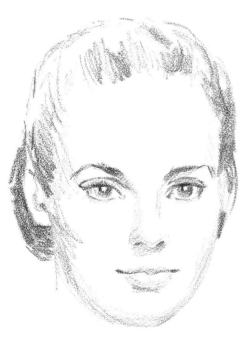

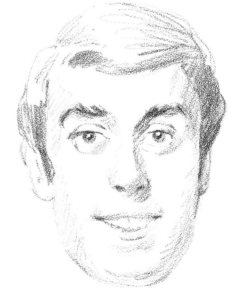

In this example, the woman's eyes are spaced an "eye-width" apart, which is about normal. But they're below the center line. This means that she has a high forehead.

It's not unusual to find close-set eyes on a narrow head. If you measure their spacing you'll see that they're less than an eye-width apart.

Placement of the Nose

The nose is located on the center line of the head, vertically, and lies between the upper and lower boundaries of the ears, horizontally. The nose is the anchor point for all of the features. If it's out of place, then a face will start to look grotesque.

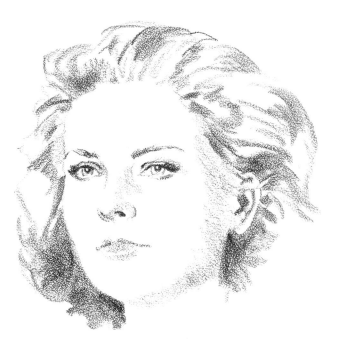

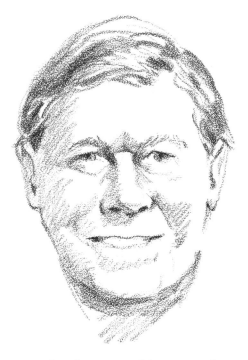

In this three-quarter view, you can see the nose in relation to the ears more clearly. Along the length of the face, the nose occupies less than one third of the space between hairline and chin.

Now compare the placement of the nose to the ears in this straight-on view. The bottoms of each are on the same level, but observe that the bridge of the nose is below the top level of the ears. In most cases, a man's nose is longer than a woman's, but still, guard against making *any* nose too long!

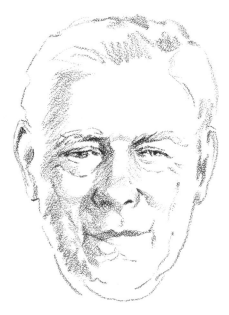

The ears here are smaller and lie closer to the nose. The nose also swings over to the right somewhat, an important individual characteristic.

Placement of the Mouth

Because of its flexibility, the mouth can be difficult to draw, and subtle differences there can completely change a person's looks. However, its basic position doesn't vary much: slightly above the halfway mark between the nose and chin. The separation line of the lips is one-third the distance from the underside of the nose to the chin. It's also the same distance from the tip of the nose as the nose tip is to the eyeline. Seen from the front, the outer corners of the mouth are parallel with the pupils of the eyes. But observe its boundary carefully. It may shift slightly to one side or up and down on different individuals.

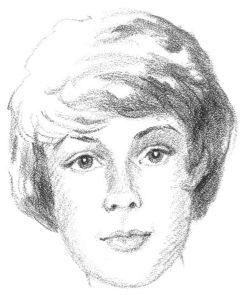

In drawing a tilted head, you may be fooled into thinking that the mouth is level. But start the portrait as if it's symmetrical and make sure it lines up across the face and parallel to the eyes first, then note any deviation. Notice on this sitter that the corners of the mouth fall directly below the inner iris of each eye.

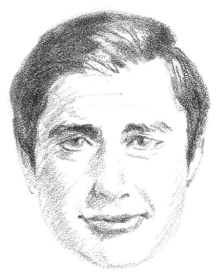

Here some individuality begins to develop as the line of the mouth rises on the right. Also, as you can see, that same corner is further to one side a tiny bit.

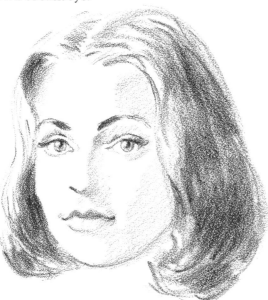

If the head is somewhat turned, there's a change in perspective. Because of its anatomical structure, the mouth protrudes from the face further than the eyes, so the distant end actually appears larger than you'd expect.

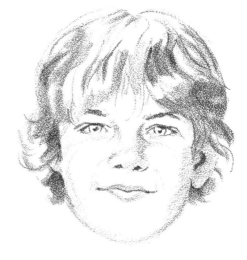

The line of this young lady's mouth is slightly above the one-third mark from chin to nose. However, it may seem even higher because the lower lip isn't as deep as it is on other heads.

Placement of the Eyebrows

The underside of the nose is the pivot point for locating the position of the brows. Or, to put it another way, the distance between the base of the nose and the chin is the same as that between the base of the nose and the eyebrows. Notice, too, the relationship between the eyebrows and the eyes. The so-called "arch" of the brows is really angular. If you lengthen the line formed by the inner angle of each eyebrow, it will run into and along the outer eyelid of the opposite eye, making a large X formation.

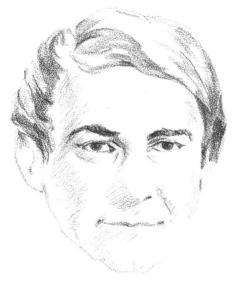

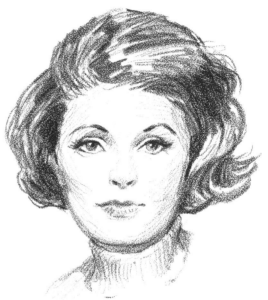

The heavier eyebrows on a male tend to make them appear to lie closer to the eyes, but actually the same proportions—the distance between the chin and the base of the nose to the eyebrows—prevail.

As you can see here, the female eyebrow is generally arched. Note the relationship of the inner ends of the brows to the corners of the eyes. The left brow starts out slightly farther from the cornea than the other one. Cover this up and see how you lose one of the keys to her individuality.

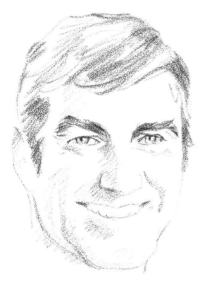

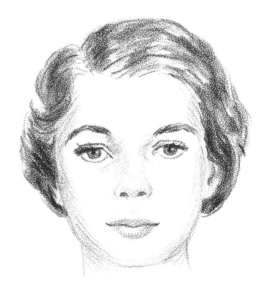

You can spot the point of individual likeness on this man immediately in the eyebrows. Look at the way the left eyebrow angles upward more than the right one. Also, notice how it makes a little triangle in the space between eyebrow and eyeline only on that side.

There's a great deal of variety in where this young lady's eyebrows are situated. The one on the right is quite a distance off to the side and has a flatter curve, while the other one starts a little way in from the corner of the eye. But keep in mind that there's always a close kinship between the eyebrows and the eyes. You must first relate them to each other, then place them as a unit on the face.

Placement of the Ears

Since the locations of noses and ears are interrelated, you'll first have to get one or the other correctly placed by "eyeballing" it. If they appear higher or lower than normal, it's probably due to the tilt of the head.

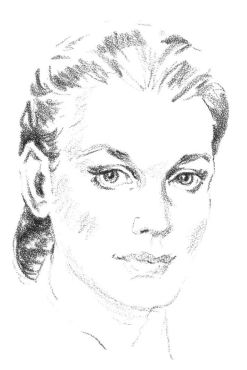

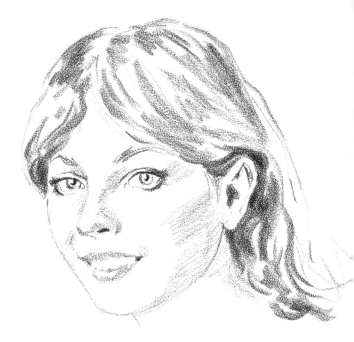

The ears lie just behind the jawline and are on the same level as the nose at top and bottom, in their placement on the head. This line varies, of course, with the tilt of the head.

The placement of this ear is normal, but the whole ear tilts back more than is usual. The shape and configuration of every ear is distinctly different, and being aware of this is one way to begin to get a likeness.

Placement of the Hairline

If you think of the hair as framing the upper part of the face, remember that it doesn't form a hard edge all around. The hairline generally starts across the top where the forehead ends or the skull turns back. At the sides, it angles down from a point almost directly above the ends of the eyebrows. That line, when on a level with the eyebrows, curves back to almost an eyebrow length away from the brows. Whether or not the hairline travels much below the level of the eyes depends on the particular hairstyle.

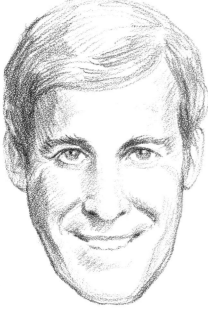

This hairline is governed by the way this man combs the top part of his hair across his forehead. You have to relate the part to the eyebrow; notice here it's quite high. The sides dip in at the temples and curve back to the sideburns.

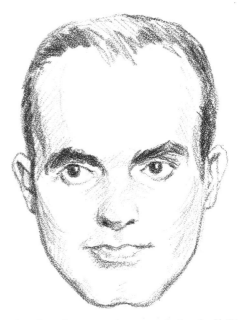

This hairline barely comes in around the skull. It's ragged and even the wisps at the peak have a definite regularity.

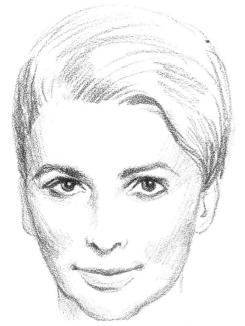

Compared to the others on this page, this hairline is quite low and very straight across.

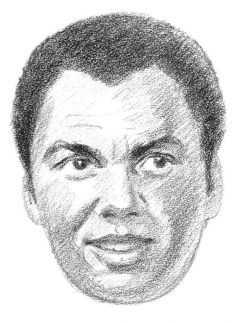

The pronounced widow's peak gives this man a distinct look and, with an Afro hairdo, you'll find a soft, but definitive hairline.

General Shape of the Hair

Here are four of the countless varieties of hair shapes. The key to drawing hair is not only in getting the outer contour correct, but also in accurately forming it around the face. You have to be certain that the hair on top seems to truly fit the head, especially if the hair is straight. In a majority of hair styles, the part shows, then balloons out into larger masses of hair. The inside edge of the hair defines the contour of the face.

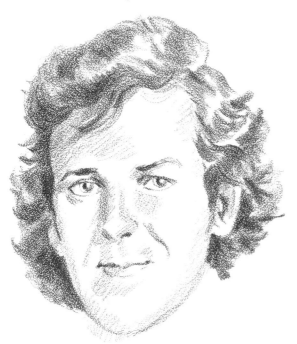

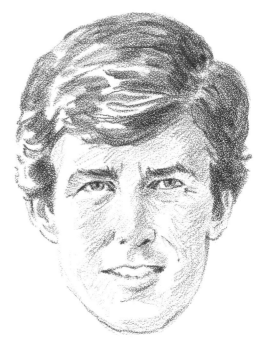

At first glance, this is seemingly a very casual hairstyle, but notice that it has definite, larger patterns. The top is almost a separate shape, conforming with the head. Then, both sides are fundamentally triangles, getting wider toward the bottom. So it's really more organized than it would appear to be at first.

Here's an example of a very heavy head of hair that's short and choppy, causing the outside perimeter to stand out all around. Still, it seems to follow the contour of the skull.

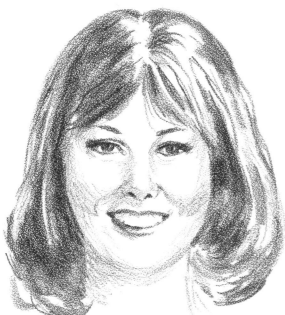

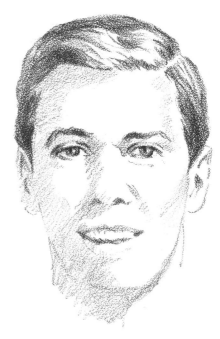

This hair is softer. It conforms to the outline of the head fairly well until it breaks out along the sides.

We see this short hairstyle every now and then. If it weren't wavy, the outline would be an exact repetition of the head shape. The head is slightly turned, so the mass of hair on the left seems thinner than that on the other side.

General Shape of the Neck

It's easy to neglect construction of a neck, since it's not as interesting as other aspects of a portrait. In general, there's very little difference in necks other than the cosmetic aspect such as wrinkles, lines, or jowls. Actually, unless they play an important role in the character, necks should be downgraded in a portrait. It's better to look for the basic proportions and shape. Don't forget a neck is not a tree trunk growing straight out of the shoulder—which, by the way, is part of the neck.

The outer contour of the neck starts behind the ears and slants slightly inward. At about chin level, the contour changes direction and spreads out. This is caused by muscles from the shoulders emerging from behind the upper contours of the neck. Very often the sitter takes an off-center pose, which makes the two sides of the neck appear different.

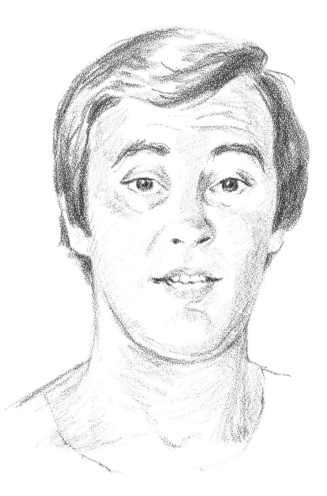

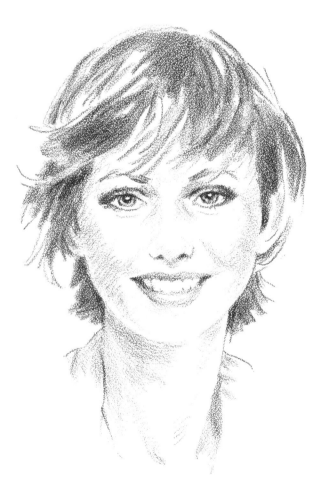

Men as a rule have thicker necks than women. The contour of the neck tends to drop straight down on this man and the cords and muscles of his neck are spread out gradually into the shoulders.

This is a slender feminine neck. Notice that the outer edges emerge more inside the jawline here than on the man.

Proportions of the Neck

Most of the time, because of clothing covering it, it's difficult to tell just where the lower parts of the neck end. Usually, its width is equal to the distance from the chin to the pit of the neck. In a front view, its width is also about an average of the outer extremes of the eyebrows. Since we're interested in specific characteristics of a given person, you must really compare these estimates to the rest of the sitter's features. For example, if the pose is a three-quarter position, then you'd have to relate the contours of the neck to other parts of the head instead of relying on these general rules.

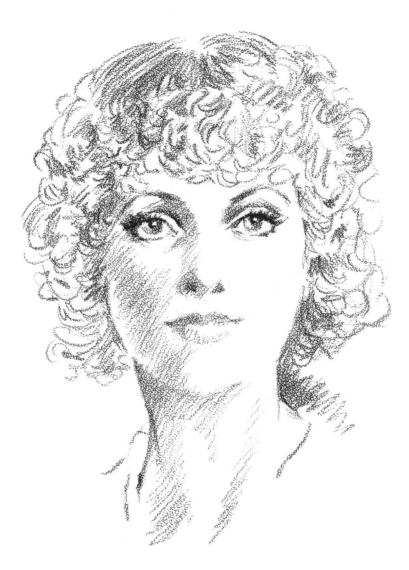

The single example here, the long slender neck of a girl, shows the angular contour of the neck getting smaller down toward the center and then widening out into the shoulder plateau.

Proportions of the Eyes

I label all the parts of the eyes—lids, openings, and corneas—as "the eyes." The parts work together as a unit and should be drawn as such. Then, taken as a whole, despite their tilt and shape, the eyes occupy a long rectangular-shaped space on the face.

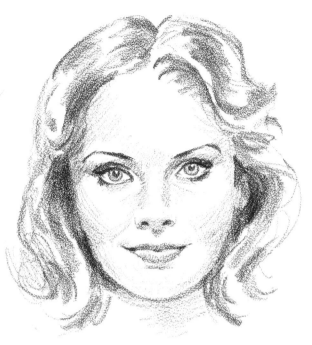

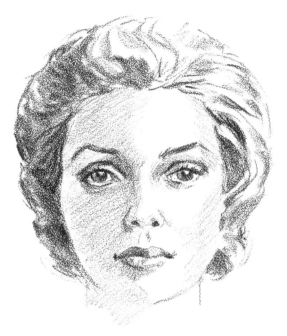

The dimensions of her eyes and eyelids occupy a square-like space. The corneas are average size, filling about half the amount of the white part or opening.

Compared to the first example, the eyes here are subtly rectangular. They occupy more space across the orb area and the corneas are larger than those in the first example.

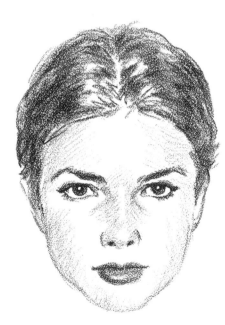

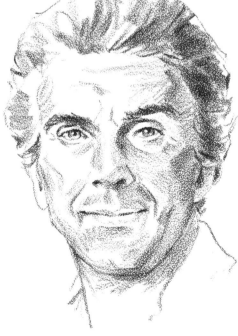

Since these lids are narrower, the openings seem long and narrow. The corneas are closer in size to the first girl's eyes.

This man's eyes appear to be smaller than those in the other examples, but actually only the corneas are. Make a fine line overlay tissue of the whole eye and compare it to the other eyes. You might think there's not enough difference to matter, but it can make the difference in getting a likeness.

Proportions of the Nose

The nose is so stationary on the head that it contributes little to fleeting changes of expression. Sometimes, where it blends into the cheeks, the proportions are partly hidden. Getting the length and width, plus the shape at the bottom, are important in expressing the character of the person.

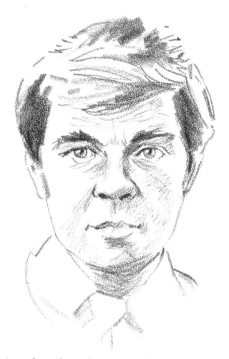

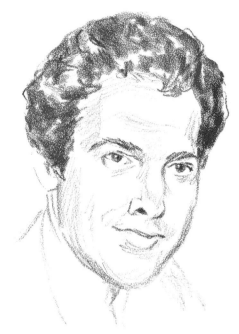

This nose is rather short for a man. It spreads to a somewhat bulbous end. The bone structure is not as evident, leaving little to measure, though it's about as wide as it's long.

In contrast to the first example, this nose is angular and longer in proportion. The front slopes outward, and the planes are more defined. They can almost be rendered in a series of straight, chiseled forms. These proportions are ideal for a man.

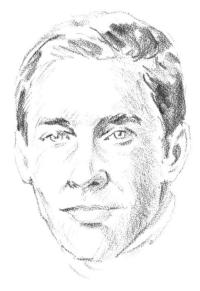

This man's nose is longer in the center, where the bone ends, than on either end. The bridge is small and narrow. The tip is also small, with shallow wings. Had the wings been shorter, the nose would have appeared hooked or aquiline.

Proportions of the Mouth

As I've stated before, because the mouth is capable of such a wide range of movement, part of the struggle in getting a likeness lies in fixing this movement in any one of the many positions natural to the sitter, without making it appear stiff. There's always a slight lift, tilt, or subtle curve to the mouth that imbues the sitter with a characteristic mood and expression. It's important to get the proportions and shape of the mouth accurate, too.

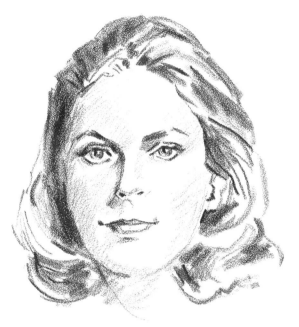

This lady's mouth is about a standard width, but both top and bottom lips are narrow. The bow is very flattened and the lower lip is long and rectangular.

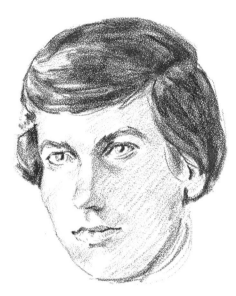

This man's septum spreads wide on a narrow upper lip. The lower lip is crescent-shaped and bulges up into the cross line at the ends. The lower lip is almost twice as deep as the upper one.

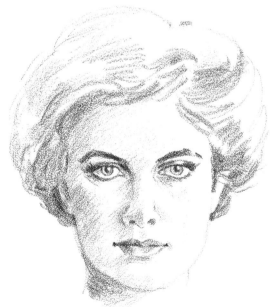

These are very feminine, voluptuous lips. The depth of the upper lip is about an ideal two-thirds of the lower lip. The bows are spaced a nice width apart.

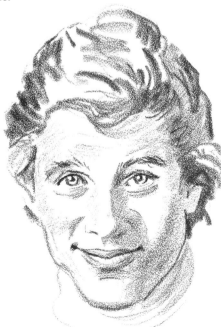

This pair of lips would be wide even without the smile. They tend to be sensuous and fleshy. However, the boundaries are distinct, showing a top lip as deep as the lower one.

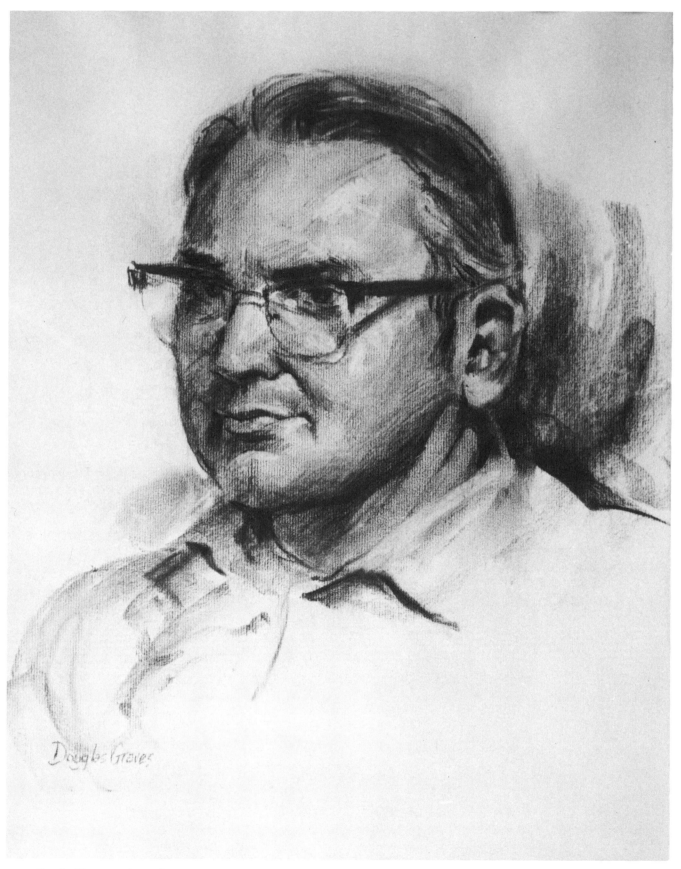

Bud, Charcoal on Canson Ingres paper, 25″ x 15″ (64 x 38 cm), Collection of Mr. and Mrs. Denver Hamman. This is a quick forty-five minute sketch done in a demonstration for an art group. Mr. Hamman agreed to pose.

II.
Procedure in Getting a Likeness

Oval Head

I'm going to take a fairly common head shape, a girl with an oval head, give you a photograph of her, and then demonstrate how to draw her portrait in forty-five steps to show you the analytical process. This and the following two demonstrations will be done with a Prismacolor pencil, Black No. 935, on Coquille board. Although each step is a new drawing, they each represent the progress of *one* portrait.

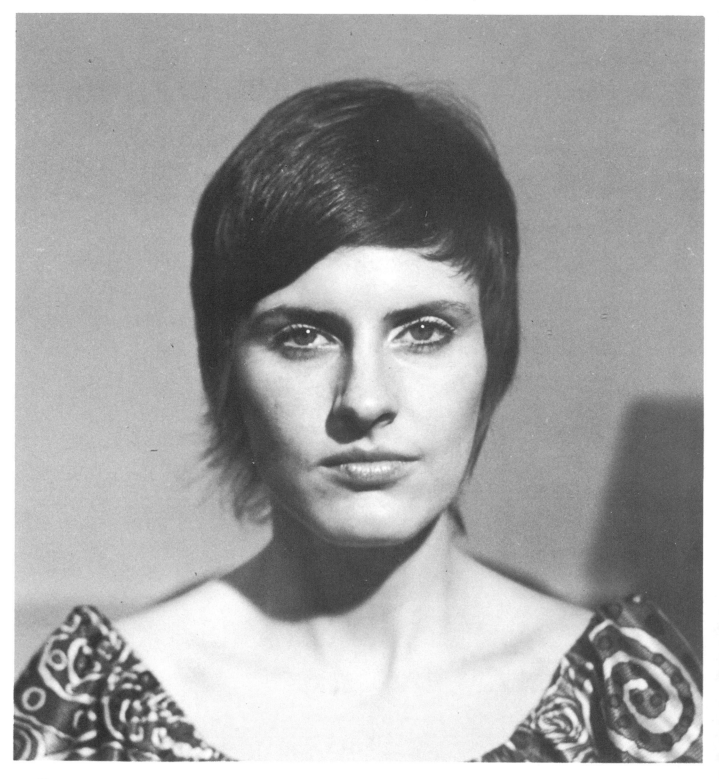

1. General Shape of the Head

As I look for the basic shape of Debbie's head, I find that it's the average oval shape, the geometric figure with which you generally start any head. The general shape, of course, doesn't include the extra amount of space allowed at the top for hair.

2. Variations Within the General Shape

Don't leave the head a simple shape, but see that it consists of modifications, such as tapering. This tapering starts at the temples and then the shape becomes angular along the jawline.

3. Placement of the Eyes

To start the placement of the features, I usually place the eyes first with two round spots, which are an impression of the corneas. These are placed halfway up and down the basic oval shape. Across the line they're spaced along four divisions, the first and third.

4. Placement of the Nose

I make the base of the nose about the same width as the space between the eyes from cornea to cornea. The top boundary of the nose is at the line across the eyes, while the sides are only roughly placed along the center of the head lengthwise. I erase the first oval line.

5. Placement of the Mouth

I rough in two coarse lines to show that the mouth is a third of the way down from the baseline of the nose to the chin. The top line is near the separation line of the mouth, and the other little dash is the boundary of the lower lip.

6. Placement of the Eyebrows

I very simply indicate where eyebrows go above the eyes. Exact placement can only come later, when other points are correctly set.

7. Placement of the Ears

When I continue the lateral lines of the eyebrows and the baseline of the nose, I can locate the ears when the head is seen straight on. Even though the ears are often covered with hair, it's a good idea to know their location, since they sometimes influence the shape of the hair.

8. Placement of the Hairline

Her hairline is fairly well defined. I draw a line showing how it encircles the forehead.

9. General Shape of the Hair

The general shape of the hair loops up higher than the original oval I established. The only way you can correctly estimate this is by comparing the area above the hairline to the face area.

10. General Shape of the Neck

In this step I indicate the general shape of the neck, with the shoulder line at the back. I start to erase some of the skull line.

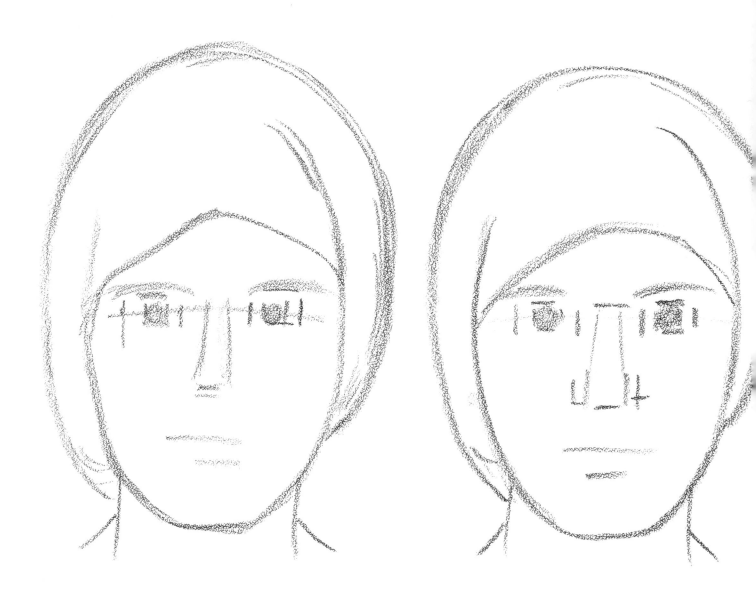

11. Proportions of the Eyes

Now I return to the eyes. To get the proportions, I mark the outer and inner corners of the eye openings and the space between them, which consists of three equal divisions from the outer corner of one eye to the outer corner of the other eye. I also mark the boundaries of the upper and lower lids and the area that the corneas will occupy. I erase the ears.

12. Proportions of the Nose

To determine the proportion of the outer wing of the nose, I sight along a plumb line drawn down from the eyes. Notice the left one is slightly past the corner of the eye opening while the other is almost directly underneath. I also estimate the bulbous sides of the nose, relating them to the now established wing boundaries. Then I carefully eliminate the guidelines across the eyes.

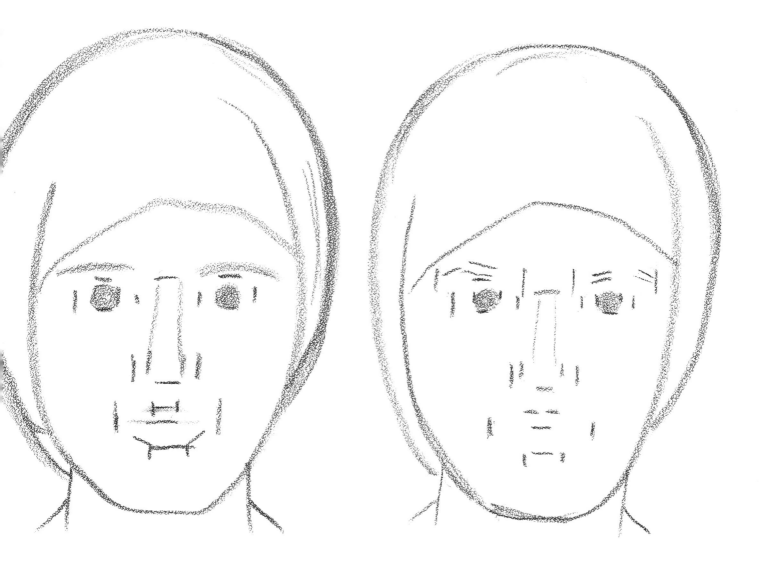

13. Proportions of the Mouth

The proportions of the mouth also are based on check points in the eyes. Even at this stage, you can see the keys to getting a likeness. For example, notice the points at the break in the angle of the lower lip. They show that the lower lip swings to the right. Again, it's important to note these departures from the ideal head in order to achieve a likeness.

14. Proportions of the Eyebrows

In noting the location of the eyebrows, I find that they angle up closer together than the inner corners of the eye openings. I also note where their outer ends stop, at the temples. In this step I also start to show where the hair breaks the smooth line at the temple and down along the back, and I erase the crude brow and mouth lines.

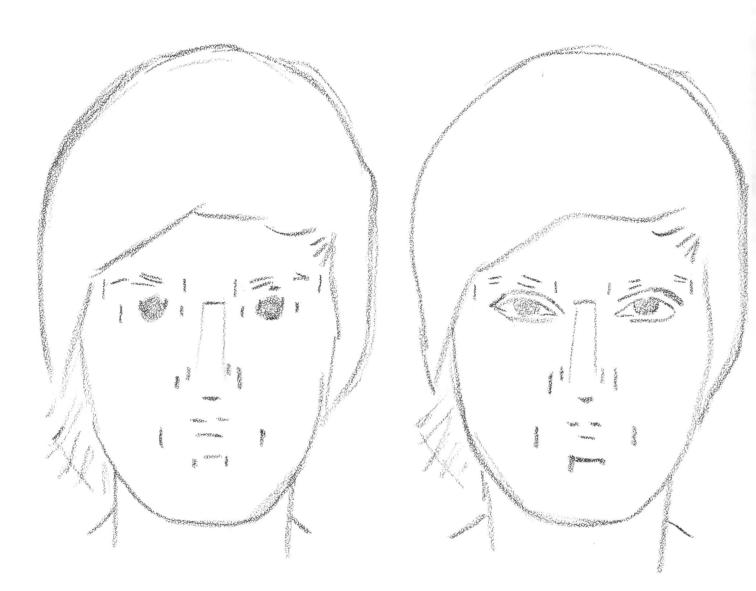

15. Proportions of the Hair

In this step, I'm a little more definitive about the shape of the hair and the line across the forehead. I also suggest the line where the hair breaks away from the sharper edges, such as in the back and over one temple.

16. General Shape of the Eyes

Now it's time to get the general shape of the eyes and eyelids. I note that the outer corners of the eye are a bit higher than the inner ones. Observe another key to the likeness: the right eye opening is a little higher than the left one, and pushes up the lid, too. I also improve the round shape of the corneas. As I outline these shapes, I rub out the proportion marks I had previously put in.

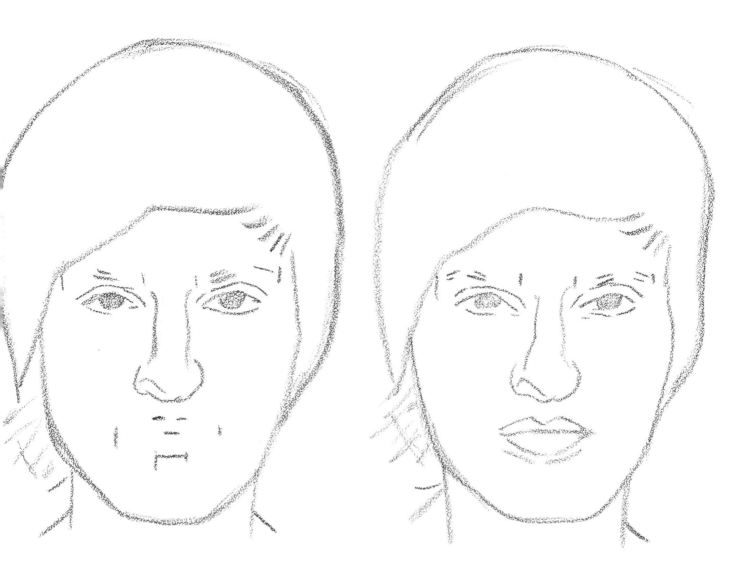

17. General Shape of the Nose

Within the confines of the proportions, I now establish the general shape of the nose. One nostril appears rounder than the other, more angular, one. The bumps along the side of the nose are just barely roughed in because lines here will soon be erased. I draw a line for the shadow on the nostril. Again I take out guidelines and checkpoints.

18. General Shape of the Mouth

I establish the boundaries of the lips, with angles on top and more curved lines underneath. Also, I broadly indicate the muzzle as it protrudes out beneath the lips. Then I eliminate the proportion lines.

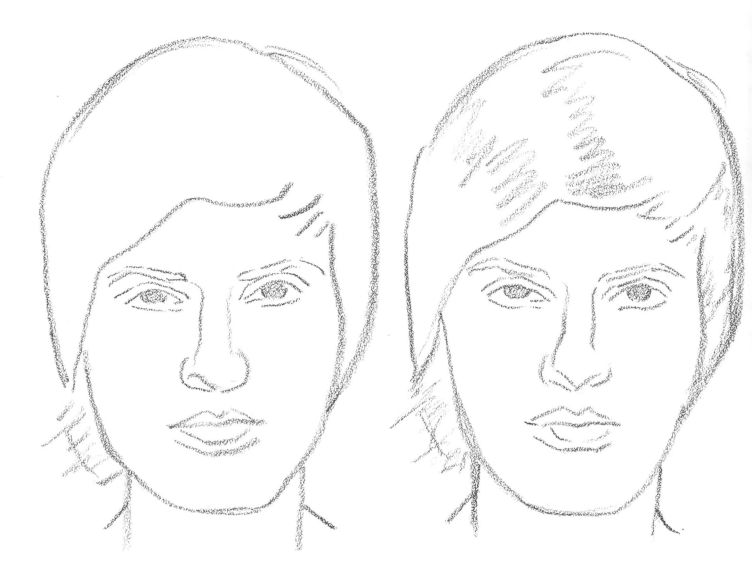

19. General Shape of the Brows

Now I outline the area of the eyebrows, noting more carefully where the break comes in the angle. The inner boundaries eventually soften so that there's now no exact cutoff point, especially on the left brow, which blends into the shadow (see photograph). I erase the boundary marks at the ends.

20. Contour of the Hair

In this step I remind myself with some zigzag lines where the highlight on the hair shows. The area of the big highlight is opposite the light side.

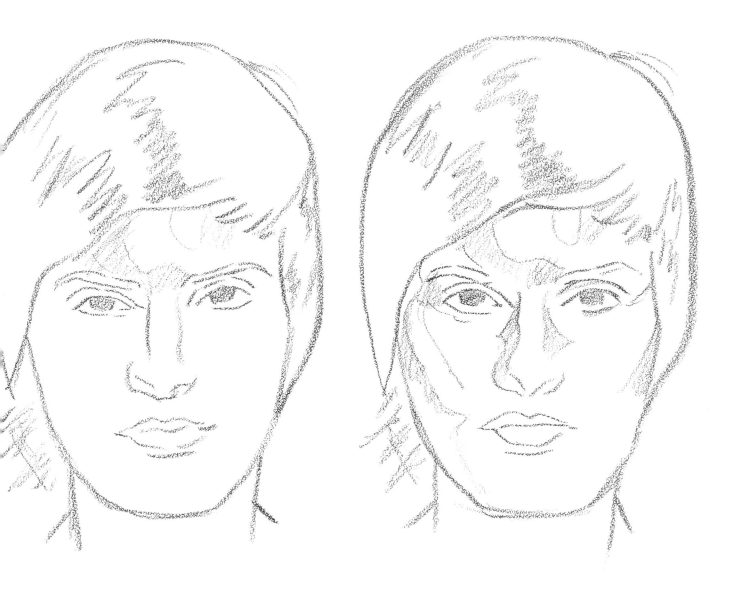

21. Contour of the Upper Face (Forehead Area)

Now I begin to consider shapes that are parallel to my vision, such as the contours across the face. I put very light lines to outline where various value changes occur. The loop at the top right is the site of the strongest light on the forehead.

22. Contour of the Middle Face (Cheek Area)

The contours through the center of the face include those around the outside of the eyes. Notice how they swing up quite definitely. There seem to be two distinct values on the left cheek.

23. Contour of the Lower Face (Jaw Area)

The lower part of her face has very subtle contours, but the sharpest change is on the shadow side and along the chin. Except for the difference in how the light affects the values, the contours on each side are quite symmetrical.

24. Adjusting the Shape of the Eyes

Now I return to the features and start adjustments where needed. For instance, the eyelids have very definite changes and accent points. Again, I stress the importance of noting the difference between the two eyes, a difference that is important to her likeness. The eyelids on the right eye are a little rounder than the left one and the lower lid rises higher at the corner, but only slightly. I indicate pupil here as a prelude to establishing more subtle values. Its dark key establishes a deep value to measure other values against.

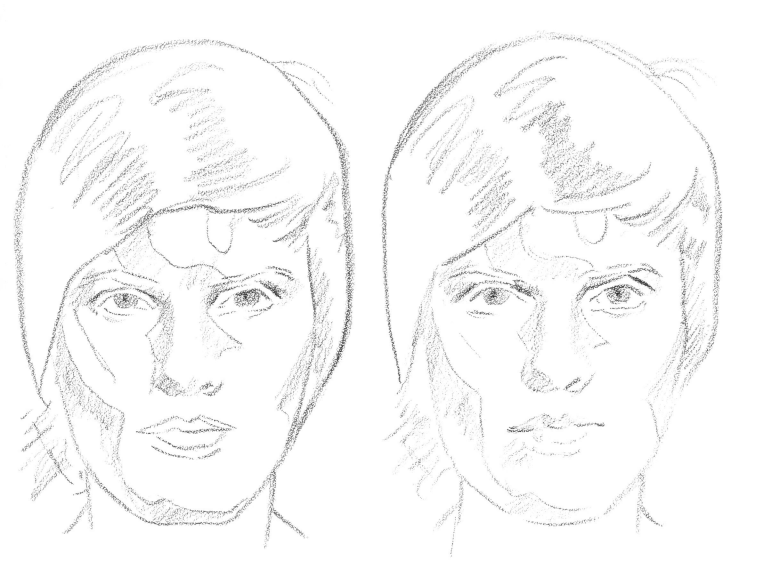

25. Adjusting the Shape of the Nose

To adjust the nose, I almost have to use tones instead of lines because of the softness of its contours. However, I delineate the boundaries of the halftones on the cheeks with a line. I locate the nostrils somewhat more precisely.

26. Adjusting the Shape of the Mouth

The mouth is adjusted by adding tones to the upper lip. The changing values on the curve of the lower lip are determined and I render a contour on the muzzle that extends down on the left.

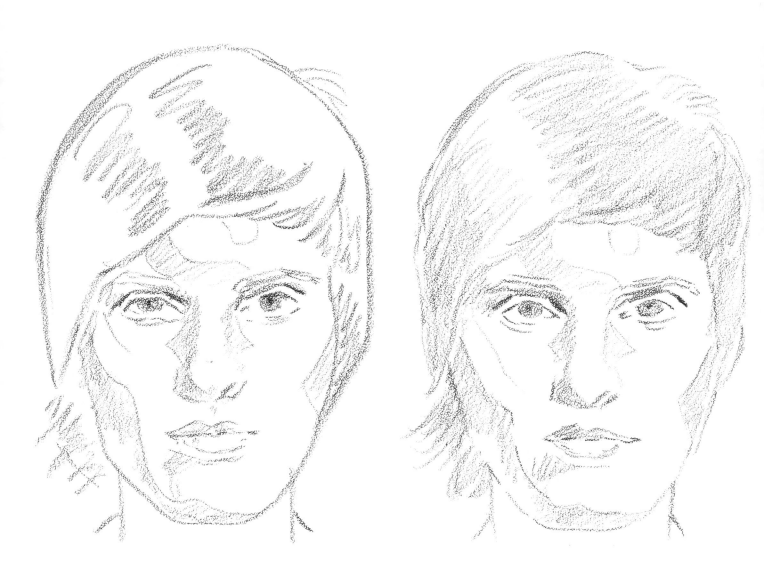

27. Adjusting the Shape of the Eyebrows
The eyebrows bend in a few more places, and I show this now.

28. Adjusting the Shape of the Ears
I indicate the hair tones, scumbling them in to get an effect of the shape and contours. This will suggest the shape of one ear, at least.

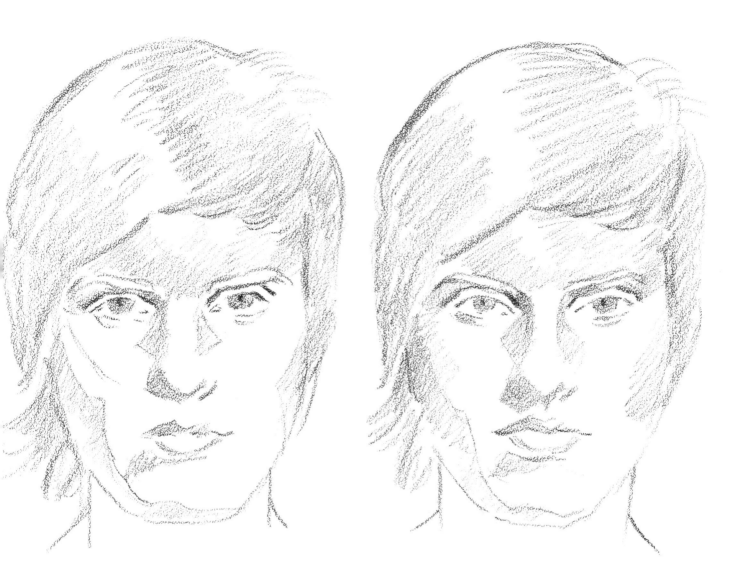

29. Modeling the Upper Face (Forehead Area)

Now I model the face with more tones. Over the forehead I shade in several values, mainly the one on the left that runs into the bridge of the nose. From now on, as I do this shading, I'll be absorbing most of the outlines.

30. Modeling the Middle Face (Cheek Area)

I start modeling the head at the center of the face and include the cast shadow of the nose. This cast shadow demonstrates how far out her nose extends.

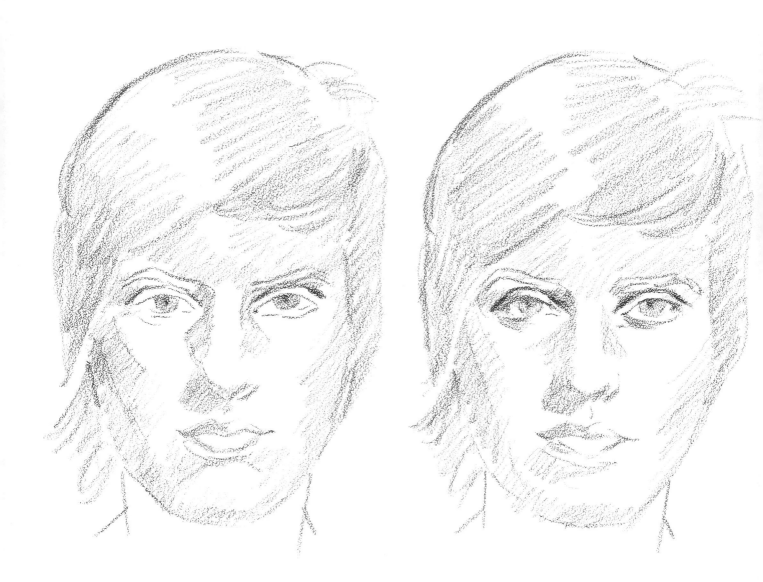

31. Modeling the Lower Face (Jaw Area)

I model the lower part of the face the same way. Later I'll add much more subtle shading here, but now I only want to carry this area as far as the rest of the face.

32. Modeling the Eyes

Modeling the eyes not only includes some of the values in the openings of the eyeballs, but also values that show the turning of the eyelids over the eyeballs, especially the lower lids. I strengthen some of the tones around the upper lids. I go over the lash lines too, for they'll have to be fairly dark.

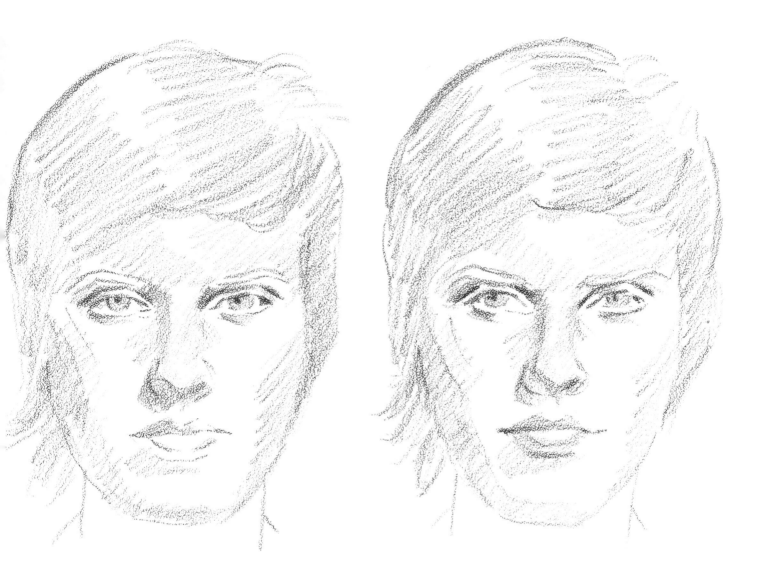

33. Modeling the Nose

I model the nose now, especially on the top and around the highlight at the tip. I define the shadows and the reflected light effect more clearly underneath the nose. The accents around the wings are strengthened.

34. Modeling the Mouth

It's time to model the mouth. Most important, I want to portray the curving lower lip and the little path of light there that dips around the red part. The drawing is somewhat changed to a closer portrayal.

35. Modeling the Eyebrows
I darken the brows and emphasize the parts that are blacker, such as the inner parts of both brows.

36. Modeling the Neck
I don't want to leave all the work on the neck until the end, so I put in the tone of the cast shadow.

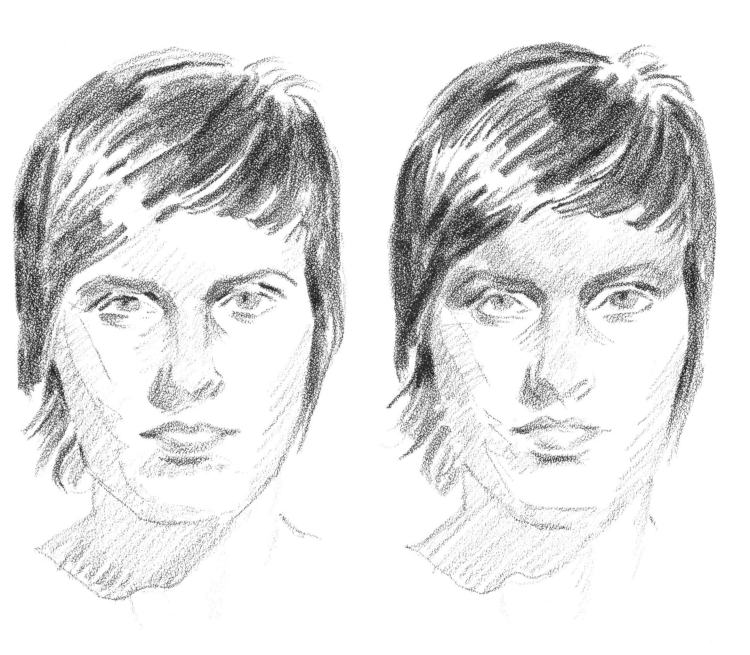

37. Modeling the Hair

Before I go too far, I have to work on the hair in order to balance the tonal values all over the portrait. The tones in the face can never look right until this huge dark area is established.

38. Refining the Upper Face (Forehead Area)

Coming down to the finish line, I begin to refine the whole head starting with the forehead, darkening or lifting out lights where necessary.

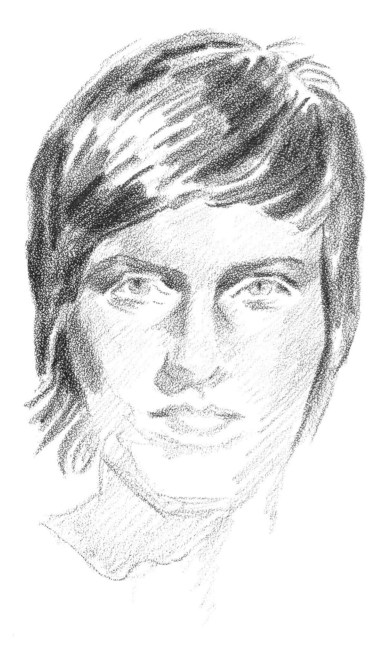

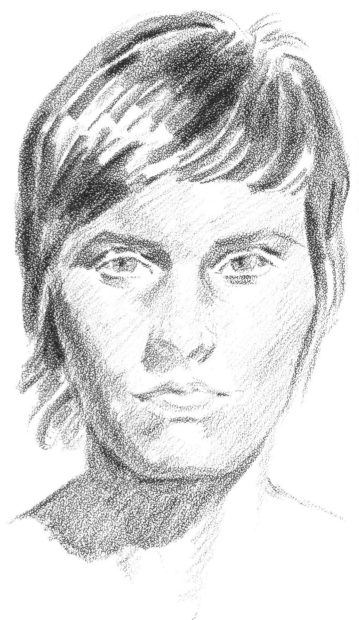

39. Refining the Middle Face (Cheek Area)

Refining the middle of the face means adding subtle values in the lightest parts. I make sure I lose the few outlines left up to now.

40. Refining the Lower Face (Jaw Area)

The lower part of the head requires quite a bit of attention because of the many varied halftones there. It's mandatory to get these halftones on the mouth shaped correctly and in the right value because a well-drawn mouth contributes more to a likeness than other feature. The neck is also worked on here. I likewise absorb those outlines.

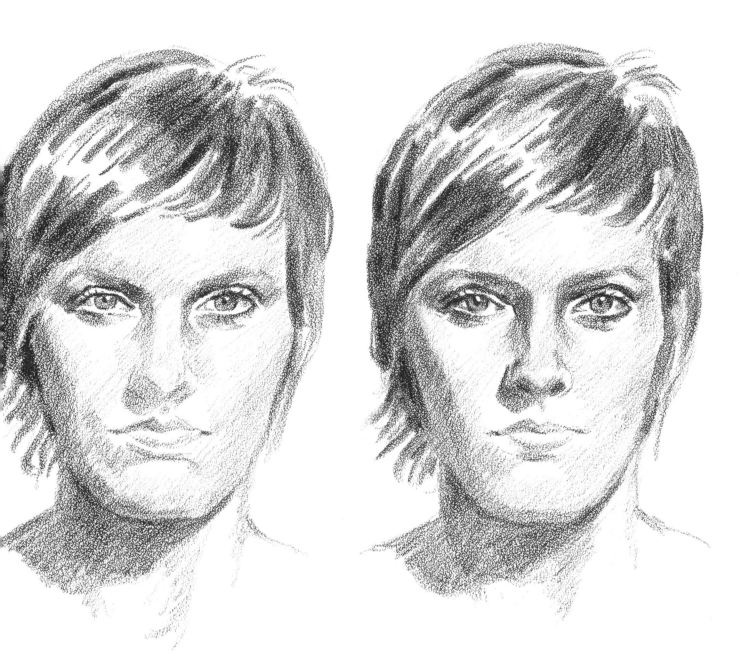

41. Refining the Eyes
Refining the eyes entails picking out the catch-lights and adding eyelashes. The very subtle tones under the eyes are also added and the lashes darkened at this point.

42. Refining the Nose
The nostril openings are darkened and the myriad of delicate tones in the light are rendered. The deep shadows on the sides next to the eyes are also darkened some more.

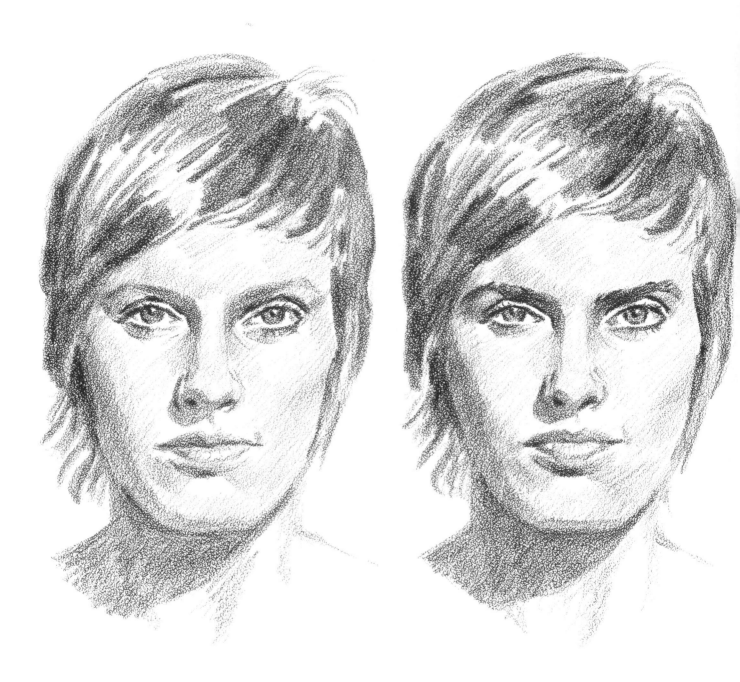

43. Refining the Mouth

The mouth is made fuller. I put in the tiny crinkles that run up and down the lower lip and note a slight smile that rises from the right corner of the mouth. The tones underneath the mouth are strengthened.

44. Refining the Eyebrows

I leave most of the rendering of the eyebrows until now because their indefinite edges create their character. There are little wisps here and there. Notice the degree of tonal variation as you move across their surface. At certain places they have sharp edges; at others, they blend into the surrounding tones. Another key to getting the likeness is by noting the way one brow (the left one) has a sharp break, while the other brow has two breaks and is thicker on the end.

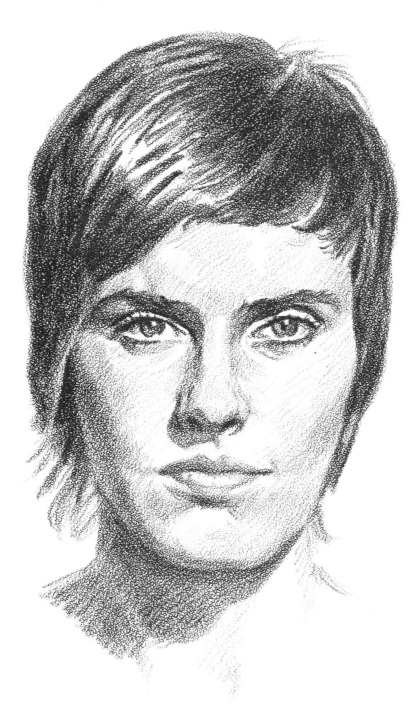

45. Final Analyzing and Refinements

At this point I ask myself if I've gotten a likeness. If I haven't, I must find out where the trouble lies. Sometimes it's caused by a tendency to exaggerate distinctions in features. This is all right if you're working from life, but in a photographic likeness you have to be more precise and not push any one characteristic. Here, I tend to exaggerate the difference in the eyes too much, so I change it. Also, the left corner of the mouth slips over too far and so I bring it in tighter. Almost all tones in the photograph are too harsh and have to be softened, and intermediate halftones must be added—for example, along the cheeks, around the nose, on the forehead, and on the chin. I then render the neck more carefully. Having left the coarse rendering of the hair until now, I finish that. I also take care of the differences in contours and edges. The one liberty I take, which does not change her likeness, is in rendering her hair. I make it more contrasty to give it a "drawing" look.

Rectangular Head

This head contrasts sharply with the first one in that its rectangular shape immediately establishes a different identity and personality. But this simple shape must be further refined by adding modifying shapes like a curving jawline and the normal rounding of the skull. Seeing the head in terms of the first, simple, geometrical shape is helpful, but too strong an emphasis on it can lead to over-characterization, like a caricature.

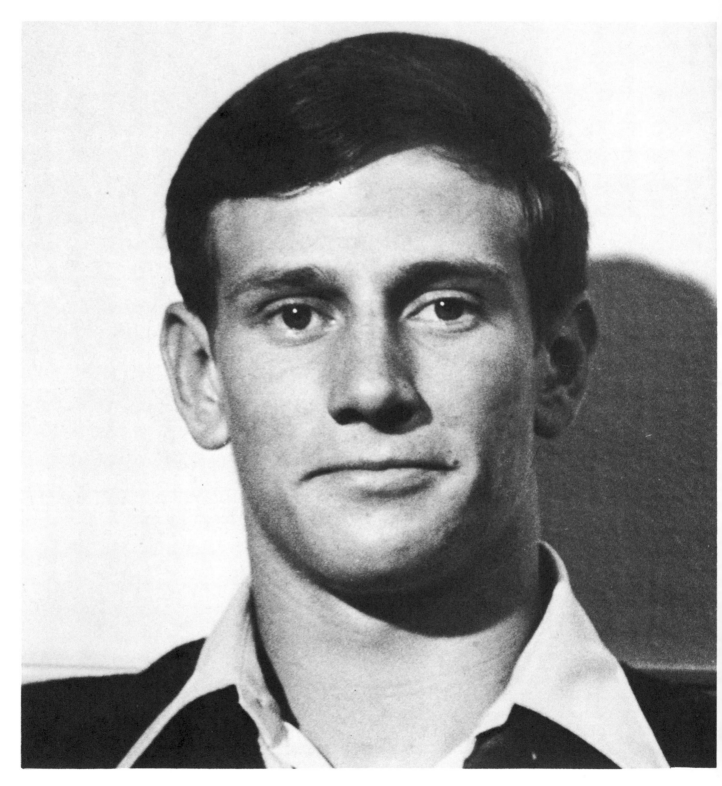

1. General Shape of the Head

The first impression I get looking at Casey's head is that it's rectangular. So I start the drawing with a rough shape that looks like a rectangle.

2. Variations Within the General Shape

As I begin to analyze the head, I see that it's the sides of his head and face that give it the rectangular appearance. Now, other shapes also emerge, such as the roundness of the skull and the dipping of the jaw.

3. Placement of the Eyes
The original rectangle has served its purpose, so I erase it. I find that the eyeline is above the usual halfway mark between the top of the skull and the line of the chin because of his large, distinct jaw.

4. Placement of the Nose
I locate the approximate position of the nose with two lines on either side of the lateral center mark.

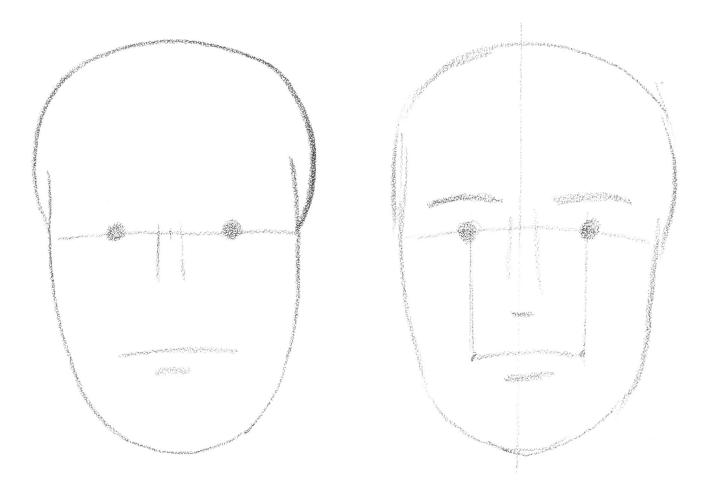

5. Placement of the Mouth

Halfway between the eyes and the chin, I place a rough mark to show the position of the top of the lip. I also add a small mark for the shadow under the mouth.

6. Placement of the Eyebrows

For the moment I add some construction aids to help me find the corners of the mouth under the eyes. At the same time I place an approximate indication of the position of the brows.

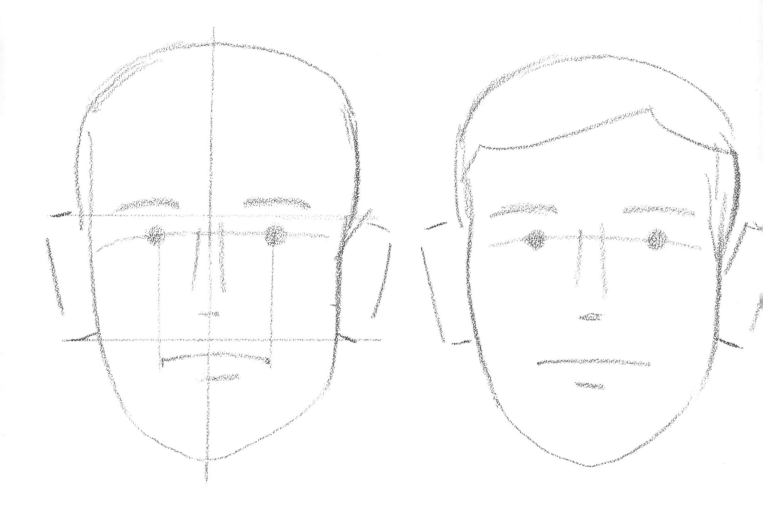

7. Placement of the Ears

Looking at the sitter with a level straight edge or ruler, I get the alignment of the top and bottom boundaries of the ears. The top line runs between the brows and eyes while the lower edge runs across slightly above the mouth. The great difference in the way the ears are positioned is one factor in getting this man's likeness.

8. Placement of the Hairline

I erase all construction lines, except the curved one through the eyes. Now I mark the lower edge of the hairline across the forehead.

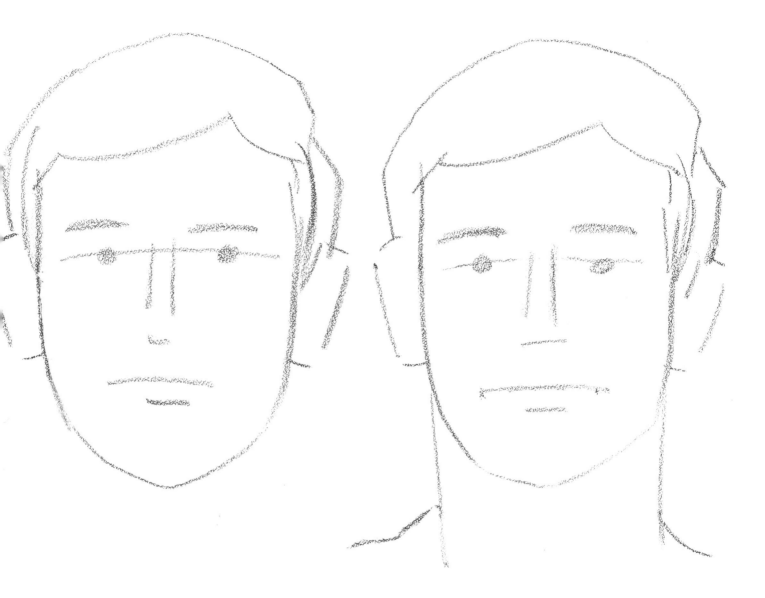

9. General Shape of the Hair
Next I show the top and side boundaries of the hair. Because of the way the hair is parted, the whole area looks lopsided. I erase the top of the skull line.

10. General Shape of the Neck
I get the general shape of the neck in this step. Notice how the lines of the neck drop straight down from the sides of the face. Even with these general shapes, you can begin to see a likeness.

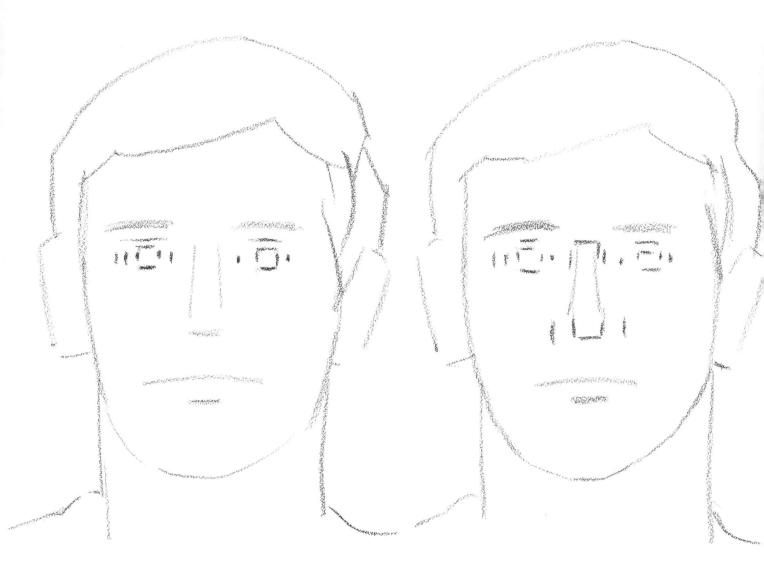

11. Proportions of the Eyes

I can begin to locate the proportions of the eyes now, marking the corners and the size of the lids. The two marks above are the top and bottom lines of the upper lid while the one check below is the top lip of the lower lids. At the sides, I locate the corners of the eye openings. I erase the smudge I put in earlier for the corneas. The upper lids appear to be deeper than average, maybe because the right one, especially, comes down over the eyeball slightly.

12. Proportions of the Nose

Now I do the same for the nose, showing just where it starts at the bridge, the width there, the proportions at the top, and the outer boundaries of the wings.

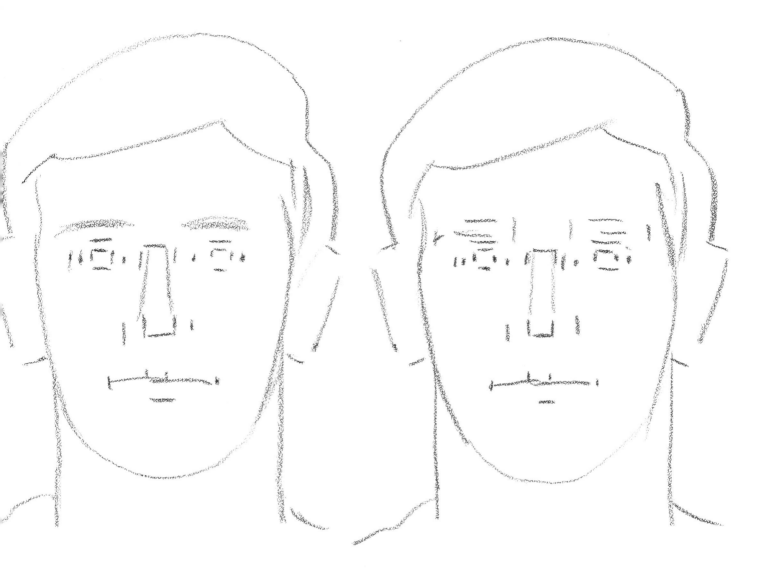

13. Proportions of the Mouth
I somehow lost the points of the mouth ends, so I reestablish them. Two points show the lower end of the septum, where it meets the mouth.

14. Proportions of the Eyebrows
The brows are proportioned with marks at each end, and top and bottom.

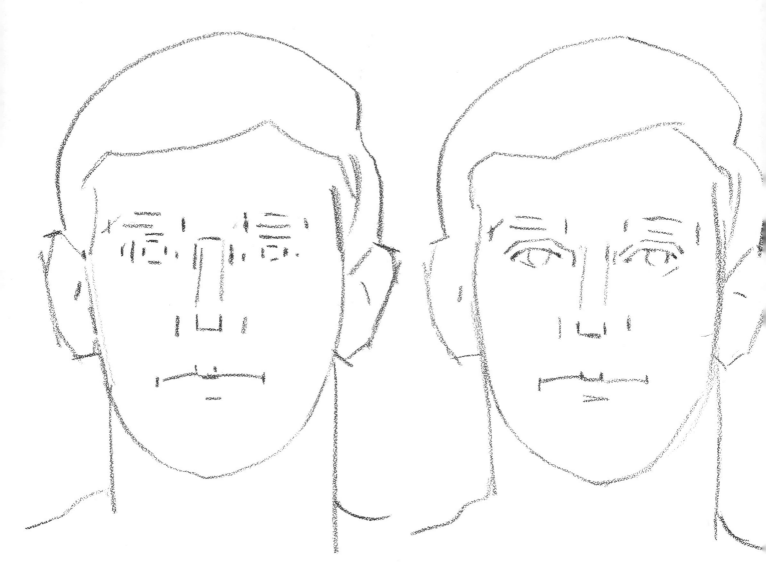

15. Proportions of the Ears

The ears are proportioned and their angularity is a little more accurately defined.

16. General Shape of the Eyes

Now I outline the corneas of the eyes and the top lids. Notice that they're fairly wide, and that the left cornea is positioned a bit to the side—a point important to capturing his likeness.

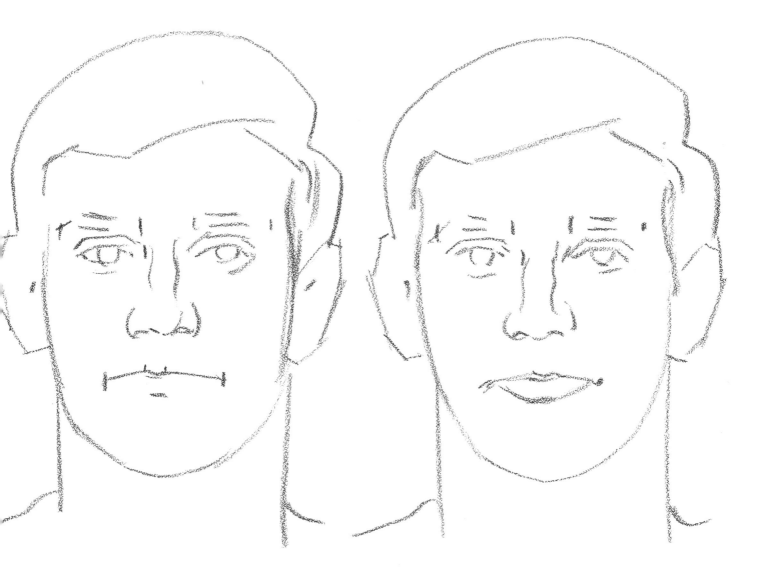

17. General Shape of the Nose

I put two lines on the front planes of the nose near the bone end to temporarily show the change in planes. (Later on, I'll put shading there.) I indicate both the outer curves of the wings and the underside of the nose.

18. General Shape of the Mouth

I see that one of his characteristics is a very thin upper lip. But the lower lip is rather average, except that it doesn't overhang very much, so not much of a shadow is cast underneath. He has a peculiar tautness or set to his mouth, which could be caused by his self-consciousness. Nevertheless, I have to abide by what I see in the photograph or my drawing won't resemble him, so I just put a light line around the boundary of the red part.

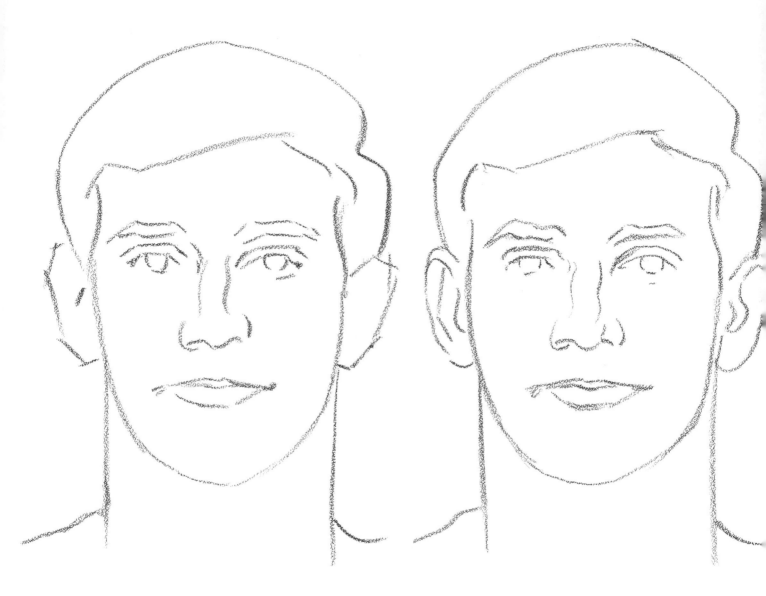

19. General Shape of the Eyebrows

He has heavy brows and, for the most part, they have no definite edges. I just roughly define their shape for now. Later I can get more of his individual character in them.

20. General Shape of the Ears

I show the shape of the ears now, with some development of the various components.

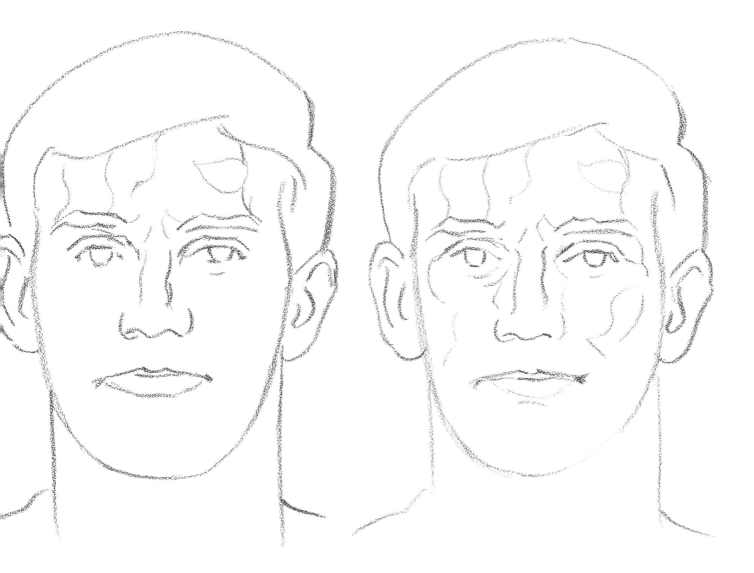

21. Contours of the Upper Face (Forehead Area)

The contours on the forehead are divisions of planes consisting of a large highlight area (with a teardrop-shaped tone interjecting), two tones at each side, and two subtle ones on the front to the left. The small areas of tones coming up from the nose, which show the form turning into the bridge of the nose, are also noted.

22. Contours of the Middle Face (Cheek Area)

Through the center of the head you can see tonal values at each side, but in differing amounts and shapes. On the right, there's a very definite half-tone between the shadow and front plane, whereas on the left, there's a more gradual shading of tones. I add some lines to show the construction of the orbits also. (In this type of light, these shapes repeat themselves from figure to figure somewhat, but they do vary slightly with each individual.)

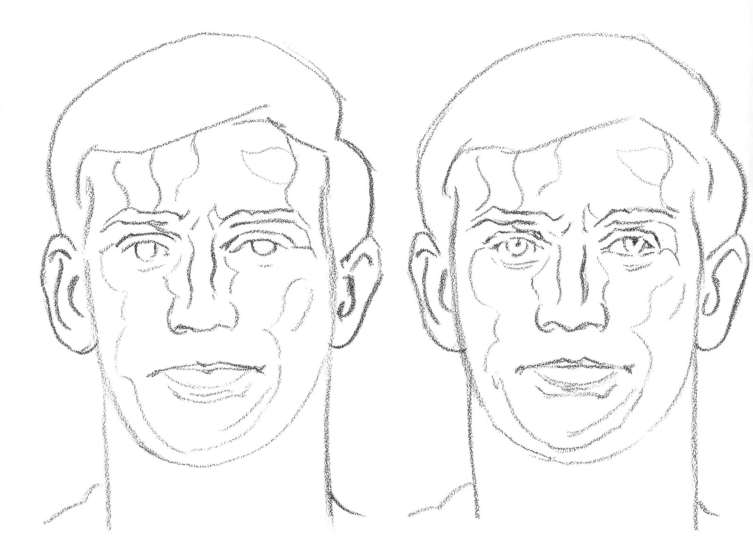

23. Contours of the Lower Face (Jaw Area)
The shadows continue moving down the sides of the face, looping around the edge of the chin and giving us an idea of how much the jaw comes forward from the neck. In this step I indicate the shape of the contours under the mouth, too.

24. Adjusting the Shape of the Eyes
My attention is drawn to the eyes again. First I mark the pupil and adjust the lids all around by getting more of their angular appearance. (I do toning or shading, later.) The upper lids make sharp breaks in different directions.

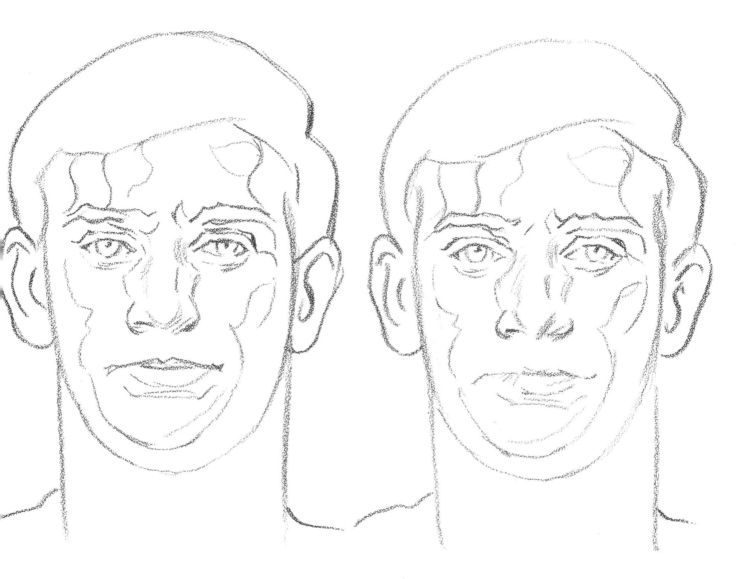

25. Adjusting the Shape of the Nose

I erase the heavy lines on the nose and substitute light tones instead because of the subtleties there. I show the shape under the tip of the nose now also. The nose is a little bit crooked, going over to the left somewhat.

26. Adjusting the Shape of the Mouth

I begin to make a clearer statement about the mouth, showing how the top lip is hardly a continuous edge. The only edges with definition seem to be on the right-hand side of the two dips. A few quick lines on the lower lip show the crinkles on the left, more as a tone than detail. The corners are one up and one down, another definite clue to finding his likeness. All steps concerning the mouth are crucial.

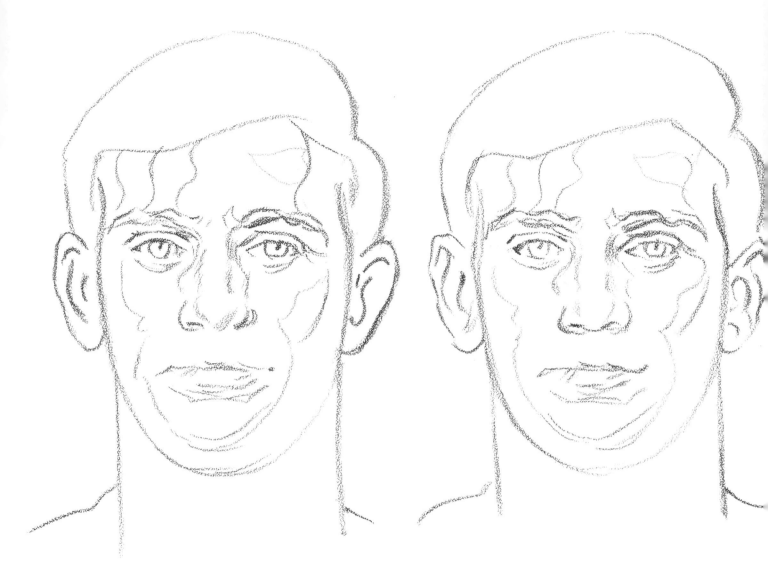

27. Adjusting the Shape of the Eyebrows

The undulations and curves of the eyebrows are more clearly established, though I'll be concerned more with their edges later, when I start to tone the drawing.

28. Adjusting the Shape of the Ears

The oversimplified ear shapes are broken down to a more accurate description. The ears look pretty much like most ears, but I try to render their differences from one another.

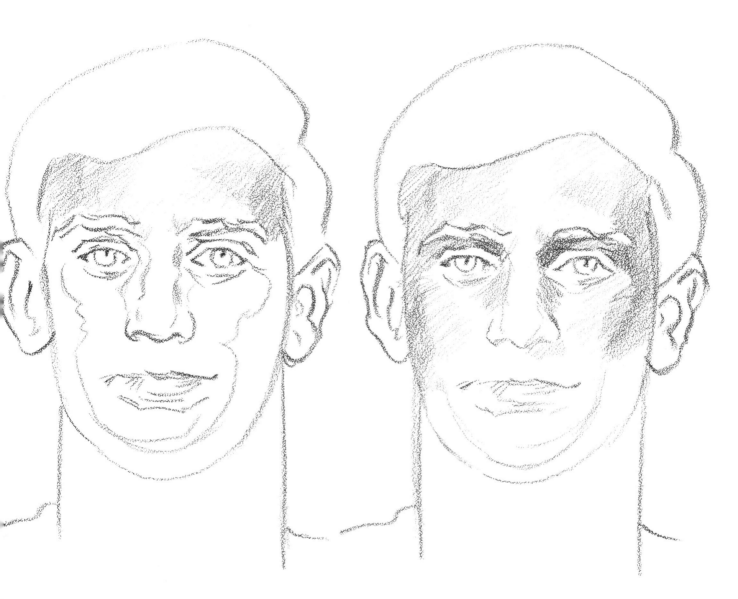

29. Modeling the Upper Face (Forehead Area)

...rough in some tones on the forehead in the same ...manner as I did in Step 29 of the preceding dem-...onstration, losing the outlines as I do this.

30. Modeling the Middle Face (Cheek Area)

Note how the tones move down the sides and across the middle of the face. I'm careful to keep the appearance of the basic structure by getting a close approximation of the final values.

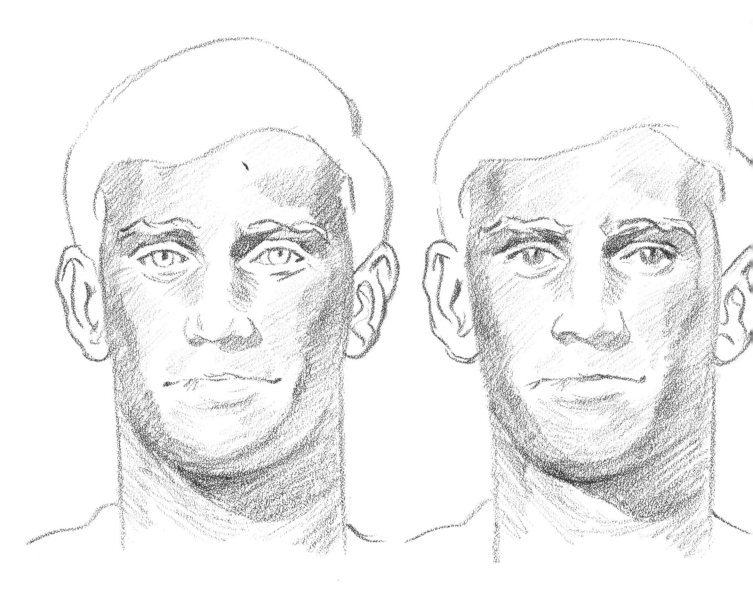

31. Modeling the Lower Face (Jaw Area)

The earlier steps in this area revealed an individual distinction—that his jaw is slightly more pointed on the left side. The tonal values cutting across from the shadow side seem to confirm this. Ordinarily there would be a cleft and an indication of a lighter area next to it (in this case, on the right side of the chin), but there isn't one here. Also I tone the neck to bring out the form in relation to the head. The cast shadow tells us how far out his chin protrudes.

32. Modeling the Eyes

I put a tone on the corneas, leaving a white spot for the catchlights. The pouches underneath are not too pronounced, but some tone is needed there.

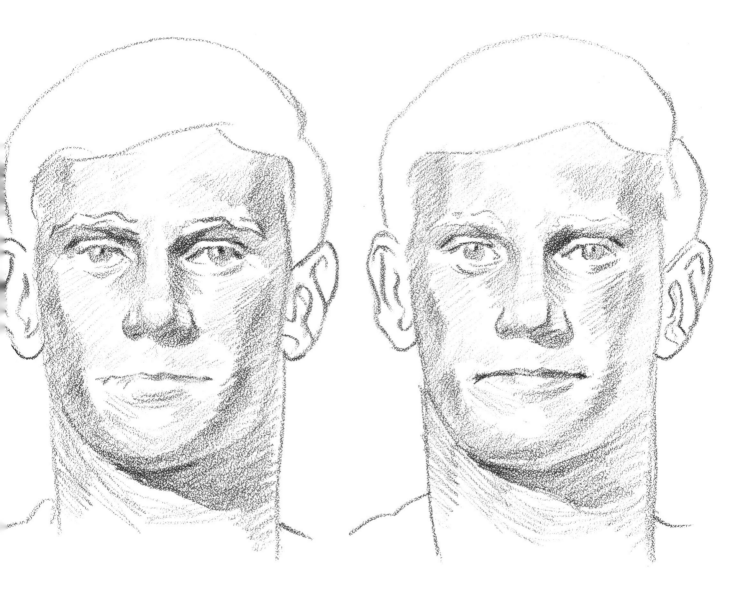

33. Modeling the Nose

A fair amount of work can be done here to bring out the minute variations of tones that give the nose its protruding form. The wings and bottom are drawn in with stronger tones.

34. Modeling the Mouth

I study and record the tones of his mouth. The appearance of his mouth is one of a definite line and little else. The thin upper lip has many tones across it, even though there is the effect of one slash. The most consistent part of it is the fine, black separation line. The lower lip, as I noted before, has light, almost transparent tones. There seems to be little to grasp, but there are delicate traps. It's almost a question of what *not* to do here.

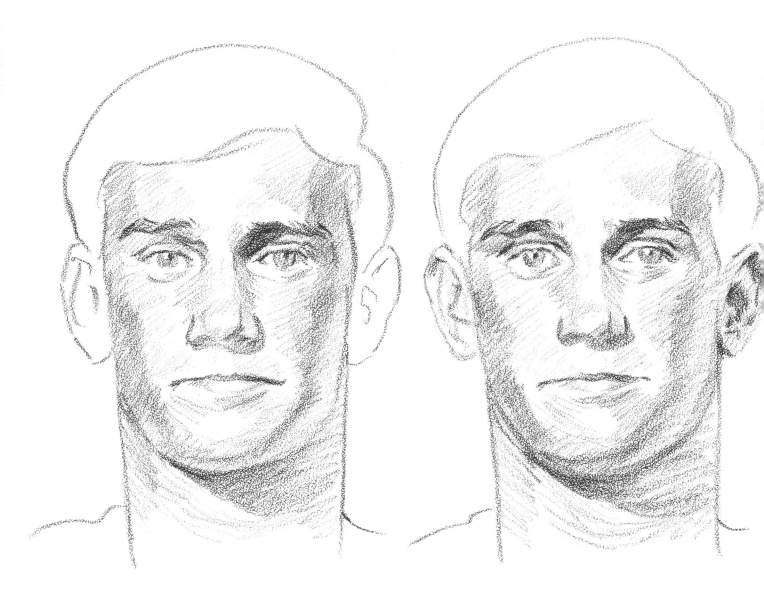

35. Modeling the Eyebrows

The undulating waves of the eyebrow tones provide the work here. He actually has a very standard set of eyebrows. Moving from the center outward, the inside edges are soft, becoming dense, dark, sharp-edged on top and soft on the bottom edge. Then they thin out, reversing their edge quality: soft on top, sharp underneath. Finally there's a slight swooping up for the drop to the sides. In this instance, to get his likeness, I note that they have sharp changes in direction. Also, the right one tends to curve downward more than the other one.

36. Modeling the Ears

The main thing I watch for here is that the ear on the shadow side is recorded as all dark.

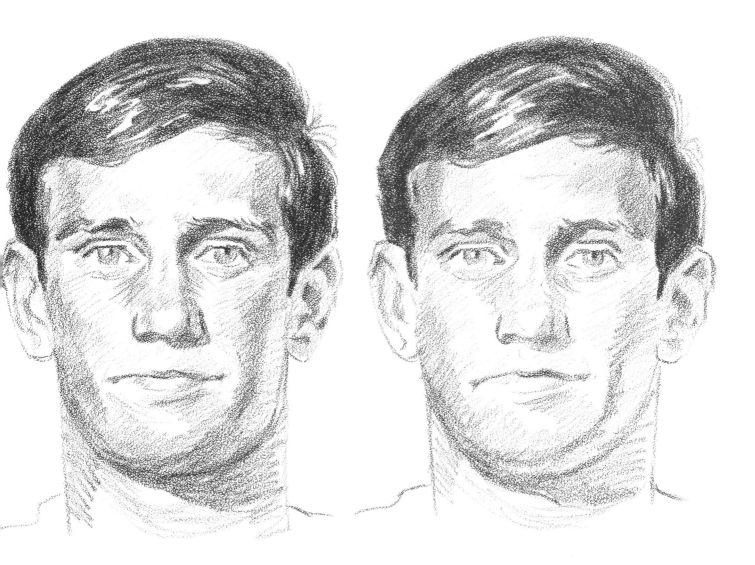

37. Modeling the Hair

To complete the tonal arrangement of the whole head, I put in preliminary shading and textural effects. I leave some spaces open for the highlights and give some hints of the softness of the hair.

38. Refining the Upper Face (Forehead Area)

Now I polish the tones I already established. Across the upper face, the values are pulled together by softening them, though the face does lose some contrast. I also add a crease.

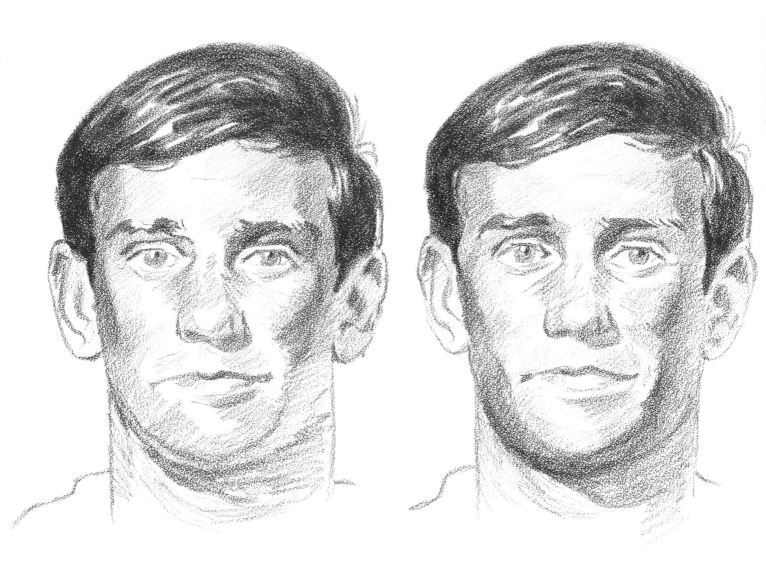

39. Refining the Middle Face (Cheek Area)

In refining the central area of the face, I find that the values on the side plane should be darker. To impart a more pleasant expression, I swing the halftones toward the face more.

40. Refining the Lower Face (Jaw Area)

The lower part of the face now needs to be considerably darker. In a rendering of this kind, it's best to hold back the shading at first. Instead, gradually work up to the right tonal value rather than to erase one that's too dark and make a smudge.

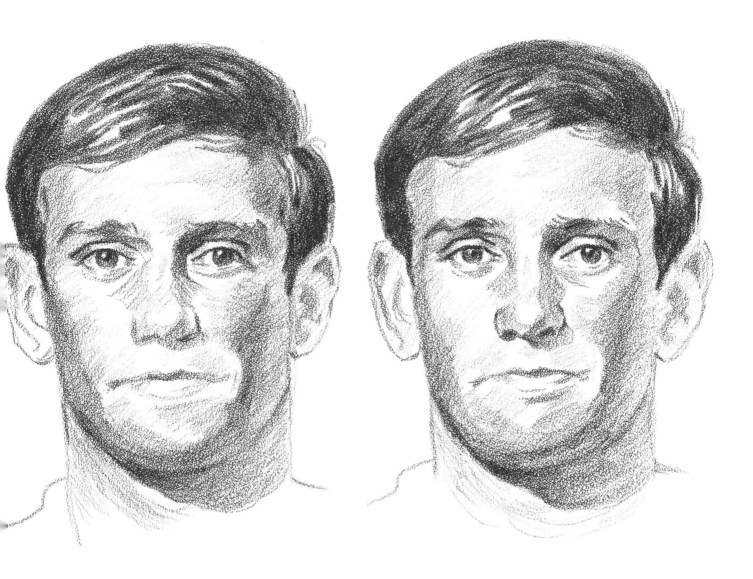

41. Refining the Eyes

I make his eyes come alive here. Adding color in them (here expressed by value) does it partly. At this stage I have to be sure that I don't lose the distinct movement of his eyes. He's unquestionably looking directly ahead, but (as I mentioned earlier) the right cornea is off to the right. But this doesn't effect the direction that he's looking in. The clue to making his eyes look straight ahead is to carefully note how the lids turn as they cover the eyeball.

42. Refining the Nose

Most of the refinement in this step is made around the nostrils, where the dark accents are strengthened and the nostril openings are drawn in. The shape of the cast shadow is improved too.

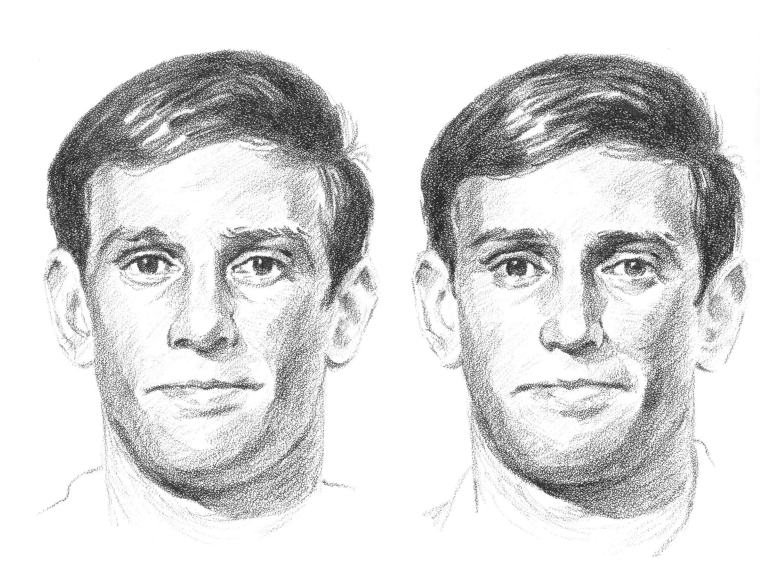

43. Refining the Mouth

Looking at the mouth, I see that the upper red part needs strengthening. Adding dark accents between the lips and at the corners helps. The upper lip blends into the flesh, especially on the right. The delicate shading on the lower lip is refined now also. The ears are also improved.

44. Refining the Eyebrows

The tones in the brows are a little jumpy and hard so that it's necessary to soften them and, at the same time, to deepen the darks more. I begin to develop the shirt now.

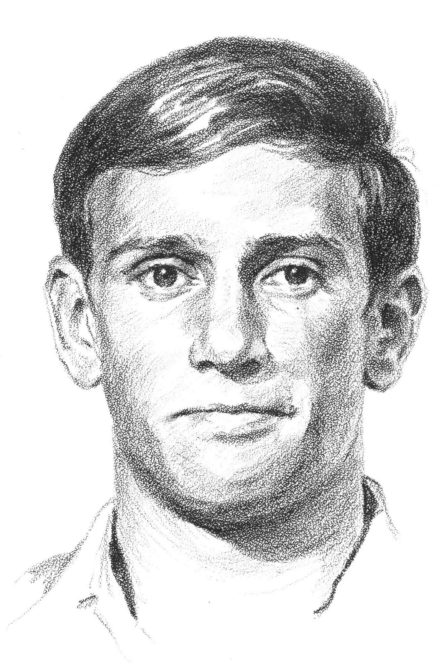

45. Final Analysis and Refinements

As I move toward a finish, you can see that it's very close to a likeness. But several little touches will still improve it. For one thing, his eyes should be brighter and a tiny bit larger. To make them that way I lift the lash line over the cornea of the left eye somewhat and smooth it out. The corneas are made a hairline larger, rounder, and darker, bringing out his strong, clear vision. The lower lids are becoming harsh, aging him somewhat, so I soften and smooth those folds. Around the mouth, I feel that more careful rendition of the values is important. For example, the right cheek protrudes. It looks like he has a marble in his mouth because the contrast is too strong and too sudden. I tone that down and add halftones to turn the cheek more smoothly. Also, the corners of the mouth aren't quite right: the left one drops quicker and at more of an angle. I also add a minor detail, the little mole at the right side of the mouth, and place an accent there. The tones surrounding the mouth are also adjusted again, the ears are more tightly rendered, and last, I finish the neck and collar.

Circular Head

In the first two demonstrations, the sitters were facing straight ahead. This entailed dealing with problems of symmetrical differences in placing various features. But you may not always be doing a portrait of a person looking straight ahead; you may find another view more interesting or more flattering to the sitter. And while a straight-on pose may be easier, as a portrait artist you must be able to draw the head well from all angles. So, in this demonstration, I'll show you how to do a head that's slightly turned. This will add some new problems, since the perspective changes a bit. Nonetheless, getting the likeness still involves the same series of forty-five steps and entails close observation to the relative positions of the contours, features, and values. Also, no matter how the head is posed, individual characteristics are still evident.

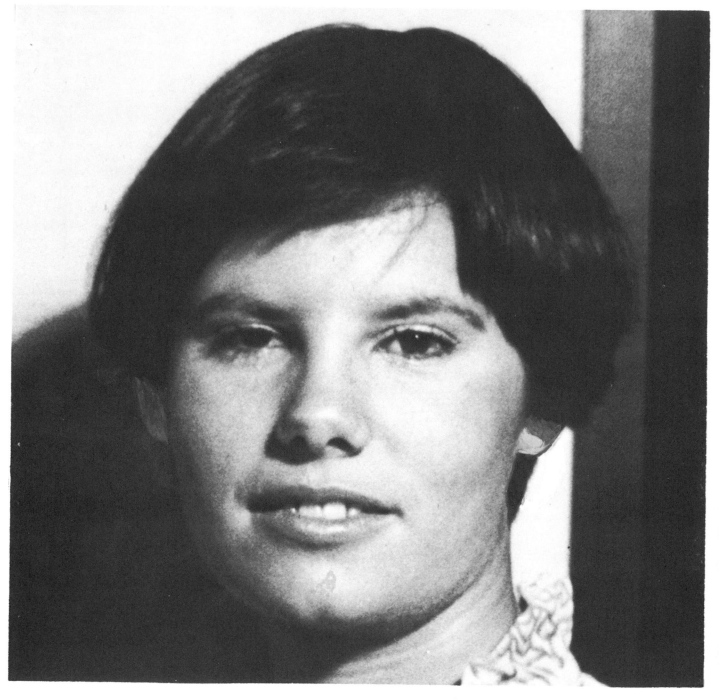

1. General Shape of the Head
Looking for a simple shape to start this drawing of Marijane, I find that the head appears somewhat circular. Actually it's somewhat between a circle and an oval. Notice that its axis is slanted to the right. This is because of the slight turn of the head.

2. Variations Within the General Shape
I need to complete the shape of the head by adding more at the top and by showing the temple indentation on the left side. Her chin has a cleft, which I locate now.

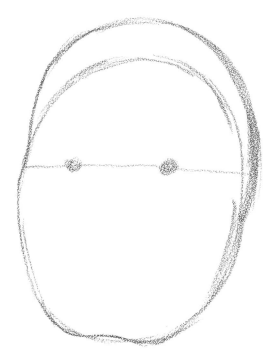

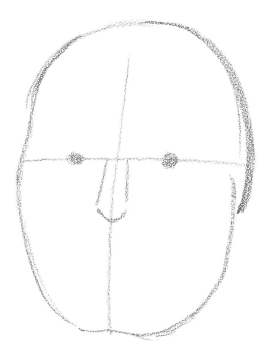

3. Placement of the Eyes

The eyeline measures about halfway between the top of her hair and her chin. But the oval I've drawn doesn't represent the top of her hair, only the top of her skull. Therefore I must take that difference into account when measuring.

4. Placement of the Nose

To position the nose, which straddles the center line, I must get the curved aspect of the line. Getting a likeness must include basic considerations like this.

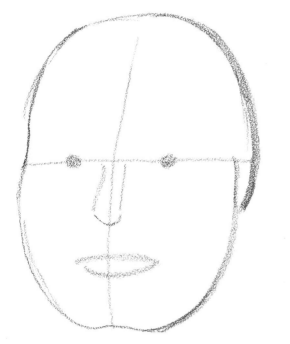

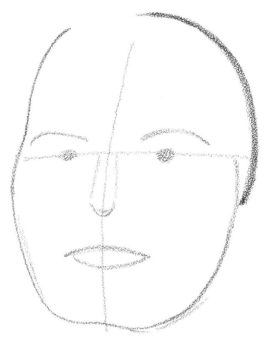

5. Placement of the Mouth
I place her mouth, which is just about centered in the muzzle area.

6. Placement of the Eyebrows
Her eyebrows arch over the corneas fairly low. I note their perspective, especially where the inner corners relate to the corneas.

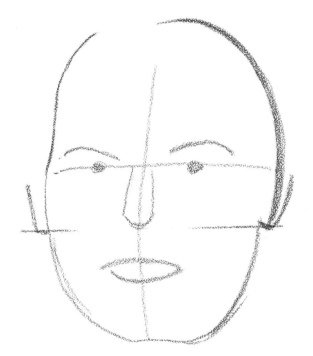

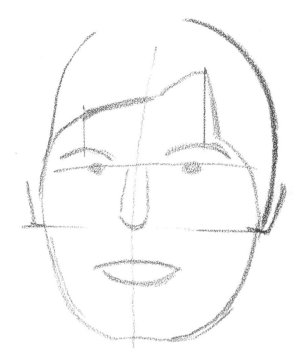

7. Placement of the Ears
The ears show only at the lower part, so it's only necessary to compare the lobes to the nose. They lie somewhat below the tip of the nose.

8. Placement of the Hairline
I now indicate the hairline, which curves over the forehead to the left part of her forehead, breaking and dropping sharply. To determine the breaks in the hairline, I drop plumb lines to the corneas.

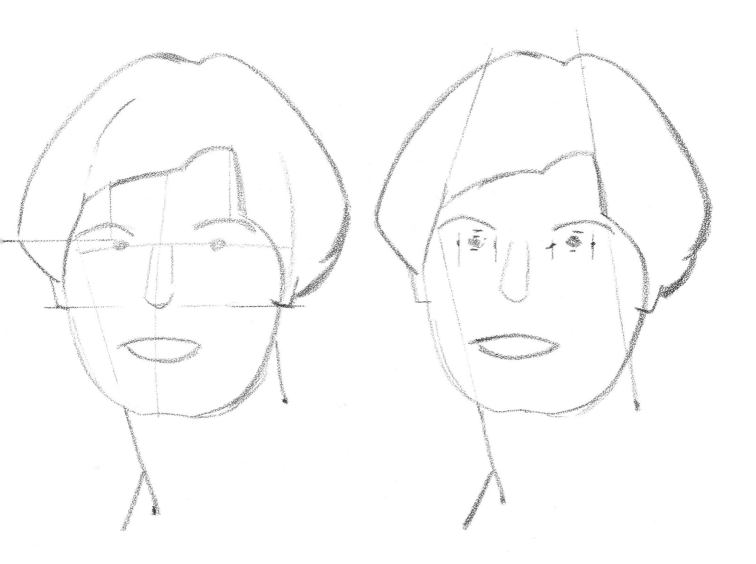

9. General Shape of the Hair and Placement of the Neck

To complete the whole hair shape, I add its outside perimeter, noting where the part is at the top. At the left it cuts back in to the ear at about eye level. Notice how I always relate these points of directional change to the features. I locate the position and outside boundaries of the neck by construction lines. One seems to be a continuation of the vertical part of her hairline, the other points to the edge of the eyebrow.

10. Proportions of the Eyes

I now get the proportions of the eyes. The one on the left appears to be only slightly narrower than the other one. I erase some of the map lines I used before.

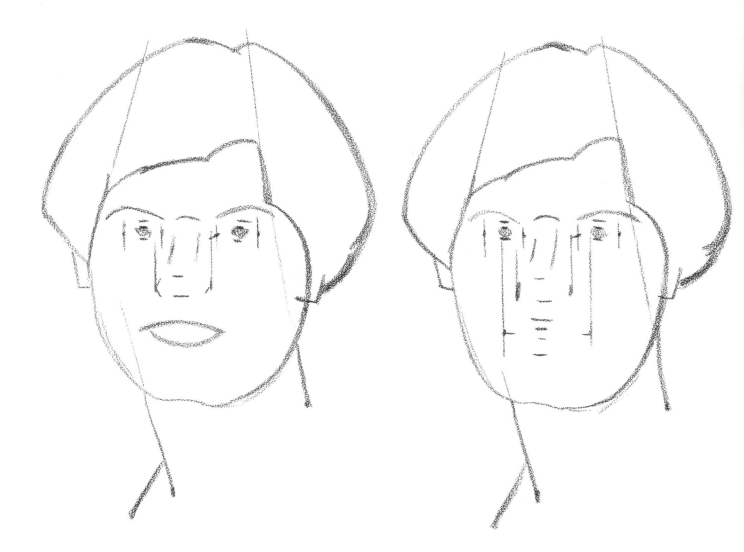

11. Proportions of the Nose

Dropping plumb lines from the eyes, I notice how the edges of the wings differ in position. There's quite a definite boundary at the bridge of the nose. The flat, front plane angles to the left and the underside turns up quite sharply, a fact that I've marked. This is a distinctive characteristic of her face.

12. Proportions of the Mouth

I estimate the width of the mouth with plumb lines dropped from the left edges of the corneas.

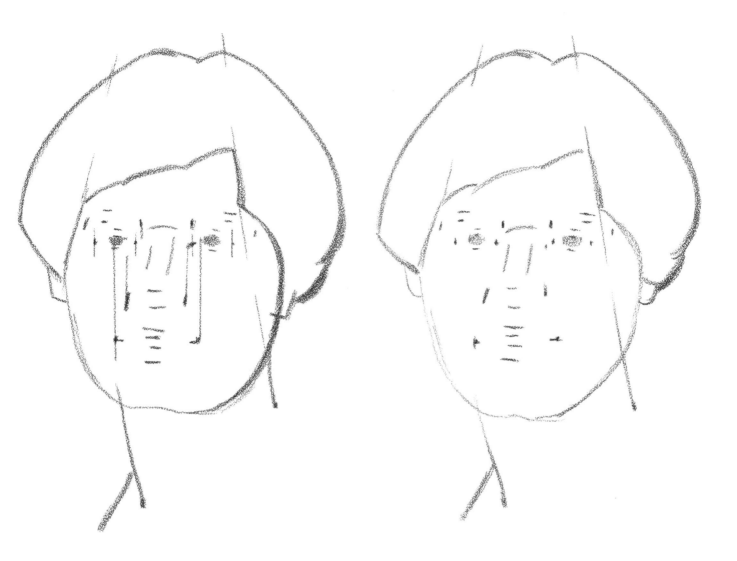

13. Proportions of the Eyebrows

I find the proportions of the eyebrows now. They're quite symmetrical in a direct front view of her face, but in perspective each one appears different.

14. Proportions of the Ears

I erase all of the construction and plumb lines at this point to keep it from being too confusing. I round the tips of the ears somewhat.

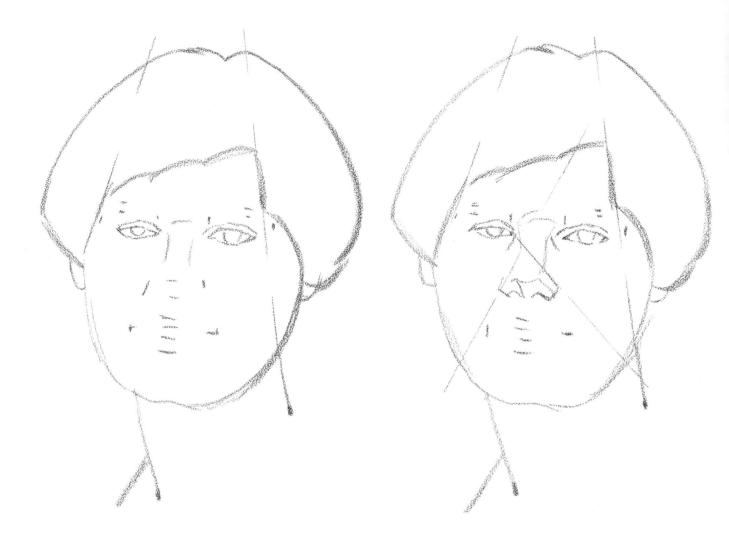

15. General Shape of the Eyes

Now I start getting the overall tonal shape of each feature, starting with the eyes. Note that the complete shape of the left eye seems smaller and that the lid droops over the cornea, which also seems smaller. There's not enough perspective to make that much difference; it's due to the variation in the size and shape of her features, specific differences that go into making a likeness.

16. General Shape of the Nose

The two previous demonstrations were complicated enough without my adding burdens like sighting lines. However, to serve as a reminder that they're part of the procedure in drawing a portrait, I'm using them now to get the correct angle of her nose. It's vital here also because getting this angle is another key to expressing her likeness.

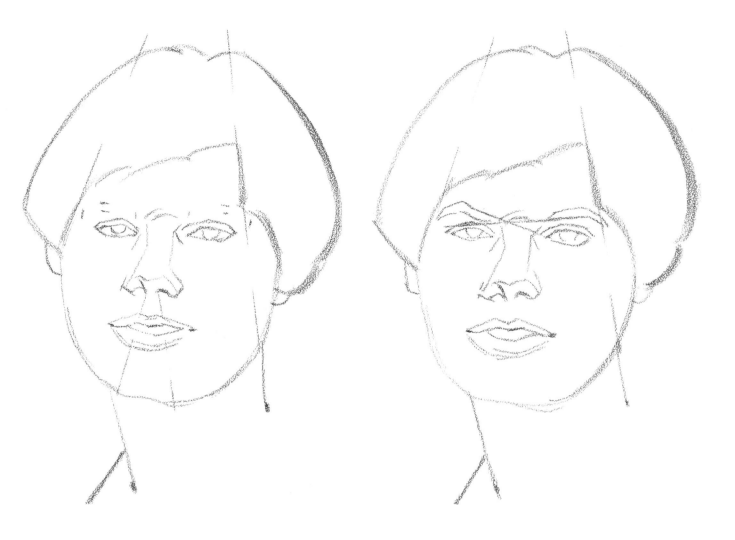

17. General Shape of the Mouth
I erase the previous guidelines for the nose and use two new ones for the mouth. It's a very idealized kind of shape, but the lower lip swings slightly to the left.

18. General Shape of the Eyebrows
I put in new construction lines that knit her eyes and brows together. There's an obvious distinction now in the way her brows differ. Study how the contours direct themselves to different places on the eyes. The left top one angles down much more than the other one. This difference would be consistent in any view of her face.

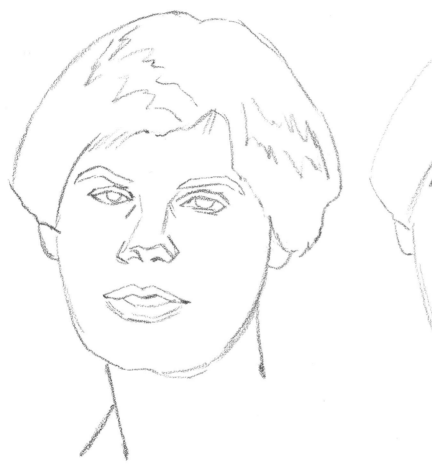

19. General Shape of the Hair

I rub out the lines around the eyes and brows. I merely rough in the approximate position and effect of the highlights in the hair. I also refine the edges of the hair all around.

20. Contours of the Upper Face (Forehead Area)

I now outline the five main areas of tones across the forehead, plus the two loops of tones coming up from the eyebrows.

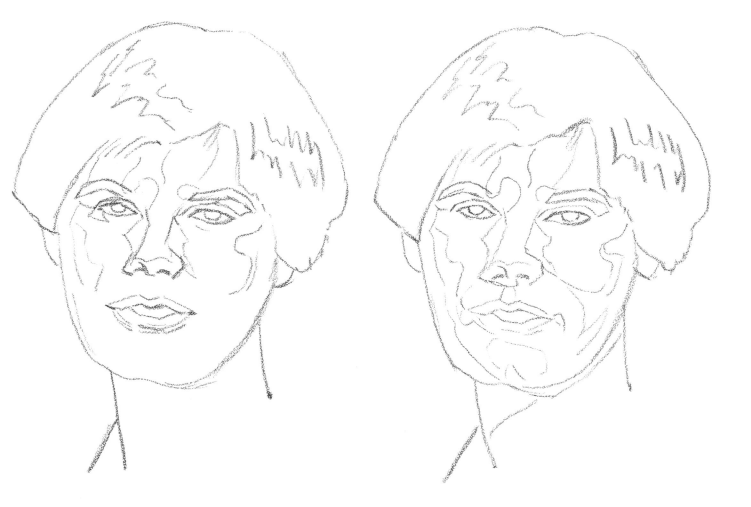

21. Contours of the Middle Face (Cheek Area)

Here I outline the shapes of the tones around the eyes, nose, and cheeks. You must accurately define these edges, for they're the key to the form.

22. Contours of the Lower Face (Jaw Area)

The lower facial tones are still typically ones in any lower face. I go through these steps rather quickly but with accuracy. The neck tones are somewhat indicated.

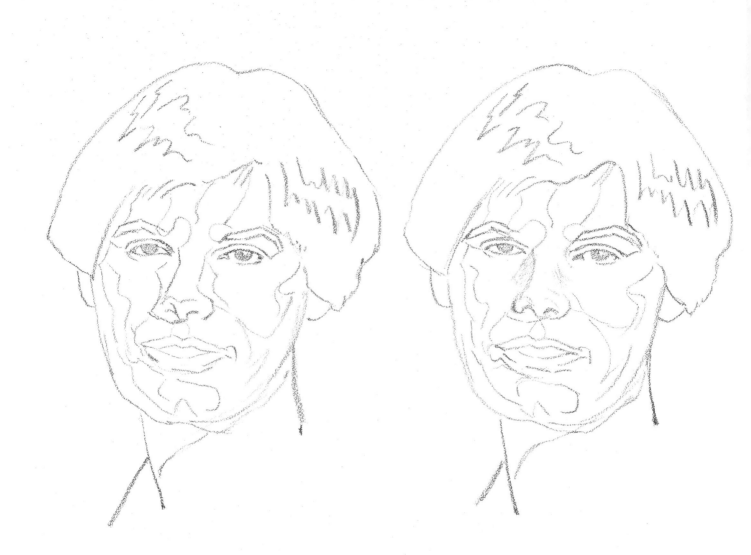

23. Adjusting the Shape of the Eyes

Beginning adjustments on the features, I complete the eyes some more, smoothing the lines of the lids, defining the corners more precisely, comparing the relative sizes of the two corneas, and establishing the exact locations of the lower lids. I leave a spot bare for the strongest catchlight. A very distinct part of her likeness is in the comparative levels of the lower lids.

24. Adjusting the Shape of the Nose

By rounding off the corners of the lines around the nose, I begin to portray it better. I replace the outlines on the sides with light tones. I also begin to form the tip with tones instead of hard lines.

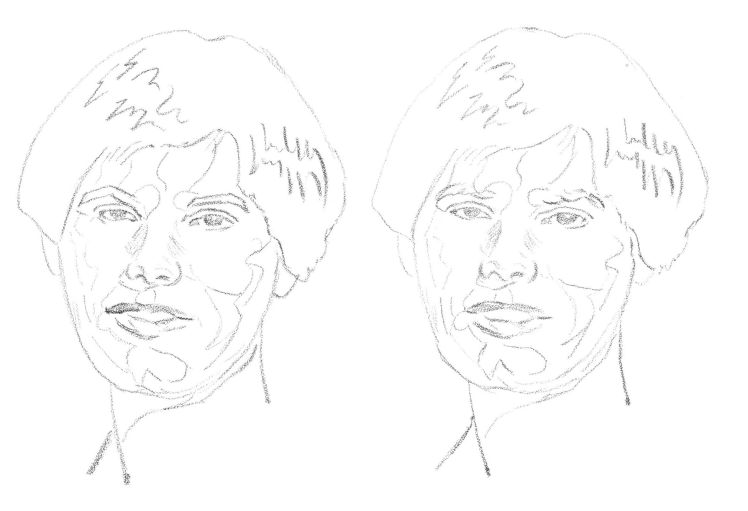

25. Adjusting the Shape of the Mouth

The only way I can continue to get a more accurate portrayal of the mouth at this stage is by toning. It may seem premature, but there's usually more work on the mouth than anywhere else. There are so many delicate nuances there that I'll need all the time I can get to render them.

26. Adjusting the Shape of the Eyebrows

After the basic formation of the eyebrows is established, I find that they have a sketchy look that seems to break up their form somewhat. I try to show that effect without losing the form.

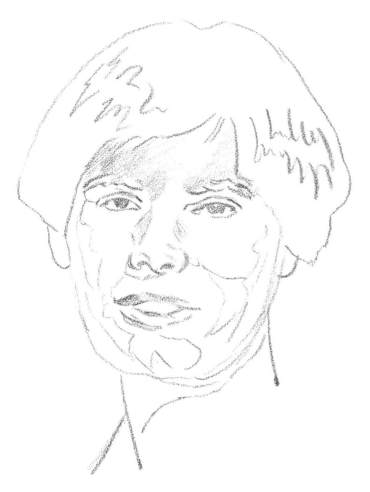 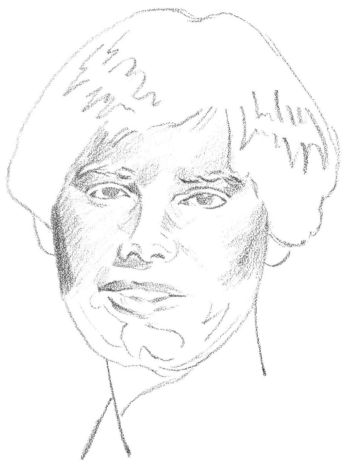

27. Modeling the Upper Face (Forehead Area)

Ordinarily, at this stage, I would render the ears. But since the ears are mostly covered, I begin modeling the tones in the forehead. The point is that, the sequence of steps will naturally differ from head to head depending upon what's involved.

28. Modeling the Middle Face (Cheek Area)

Continuing to work down the face, I find that the tones become quite dark on one side. I try to hit the tones as accurately as possible because they will help me judge the intermediate gray tones. The values coming into the light can be under-modeled.

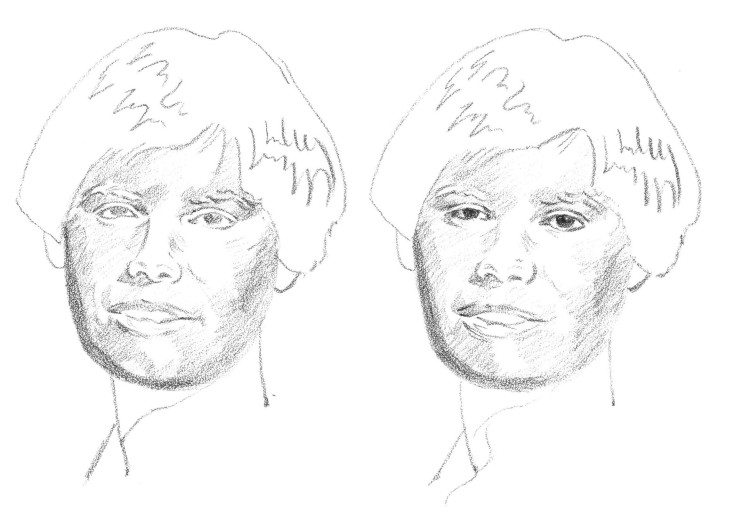

29. Modeling the Lower Face (Jaw Area)

Now I shade in the lower part of the face. Don't be startled by the dark tones there. The shading on the lower face automatically follows the middle-tones that have already been started.

30. Modeling the Eyes

As I darken the eyes to their full saturation, I lessen the shock of the previous dark tones. I can't exaggerate the dark corneas too much, since the prismicolor pencil on Coquille board doesn't go to black easily. Her eyes are quite black, as you can see.

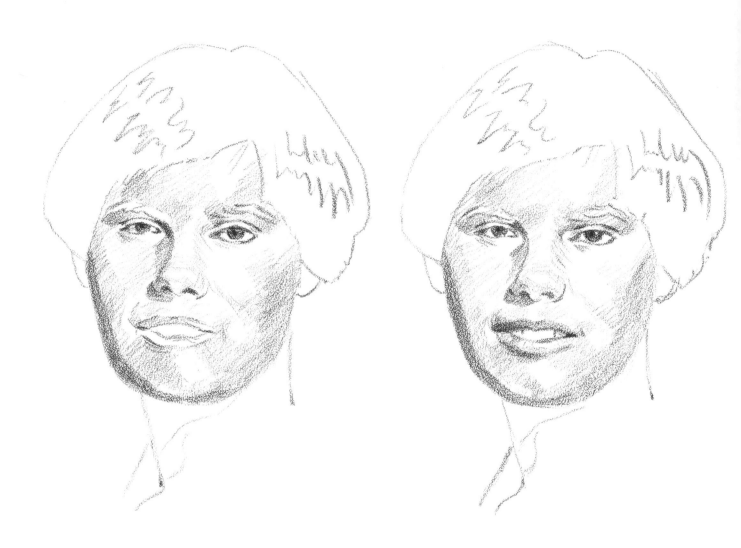

31. Modeling the Nose

Now, working on the nose, I have the opportunity to move even closer to getting her likeness because her nose has a flat plane above the highlight on the tip and I can tone that in. I also note the abrupt side planes and the tones that turn the underside of her nose up—all so much a part of getting the likeness.

32. Modeling the Teeth

The fact that the teeth are showing is more than just a temporary expression. She's a naturally "smiling" person and would, I believe, easily look this way no matter what her frame of mind. But I hold back on too much rendering of her teeth for technical reasons.

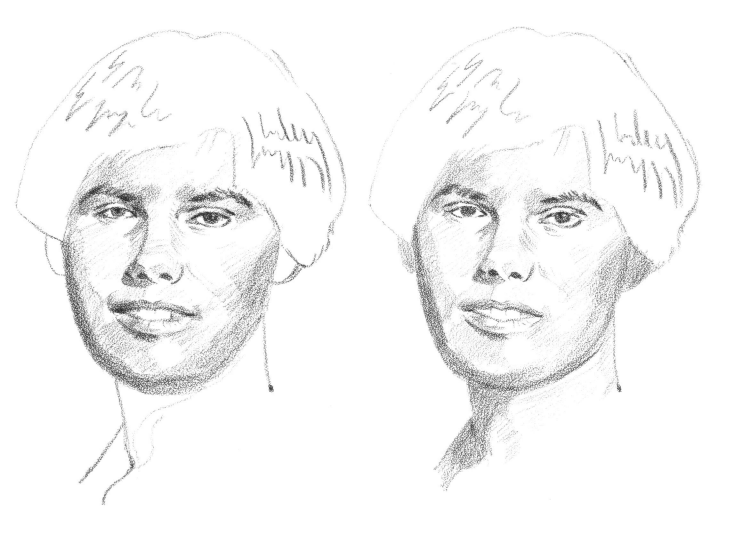

33. Modeling the Eyebrows

By using tones, I can now show the variation in the eyebrow hairs. They're thin in some places and heavy in others. No crisp edges are evident.

34. Modeling the Neck

Now I work on the tones of the neck. Tonal values there contribute more to form than to character. They show the position and dimension of the head, and reveal the sitter's age, but they add nothing to the beauty and character of the portrait. Nevertheless, they have to be there, so I put them in.

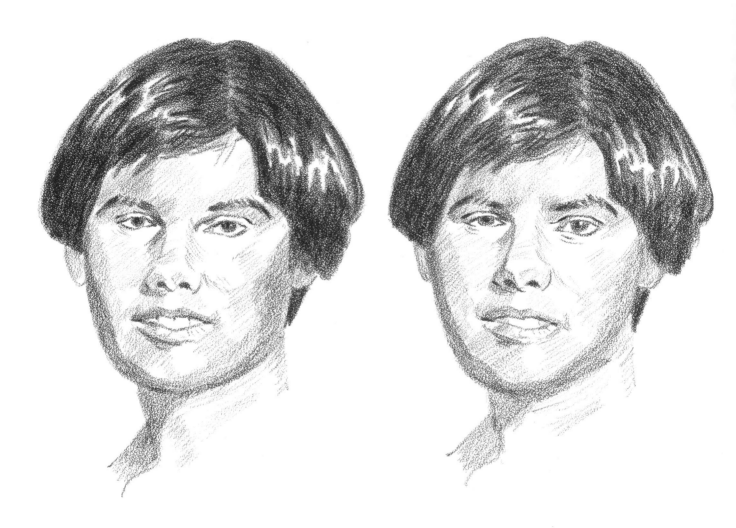

35. Modeling the Hair
In this step, I render her dark hair, leaving stronger highlights in the lights.

36. Refining the Upper Face (Forehead Area)
Now, starting with the forehead, I refine the tones throughout the face. Notice that I darken the small tones running up from the eyebrows.

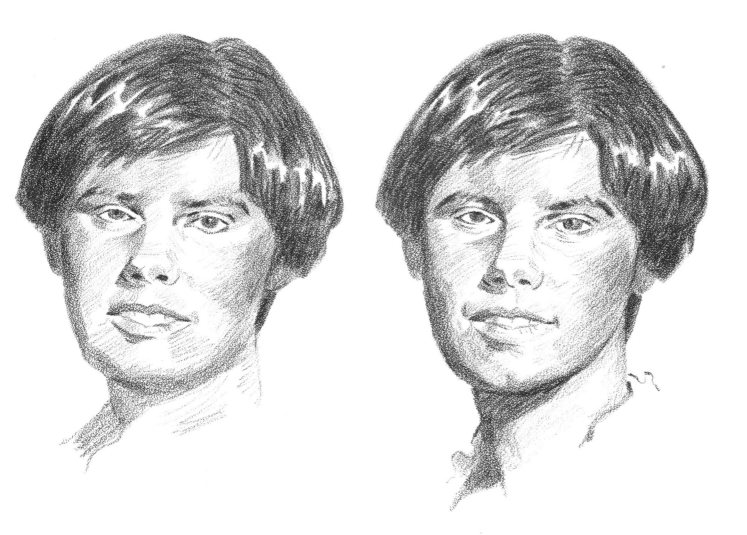

37. Refining the Middle Face (Cheek Area)

I add much more shading here in the formation of the eye sockets and throughout the cheeks. I'm actually adding halftones, which portray the quality of her flesh.

38. Refining the Lower Face (Jaw Area)

The thrust of the work now is in getting the tones swirling around the mouth, all of which are vital in controlling the likeness. The form along the corners of the upper lip has to turn under just the right amount. The lower lip must jut out only so much. This is all in the domain of subtle halftones surrounding the lips. I also add the decoration on the blouse at the neck.

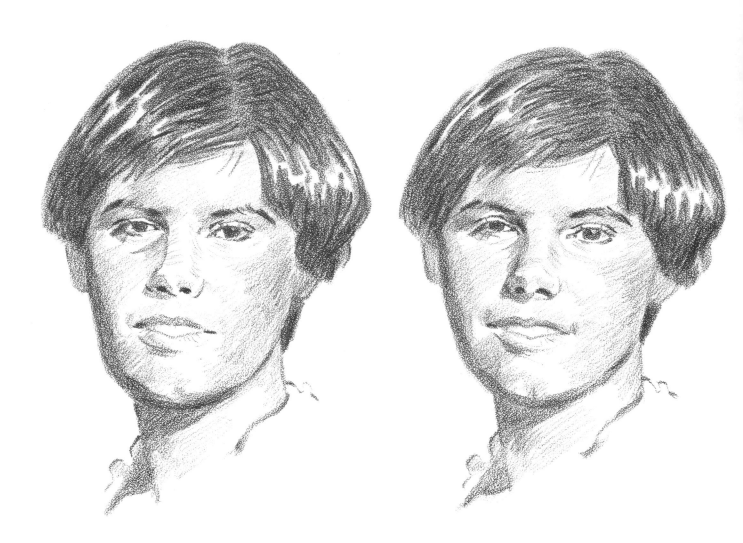

39. Refining the Eyes

The program of refining individual features begins. I accent the folds of the eyelids, strengthen the pupils, and do some subtle modeling in the whites and on the lids themselves. Lashes are added, too—hers are sparse.

40. Refining the Nose

I soften the sharpness of the tones on the nose somewhat, without losing their crispness. I now pay careful attention to the drawing around the nostrils.

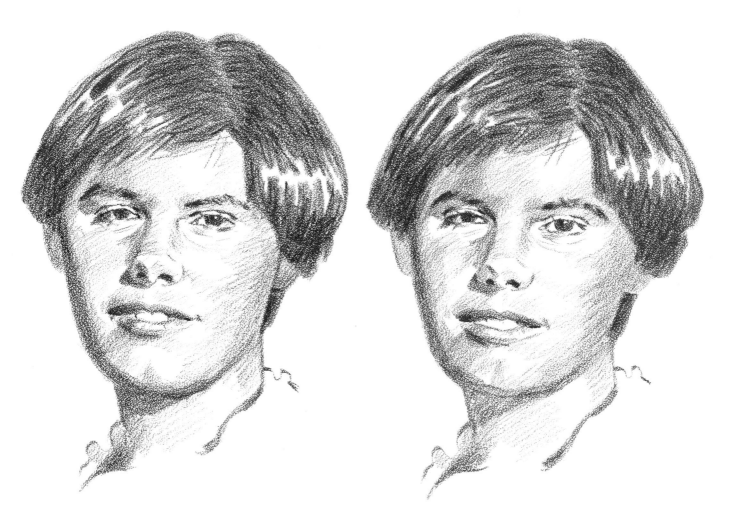

41. Refining the Mouth
In studying my work so far, it seems that the red part on the upper lip isn't high enough. Also, the lower red part is too hard and angular. I correct this, and add tones that soften and strengthen the drawing.

42. Refining the Eyebrows
I emphasize the breaks and accents in the eyebrows. There seems to be a cross texture in their centers.

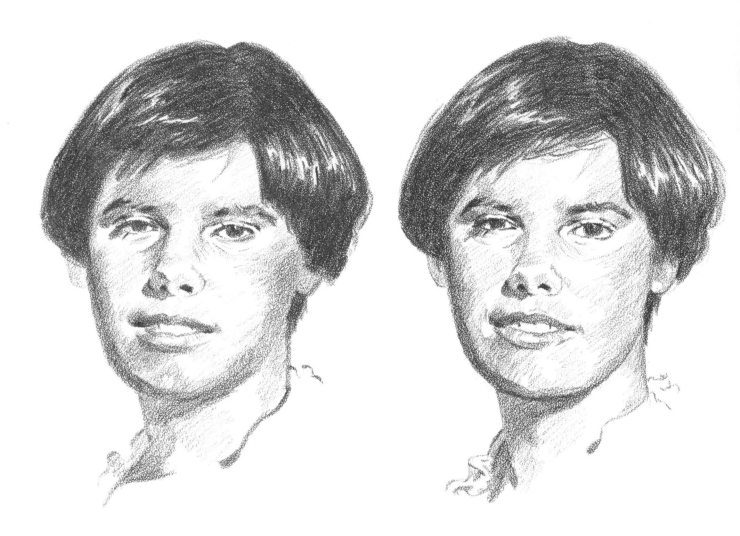

43. Refining the Hair

My time in this step is spent darkening the hair and treating the edges so that the cutout look is eliminated. The highlights, however, are still intensified for the drawing's sake, but are reduced in size.

44. Refining the Ears

The ears have hardly been attended to nor should they be anything other than suggestions. The lobe of one springs out into the light giving that side of the head depth. The frilly blouse is changed a little.

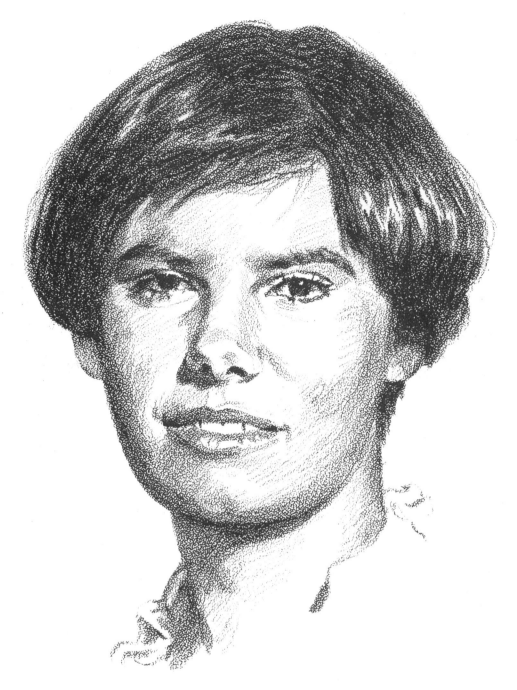

45. Final Analysis and Refinements

I'm completely satisfied that I had a summary likeness in Step 44, but to zero in on it more, I go over the entire drawing. Perhaps when you compare the last two steps, you'll see that the difference boils down to a matter of finish. Yet I don't aim for slickness, either. The intention of this book is to train you to strictly adhere to the facts before you, at least at first. Editorializing can come later. Whether you do more of a free-style drawing than a rendering of a photograph is also a matter of choice—for later. For the moment, what I'm teaching you now is to get a likeness.

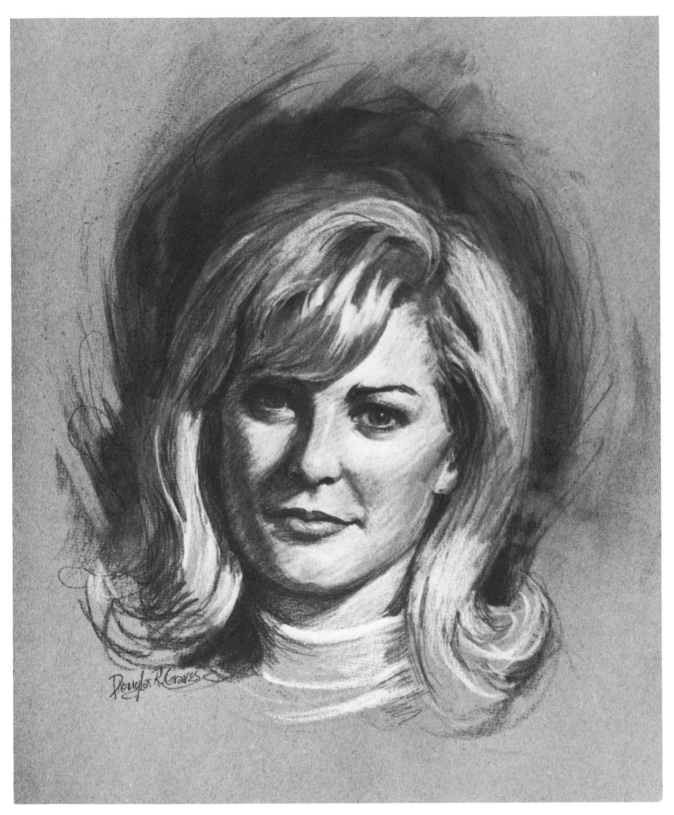

Betsey, Charcoal and white Conté pencil on blue Strathmore paper, 16″ x 12″ (41 x 30 cm), Collection of the artist. I did this drawing in a classroom demonstration in order to show the effectiveness of working on a middle-toned paper. This kind of a rendering falls in a category between a quick statement, like the "Alexandra" drawing on page 10, and the tighter studies of the demonstration drawings in Part III of this book. It has a little of both elements. The only thing I fussed with here was getting a likeness.

III.
Demonstrations in Various Drawing Media

White Conté Pencil and Carbon Pencil on Gray Charcoal Paper

I render this 24″ x 19″ (61 x 48 cm) drawing on the rough side of warm gray Strathmore charcoal paper. I use a white Conté pencil for the light tones and a BBB Wolff's carbon pencil for the blacks. I feel that the deep darks of her hair, eyes, and dress call for a rich, black medium like the carbon pencil. Also, her lustrous tanned skintones are well suggested by the gray paper, and the glowing highlights with the white pencil. Occasionally I rub the whites either with my fingers or with a stomp or tortillion (a small round paper roll, pointed at one end) to soften and blend tones.

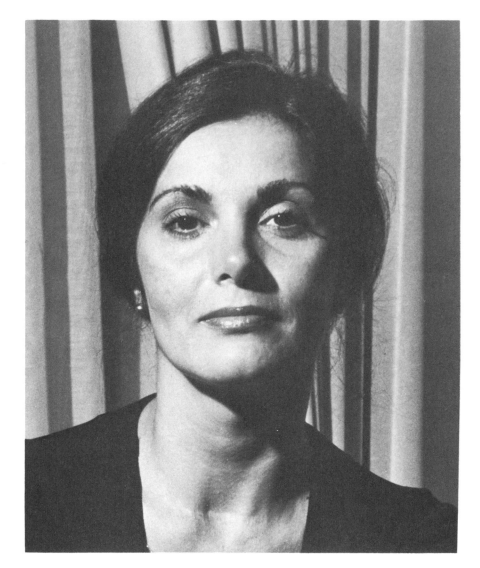

Photograph

Imagine that you're looking at a sitter like Kathryn in your studio. You observe that her head is oval-shaped but angular across her high cheekbones. Her features are smooth and well balanced. They are the features of a beautiful woman—eyes large and dark, petite nose, and a full mouth. But she's a real person. She doesn't have the slick perfection and packaged beauty of a professional model. Her face has individuality and subtle variations from the ideal face that test our powers of observation to grasp them as indications of her character.

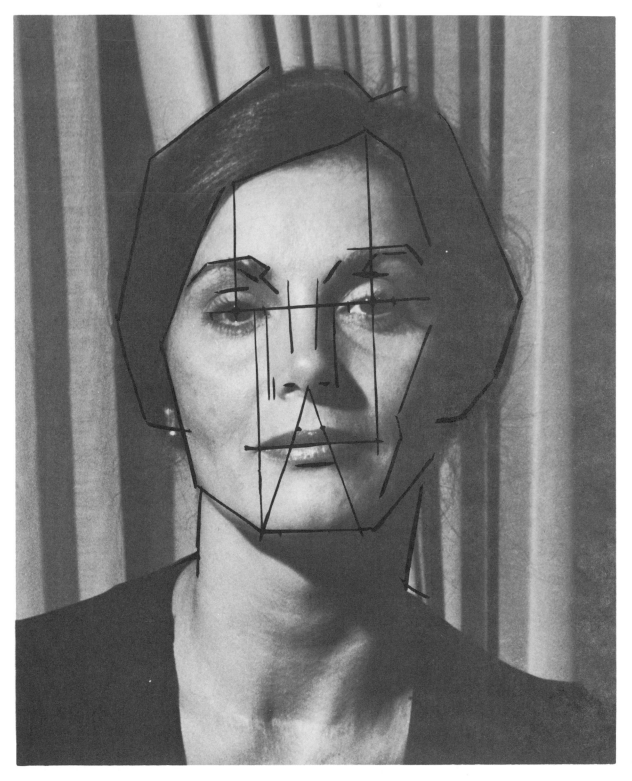

Analysis

Diagramming this woman's facial structure makes it at once apparent that the eyes hold the key to her likeness. Their imbalance shows first through the upward slant of the eyeline. The lids also have a different configuration, the one at the right being larger and higher. Plumb lines from the orbit areas to the nose are in slight disagreement from one side to the other. Also, the position of the mouth in relation to the pupils is shifted to the right. Breaks in the hairline should be noted in their relationship to the eyes by dropping plumb lines to the pupils.

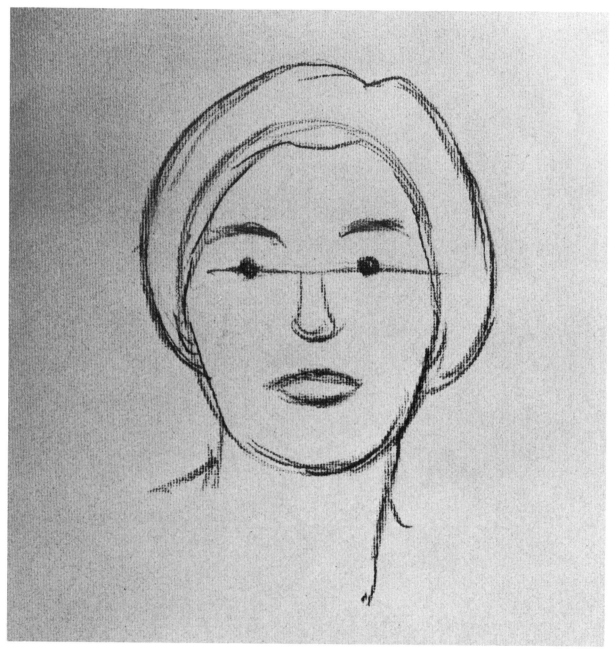

Step 1

Using only charcoal to start the general shapes, I lightly sketch the oval shape of the face area first. I'm influenced by the light area so that it all swings over that way but the hairline cuts back into it. Her hair is not fluffed up much on top, so I can locate the top of her skull, the upper boundary for placing the eyeline (which is halfway between the skull and chin). The impression of the nose, which goes to the right, is stronger now than it will be later. I rough in a full mouth with the prominent lower lip.

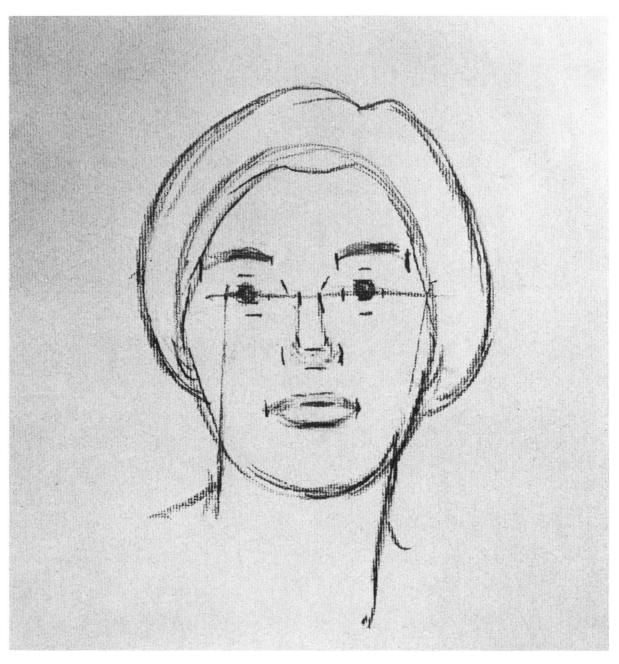

Step 2

I establish the proportions of all the features. Their subtle imbalance begins to show. For example, when you compare the inner ends of the eyebrows to the eyes, you see that they shift slightly to the left. Based on the eye placement, the nostrils seem to go the other way just a bit. The mouth is in accord with the nose being a bit to the right, also. I establish the width of the neck with construction lines from the eyes.

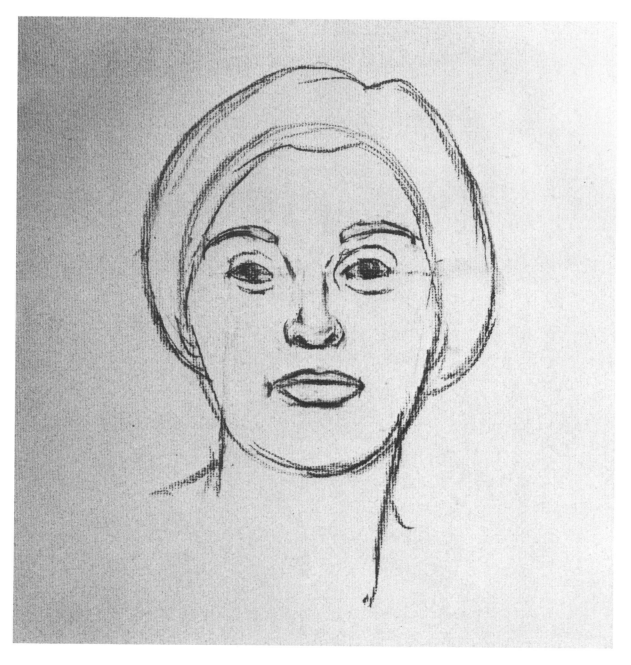

Step 3

I get the general shapes of the features at this stage, starting with rough sketches of the proportions I had estimated. At first glance, none of the imbalance of her features is obvious, which makes a portrait of this kind of face difficult. By analyzing the face more carefully, I find the keys to her likeness more apparent. Going over them one by one, I find that the right eyebrow is a bit higher than the left one. I also notice that the lids are wider around the right eye. I have the impression that the axis of the left eye slants up. The position of the nostrils angling slightly down is firmly established. The mouth's relative position to the nose is reaffirmed. I draw these features carefully, erasing the lines of the neck and eye axis as I proceed.

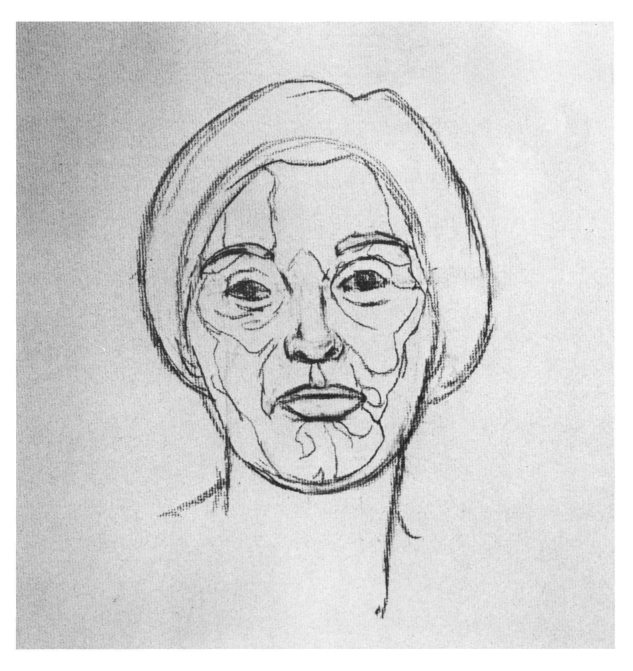

Step 4

In the first three steps I indicated most of the two-dimensional aspects of the head. Now I'm ready to get the third dimension of the face area. I outline the contour tone values, breaking them down into three basic value areas: light, halftone, and shadow.

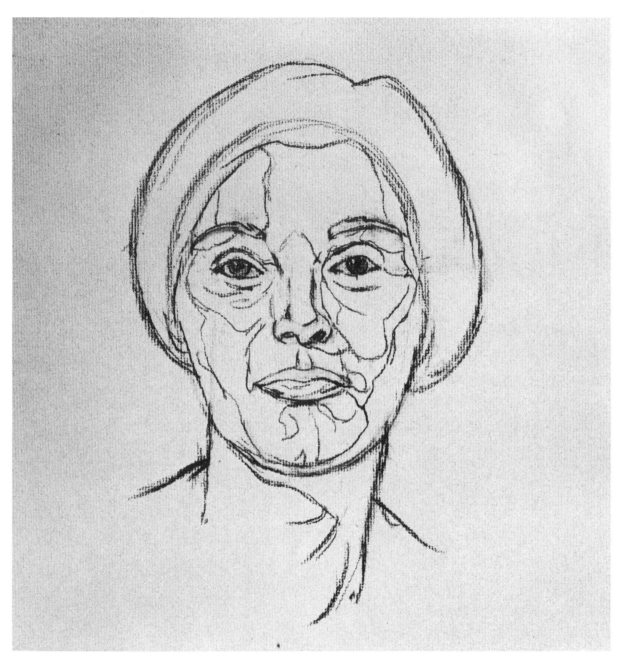

Step 5

Going over the features, I adjust several details. First I adjust the shape and size of the corneas. Then I zero in on the shape of the nose by carefully noting the tones there. I also adjust the septum, thinning it on the light side—the shadow side doesn't matter now. I make more precise lines for the shape of the mouth. The edges and boundaries are now fairly defined. I also delineate the shadow edge and tone shapes on the neck.

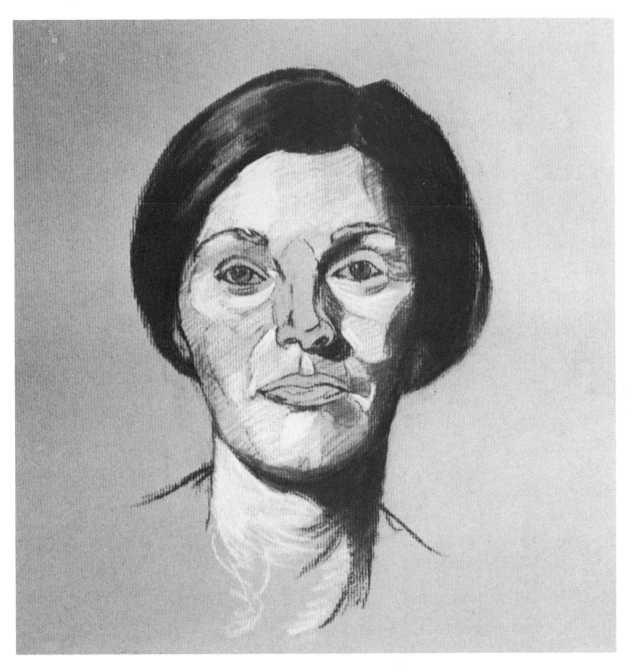

Step 6

I start modeling the major areas of the face, neck, and hair. I establish the rapport between the light facial tones and the dark hair. I use the white Conté pencil to bring up the lights from the gray-toned paper. The drawing is still at an academic stage, but again it's necessary to be cautious about keeping the values within their proper confines.

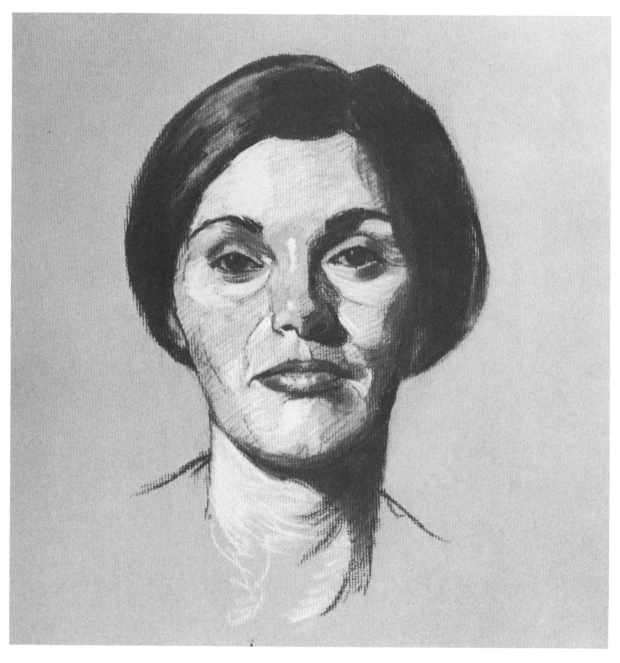

Step 7

Now I model the features. The eyebrows are put in fairly dark. The tones around the eyes start to show their basic roundness and I continue to develop the difference between them. I put the highlight on the nose to give it a third dimension on the light side and straighten and darken its shadow edge. The tones on the mouth are practically accurate, but they still lack polish.

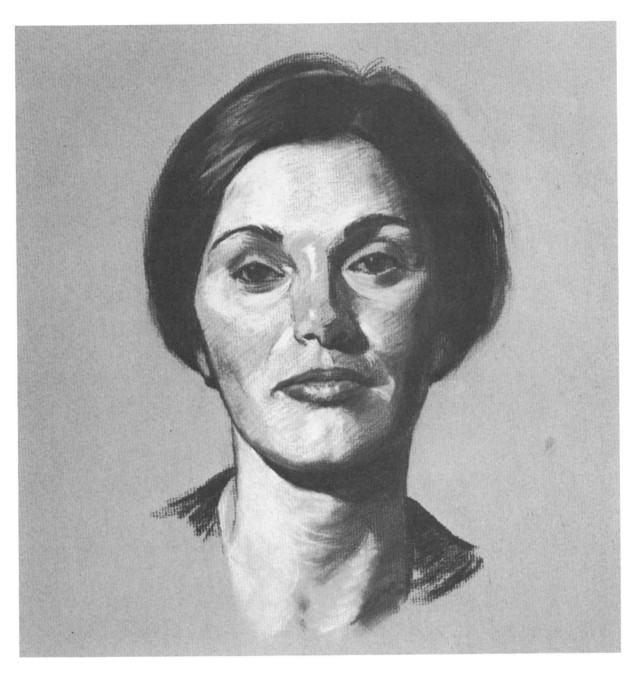

Step 8

As I progress, the work takes more time. The outline of the hair is refined, with variations of softness and crispness and a few wisps added here and there. The same is true of the hairline. Notice how the hair blends completely into the tones on the forehead. The tones in the face absorb all of the outlining. All of the tones around the edges, from lights to shadows, are noted. The shadow tones are smoothed out on her forehead, along her cheeks, and around her chin. The only change that occurs here is some widening of her jaw. Other than that, her likeness in the drawing of the facial structure has been set and I merely carry it along.

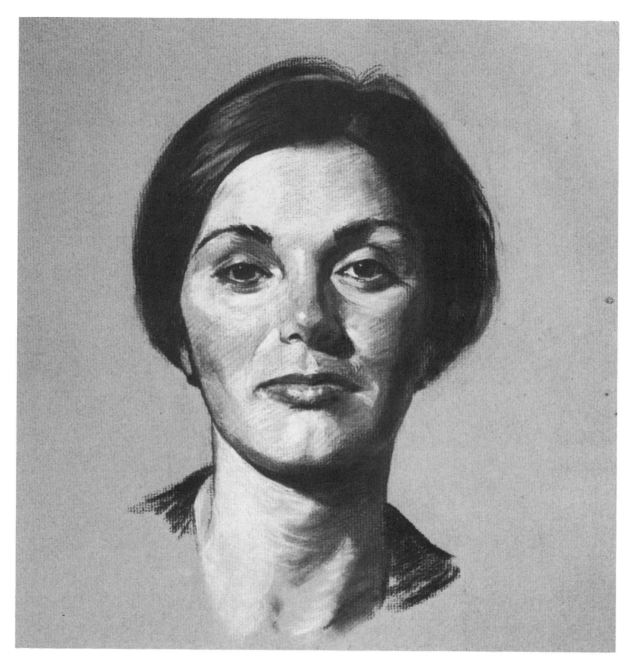

Step 9

As I develop her features, the likeness becomes more apparent. Starting with the eyebrows, I lift the one on the right a little more and soften it. Her eyes are adjusted again— the upward tilt is reduced, particularly on the right eye. The inner lid of the left eye is raised on the inner side. A little shininess is indicated on both upper lids. The white part is emphasized only on the inside right eyeball. The top rims of the lower lids are highlighted. Lashes are added and catchlights placed on the pupils. The likeness is still based on the difference in the size of her eyelids. It's even emphasized on the right eye with a dark accent above. I add white to the angled plane on the light side of each lid. The dark of the right nostril is made smaller and the other nostril is arched slightly. I blend values into each other and lessen the outline effect around the wing and septum. The top edge of the mouth is trimmed slightly. I lighten the tone on the lower red part next to the separation line of the lips. Observing her more carefully, I see, and thus indicate, the softness of tones around the lower lip on the left.

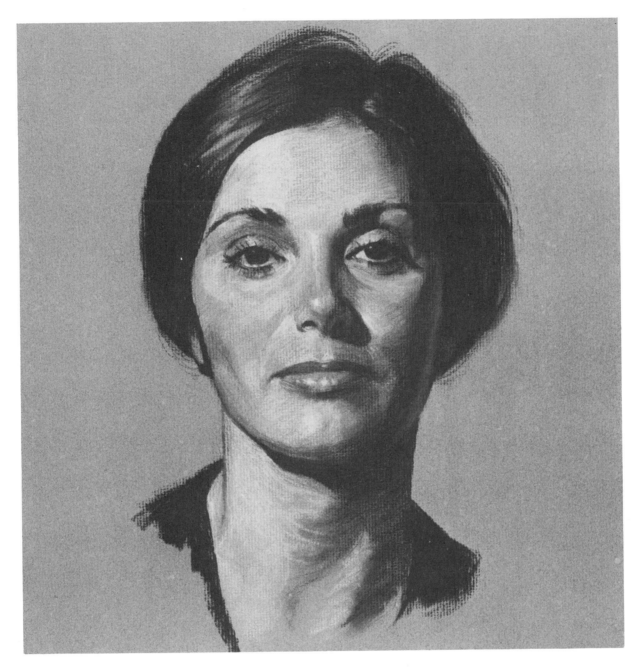

Step 10

As you can see from the last step, I'm still a way from a likeness. As I step back and analyze my work thus far, I note the following changes yet to be made. The right eye is over to the left too much. The jaw is too long, and the neck is too narrow. The hairline shape, both inside and out is wrong, too, and the values are hard and jumpy. However, if I hadn't proceeded carefully and logically as I did in the early steps, it would have been a complete muddle now. I don't consider the necessary changes now as being major ones, and correcting them gives me the likeness.

Graphite Pencils on Illustration Board

I use three grades of graphite pencils, 4H, HB, and 2B, for this drawing. The paper is Crescent No. 300 illustration board, of medium weight and with a cold-press surface. I am working on a half sheet, 20″ x 15″ (51 x 38 cm). I don't plan to blend or rub any tones in this portrait.

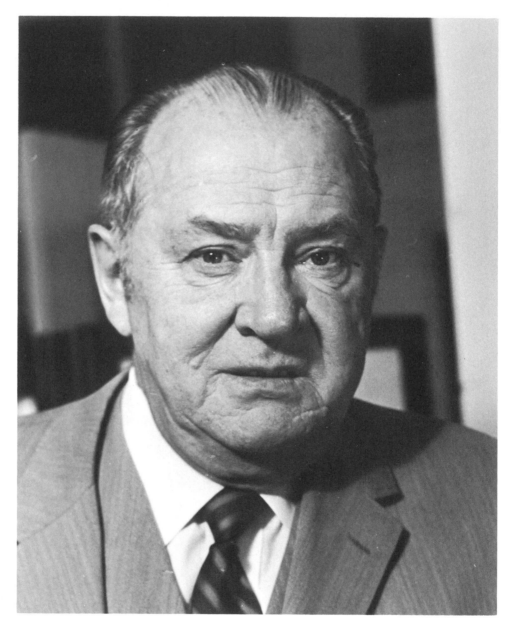

Photograph
Chester's portrait presents a different challenge from the last demonstration, both in the type of face and the technique I plan to use. This rugged face is full of character lines which border interesting planes. They show a vitality and experience that I hope to capture with graphite pencils on illustration board, mostly by the strength of the pencil hatching. Other techniques—such as blending or rubbing tones—would be too delicate.

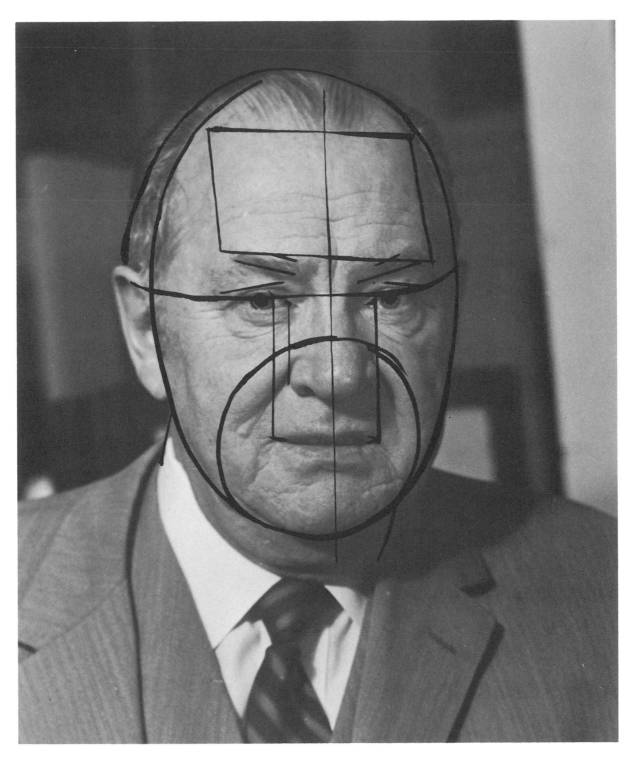

Analysis

In analyzing the photograph, I note on the overlay that the forehead area is blocky and resembles a parallelagram. The lower part of the cheeks and jowls are round and encircle the mouth. There's quite an uptilt to the brows. They don't line up with the opposite eyelids, which are flatter. On the right, the outer edge of the wing of the nose and the corner of the mouth almost line up under the lachrymal duct. But on the left, the corner of the mouth falls below the edge of the cornea of the eye. At the outset of any drawing of a head you should determine the axis of the head. I draw a line to show this axis, which is nearly vertical.

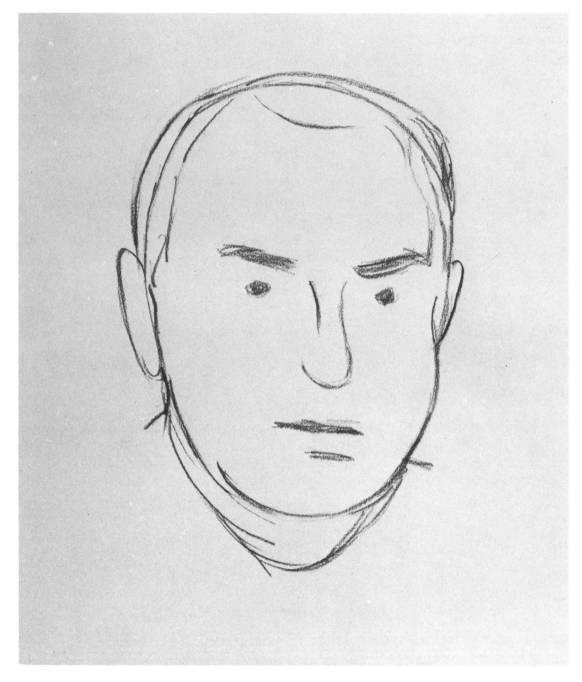

Step 1

Using a 4H pencil I put in a round shape for the skull and lower face. Next I add a line for the contour of the hair, and short curving dashes for the hairline with an HB pencil. I rough in the brows, eyes, nose, mouth, and the shadow below the lower lip. I also show the top of the shoulders and where the collar will be.

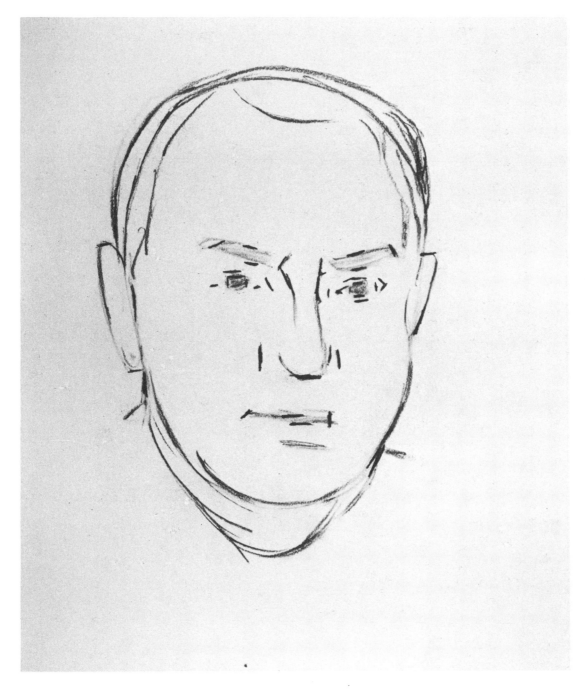

Step 2

I try not to put in too many construction lines because erasing them later will make the surface of the paper unsuitable for shading light areas. This is why I didn't include the rectangles and circles that are shown on the photograph overlay. However, smudges showing the brows, pupils, nose, and mouth could be rubbed out because these places will be covered up later with darker tones. I also mark off the proportions of the brows, eyes, nose, mouth, and ears.

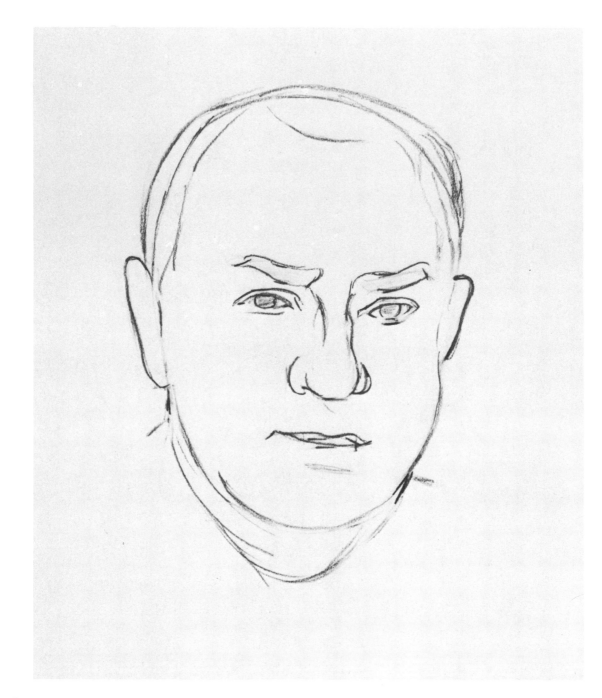

Step 3

Using the marked proportions of the features as a guide, I now draw in their general shape, still using the HB pencil. I outline the curving eyebrows, the lids of the eyes, and the corneas. I put down a line for the right edge of the nose, indicating the bump near the eye. I also get the roundness on the end of the nose. I begin to show that the lip curves up at the left, and I see now that the right corner runs past my previous mark. Lastly, I get more semblance of the outside shape of the ears.

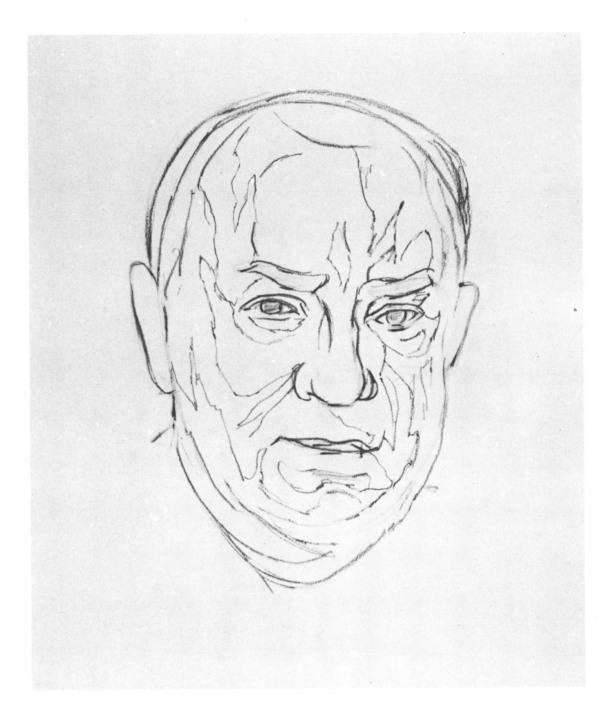

Step 4

I now indicate the boundaries of some of the tonal changes across the face that show the planes. I use a 4H pencil again, so the lines will be very light. There are three basic ones on the forehead: the shadow side on the right, the light area in the center, and the halftones opposite the shadow side on the left. There are also two main separation lines running down on each side of the middle and lower parts of the face. They're sort of ridges from which planes are formed. I indicate them on the drawing and plan to use them as a basis for many more subtle halftones because there are too many on his face to adequately outline them all, and some of those contours are too close in value to see. At this point, let me offer a word of advice: When you have a commission for a portrait, try to take your own pictures, ones that have good tone value resolution plus details. That is, if possible, your photographic copy should have good separation of tones. Use a fine grain film also. Instamatic or portrait photographs are not helpful at all.

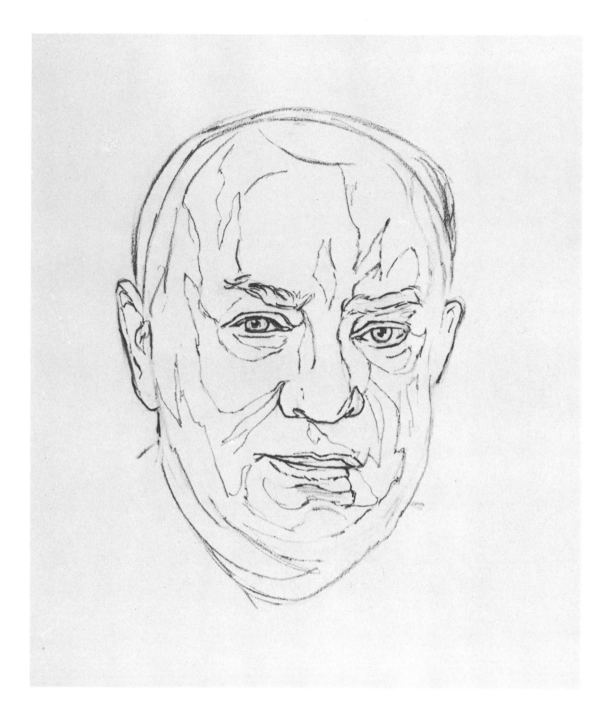

Step 5

With the HB grade pencil, I now shape the features in more detail. Note that the left brow is more irregular and craggy and the corner of the right eye is uptilted. To get eyes to look right at you, it's important to note the turn of their corners as well as get the correct spatial relationship between the white parts and the corneas. I indicate here the evidence of the sagging lower eye muscles (the sign of maturity) and designate the end of the bone on the nose (at mid-nose) along the right-hand side. Notice how the left side of the mouth curves up higher than the right. The ear that's showing is delineated; it's not unusual in shape or size.

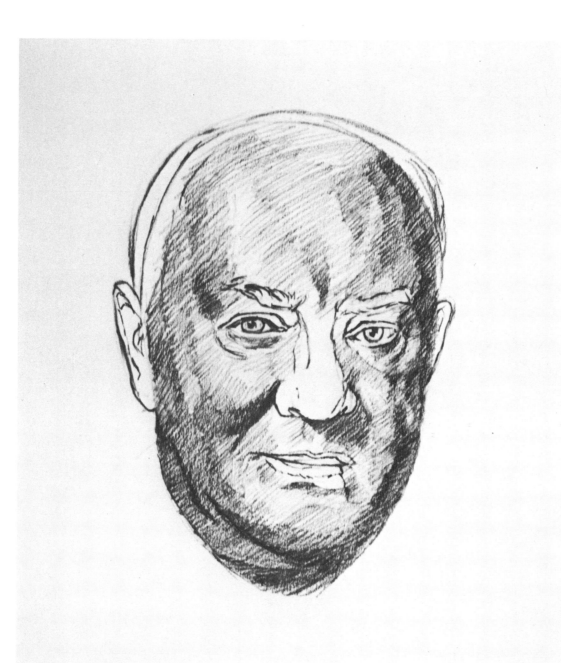

Step 6

I use two grades of pencils for shading now; an HB for the light tones, and a 2B for the dark tones. I now begin shading. I keep the tone values close in range and don't hit the darks too hard. I try to get the light tones and halftones as nearly correct as possible because pencil rendering can't be changed easily. If you study the tones, you can see that the contours don't go around smoothly but undulate, getting dark, then lighter, then dark again. Note how this happens on the cheeks, especially on the left one. The way I handle this is by shading the darkest parts first, then filling in the lighter areas next to them. In other words, I establish the darker key first, then work from that.

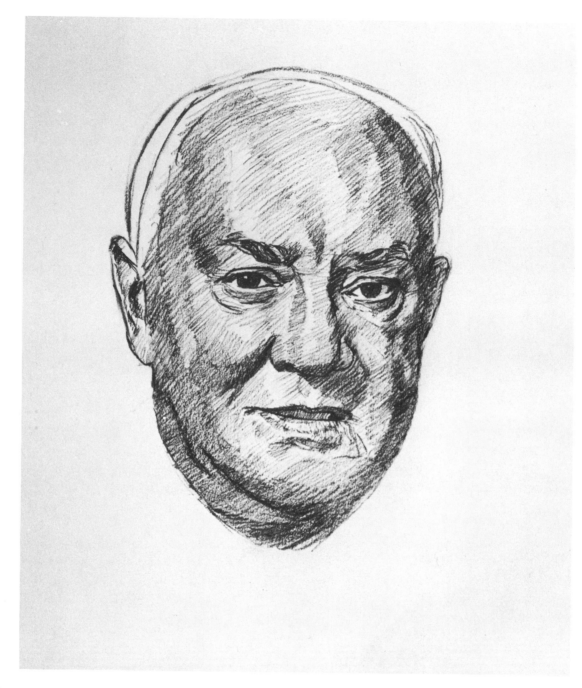

Step 7

I model the tones of the features. At this point, the whole tonal pattern begins to change; contours don't jump out as much. Although I shade and round the features quite a bit, I still hold back a bit because further adjustment in drawing may be necessary. Until all the tones are completely filled in on the whole head, I can't properly judge their correctness.

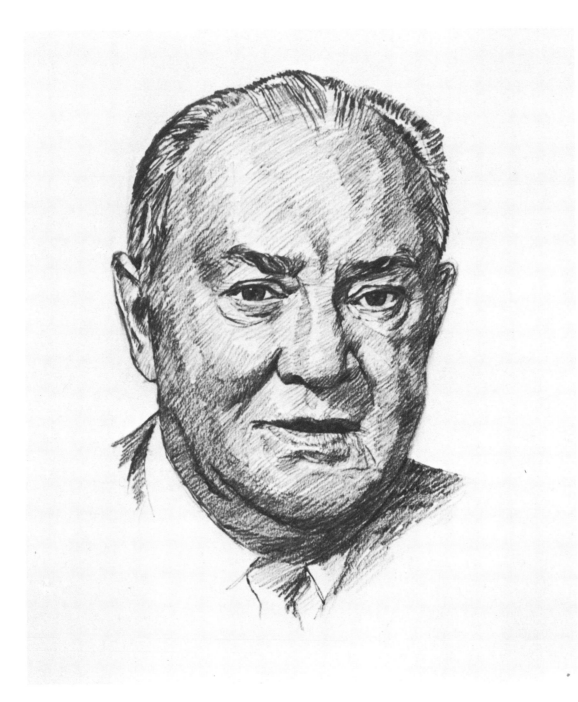

Step 8

The pencil strokes imitate the direction and feeling to the hair strands. Again the lighter ones are with the HB pencil and the darker ones were with the 2B pencil. I render the hair the way it's combed and establish the shine and the darks. The pencil strokes imitate the direction and feeling of the hair strands. I show the suit, collar, and tie in a vignette fashion to begin the complete picture.

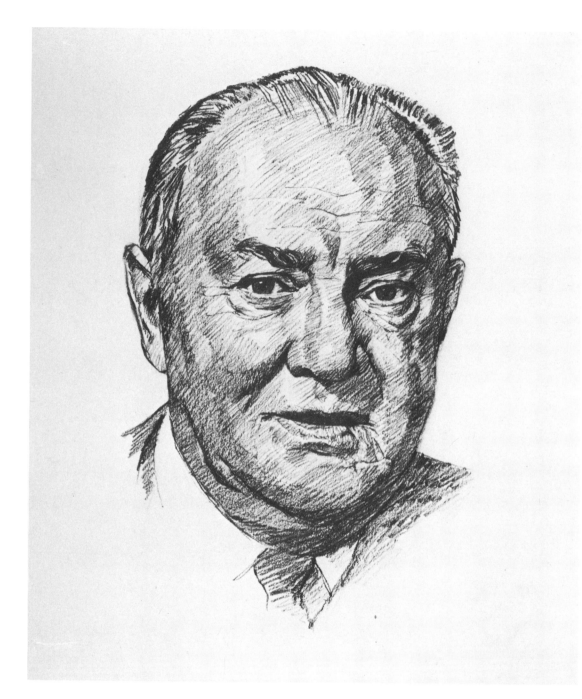

Step 9

Now I refine the entire head. I use the different grades of pencils according to the need; the lighter the tones, the harder the pencil. I add the wrinkles that contribute so much to getting his likeness. I shade the brows more, making the tones there blend better, and I soften the lines where the eyelids merge into the flesh. I also make them darker to emphasize the deepset nature of the eyes. I arch the lids up a little higher over the pupils and soften the pouches under the eyes. I clean up the edges of the nose and add darks to the nostrils. I also soften the edge of the upper lip and the opening, giving them their proper values and adding the separations of the teeth. I soften the pencil strokes on the lower lip, put in darker accents at the right corner of the mouth, and accent the line under the overhang shadow. I model the neck, merging the dark shadow on the cheek and neck. Next I refine and soften the ears. I add more darks to the hair, to the side of the nose, and along the sides of the face.

Step 10

Now I step back and analyze the drawing. If I want to do a stylistic rendering I'd leave the shading more open and make the tonal changes more distinct. But since I'd rather concentrate on content than style now, I smooth and soften the drawing with a kneaded eraser, to get a more realistic effect. I develop the likeness in the eyes more by making the corneas lighter. I also sharpen the angle of the inner, upper right eyelid. Careful control of all those subtle tones around the eyes and mouth makes a tremendous difference in getting a likeness.

Vine Charcoal on White Charcoal Paper

I draw this portrait on 23½″ x 17½″ (60 x 44 cm) Canson Ingres charcoal paper, working entirely with vine charcoal of different degrees of softness. The linear work is done with a finely sharpened piece of hard charcoal. The tones are made with softer charcoal, blended by brushing it lightly with a foam rubber makeup pad. Because this young man has light hair and skin, vine charcoal works well in this case, lending a sensitive air to the drawing, without being overly sweet.

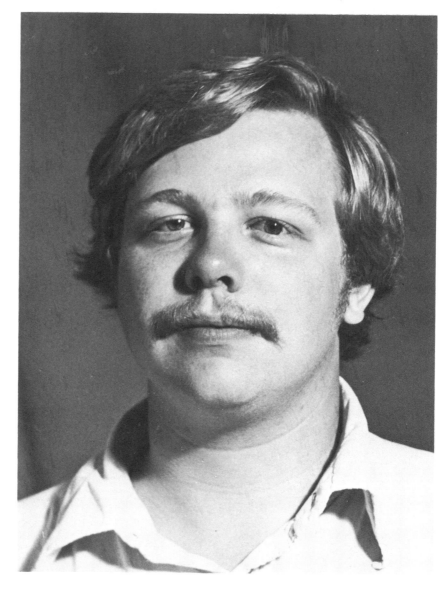

Photograph

Jim has a pleasant, intelligent face; he also has a mustache. But mustaches (and beards, too) don't determine a likeness. What does portray likeness and personality are: the shape of the head; the location, shape, and size of the features; plus the subtle imbalance between the two sides of the head. These are the items we're interested in.

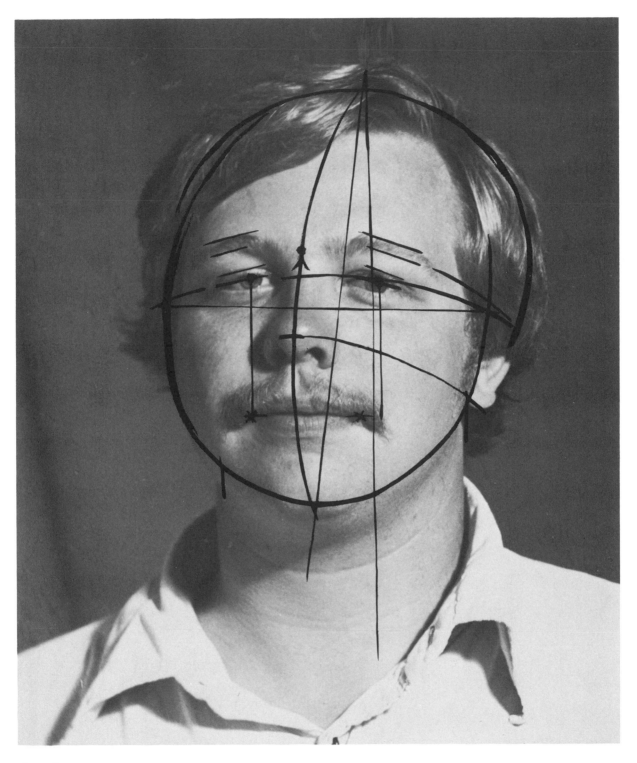

Analysis

The perpendicular line of the axis and the curved line of the front contour describes the attitude of the head. The fact that the sitter holds his head slightly tilted back should be considered when making measurements, since it moves the eyeline above the median line. As for strong individualistic characteristics, there's a downward slant to his eyes and eyebrows. Or, as another way to look at it, the area around the dot on the bridge of the nose is thrust upward. The right pupil is over to the right when compared with the outer corner of the mouth. This is partly due to perspective, but it's also a characteristic of his particular countenance.

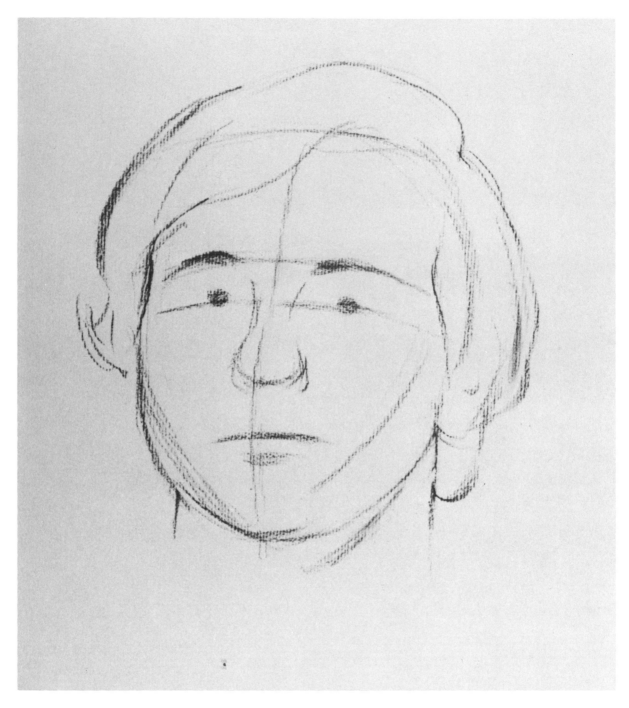

Step 1

I indicate the general shape of the head. This young man's head looks rather wide and kind of circular, partly due to the slight turn of his head. Turning the head in a pose is always a good way to show more of the third dimension, such as how far the nose protrudes. All of the general proportions are sketched, such as the hair outside and inside lines plus the line up of the eyes and the general medial contour down the face. In addition to getting a rough idea of the features, I get a general concept of the contour of the cheeks.

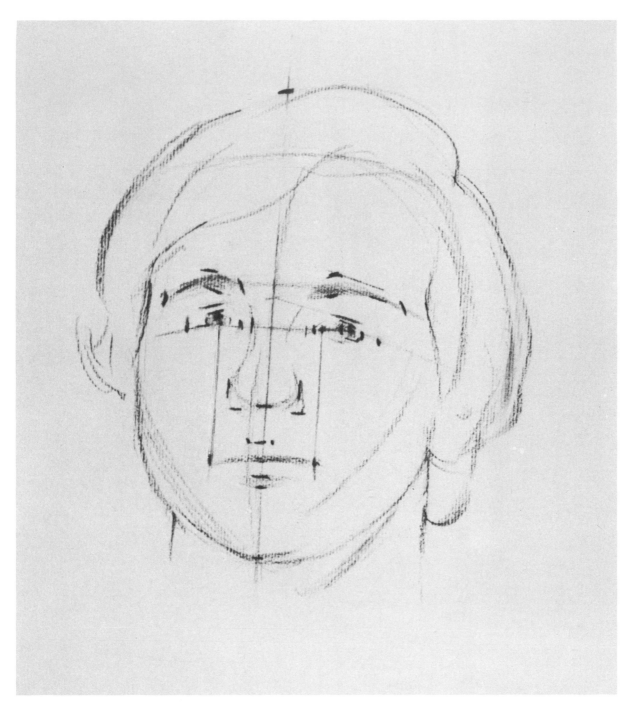

Step 2

In a charcoal drawing it's easy to brush off unwanted marks, so there's more freedom to put in construction lines. I therefore put in a few of the ones on the overlay to show you where they'd go on the drawing. First, there's the perpendicular construction line, which should be parallel to the side of the paper. This line is a device to measure comparative proportions from side to side. For example, I can now estimate that the distance from the left pupil is approximately the same from the center line to the inner corner of the right eye. These points are also aligned with the outer corners of the mouth. Vertically, I now measure the halfway point between the top of the hair and the chin for the eyeline. In this case, because the head is tilted back, the top of the hair rather than the skull is the measuring point.

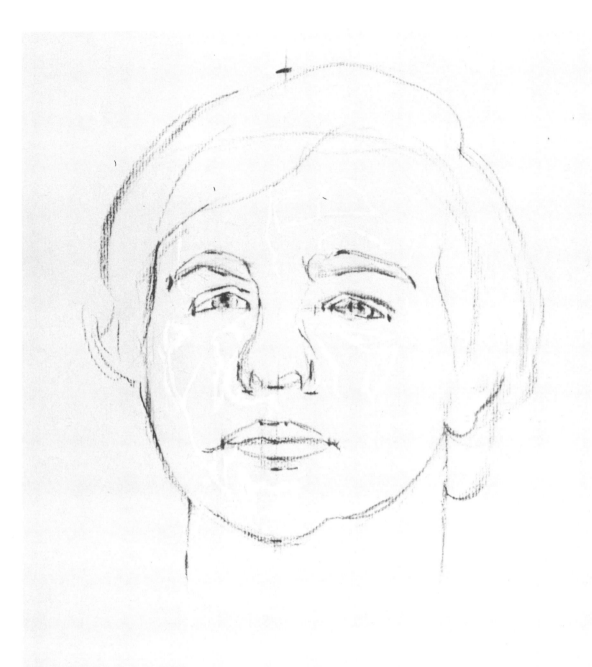

Step 3

Now I turn my attention to the shape of the features. Again, I outline everything in a general way. I outline the brows without worrying about the exact shape of the hairs, then the eyes, getting the angularity of the lids. I get only a vague indication of the upper planes on the sides of the nose then draw in the nostrils and wings. Finally, I outline his mouth. It's easy to draw since the boundaries of the red parts are well defined.

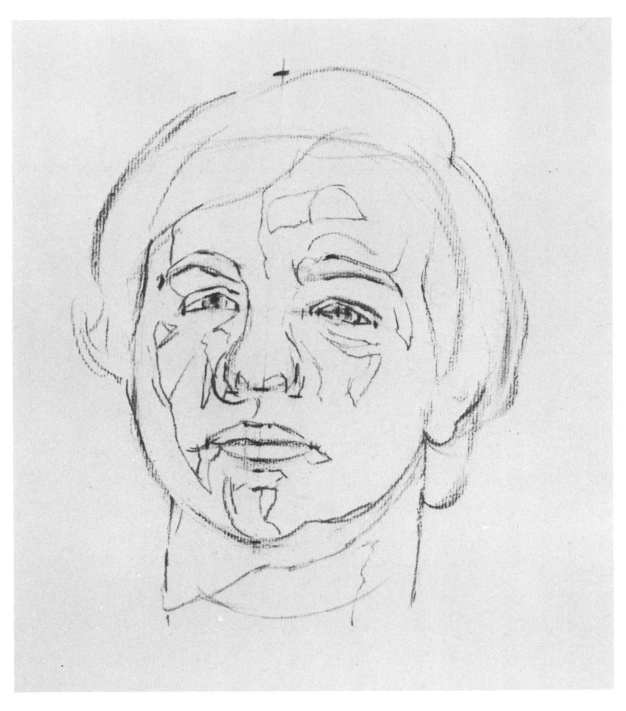

Step 4

The next step again is outlining the planes across the whole face. There seem to be three highlights on the light side of the forehead. They may compete with each other for importance, but I put them in that way for now. The area around them is one tone, then there are halftones across the shadow side, going into the deep shadows. At this point I don't outline every value change I see, only the most outstanding ones. For instance, along the lighter side of the cheek and jaw, the values slide very softly into one another. I'll develop them when I render the tones. In this step, I just locate the strongest ones.

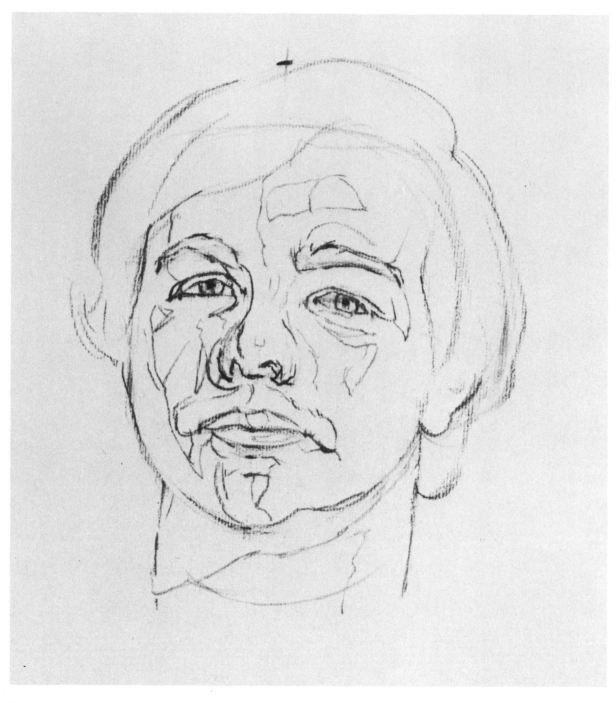

Step 5

I go back to features with more regard for their precise shape. I get the feel of the hairs splitting at the edges of the eyebrows. The corneas and pupils of the eyes are brought more into focus. I also give a crisper definition to the shape of the nose. I erase all the marks of proportion. Along with improving the outline of the lips, I add more contour planes around the mouth.

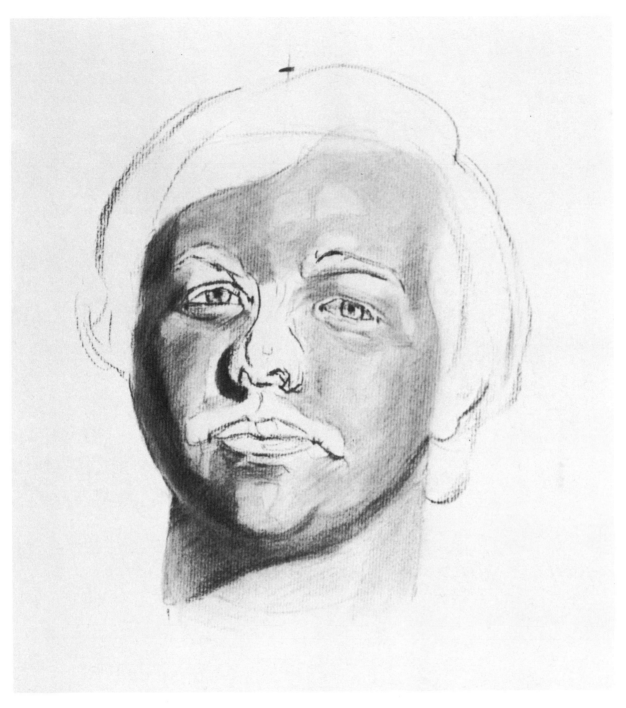

Step 6

I decide to treat this portrait differently from that of the preceding demonstration. Here, even though I start with a hatching technique, I'm going to smooth out the shading. Compare this step, also, with Step 4, where I outlined the contours. Notice that I keep my value changes pretty much within those confines. You may want to get through this stage quickly, but don't underestimate the importance of accuracy here.

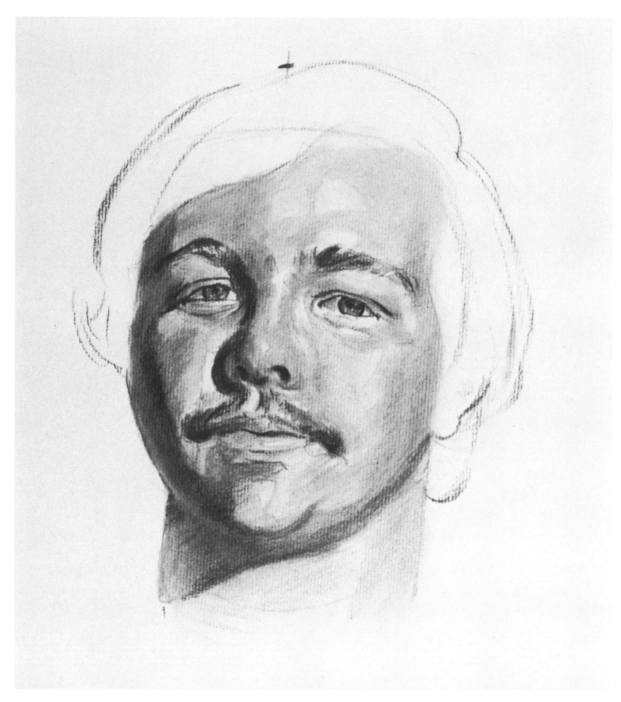

Step 7

Now that I get some tones on the head, I begin to feel better. But getting a likeness depends on an "easy does it" approach. I hold back on the rendering of the eyes and mouth even more than the rest of the features. Their accuracy will be so critical that I want to have all the tones present on the head before I go back to finish them. As I work, I am continually conscious of the basic curvature of the eyeballs, the eye sockets, the bridge of the nose, and the curves across the mouth and muzzle.

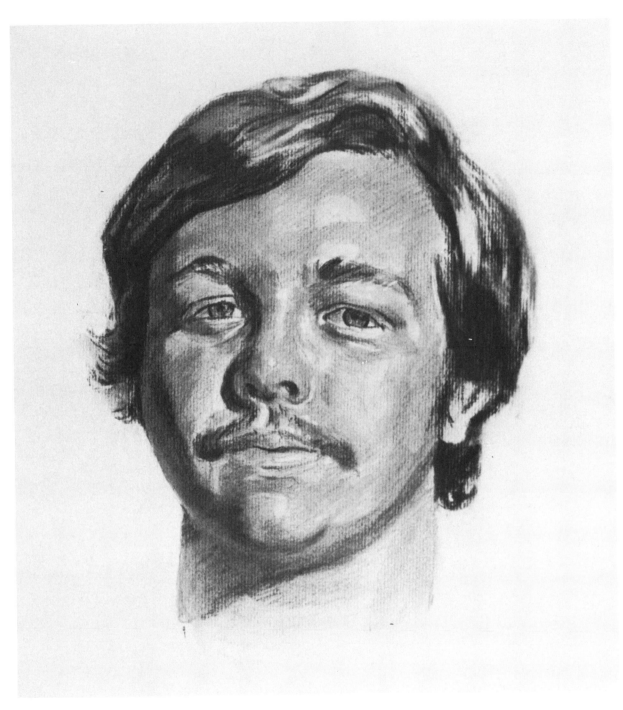

Step 8

In my attempt to bring up the whole drawing to the same stage, I can't neglect the hair any longer. I render it in three values mostly: dark, middletones, and highlights. I follow the flow of the hairs with broad charcoal strokes and tones, but I don't generally show individual hairs all over the head, just at the edges.

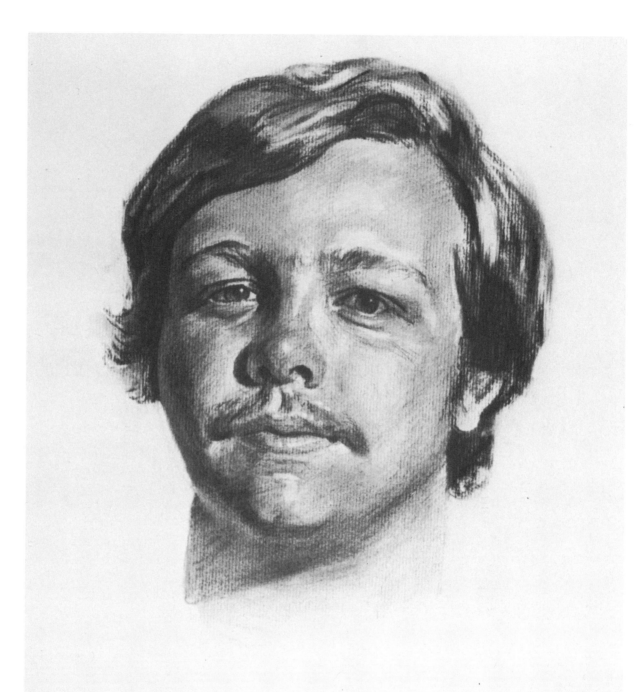

Step 9

I return to the features now and getting their precise tonal values. I make the brows look like hairs but keep the tones as accurate as possible. The outline of the left brow is smoother than the right one, which is ragged and irregular. By now, if the proportions haven't been lost, the eyes should look correct, with the final tones on them. His nose is slightly darker, probably because it's pinker. This can be shown by a hint of tone shaded over the whole area. The nose also turns up slightly so that it's a little darker above the highlight. The mouth is molded to get the proper rolling out of the lips. His lips aren't too unusual. The chief distinction is the way they part slightly—it has to be just the right amount. Now, a word about mustaches. While there are many young men with them now, they don't always distinguish one man from another, but are strictly superficial to a likeness. All I have to do in drawing them is get their particular shape and color right.

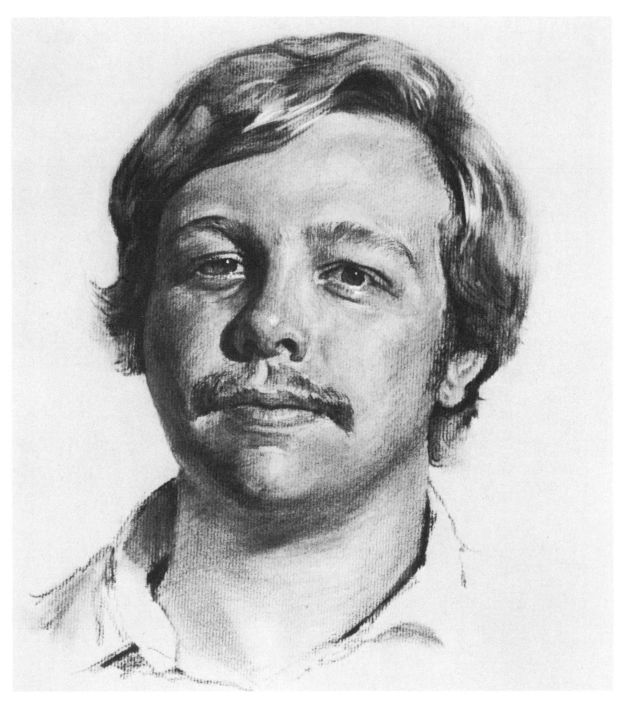

Step 10

Putting the final touches on the face consists of softening and blending a lot of tones, specifically, on the forehead, around the eyes, and on the eyebrows. I also reshape and correct the shape of the nose above the wing along the shadow side and make the tones on the front of the nose lighter. I add the shirt and lower part of the neck. As far as getting his likeness is concerned I have an advantage over you: I know that his hair is lighter than it appears in this black and white photograph. So I take the liberty of making it a lighter shade. Wherever possible, always try to get as much data about your sitter as possible. It will help you properly interpret the photograph, which is sometimes misleading.

Charcoal Pencil and Sticks on Bristol Board

I find that a portrait like this works well on a smooth, 2-ply 19½" x 14" (50 x 36 cm) Strathmore Bristol board using various charcoal mediums. First, I roughed in the drawing with soft charcoal then later stroked on tones with a General's 4B charcoal pencil in the hair, especially. The skin tones are mostly blended vine charcoal using the foam rubber pad. This method of rendering is a cautious approach. The medium doesn't take too fast. It's very suitable for the subject. Her hair seems to command a lot of detailing with individual pencil strokes, like those a magic realist would make.

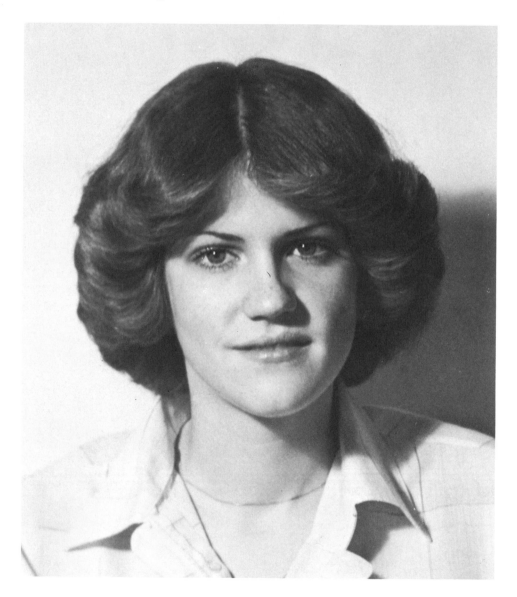

Photograph

Amy is a pretty young girl with a well-shaped, slender face and clear, open eyes, but I know that her smooth skin and subtle facial contours are going to require some delicate rendering. She's an interesting example of a person with an attractive face, one that also represents her personal qualitites. If you cover each side of her face separately, you'll notice that her features are well formed, but that each side varies slightly. It's this variation that adds interest and character to her face.

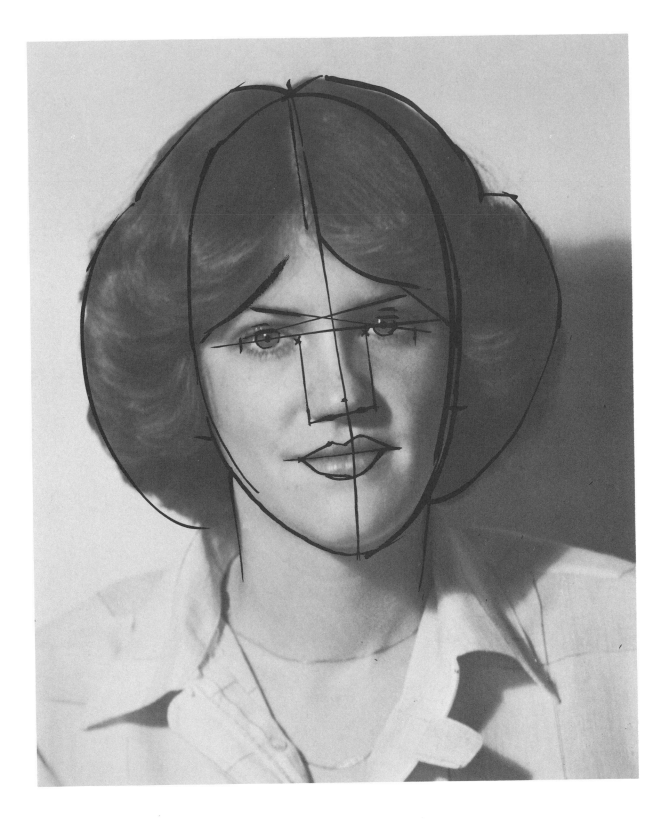

Analysis

The striking aspect of this head is the long, slender oval shape of the skull. However, from the beginning of the hairline to the top of the head, the head is turning away from us. Noting her individual characteristics I see that the eyeline drops slightly down at the left. While the level of the base of the nose is rising, the mouth slants down in the opposite direction. The bow of the upper lip is larger on the right, and the bottom lip is larger on the left.

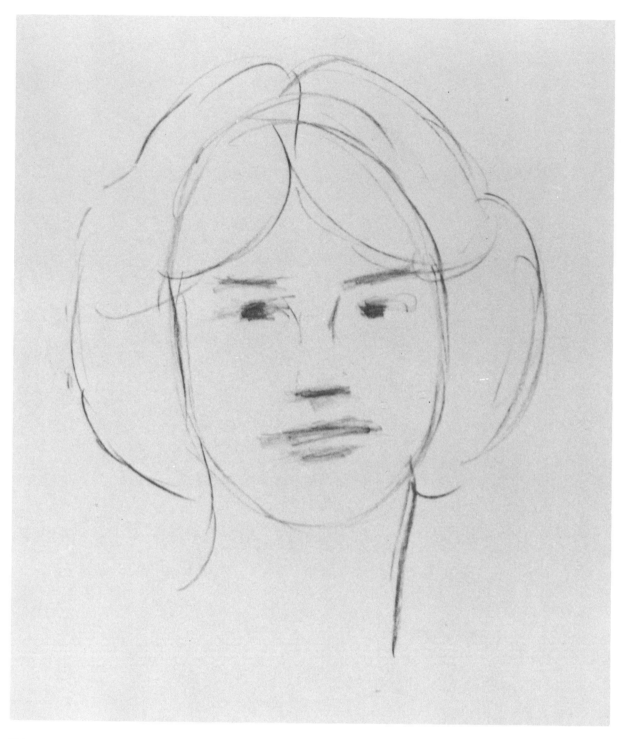

Step 1

I draw this demonstration in two kinds of charcoal on a smooth, plate Strathmore board. I do the first rough sketching in vine charcoal, which is easy to alter. When I'm sure the drawing is correct, I nail it down with General's charcoal pencils. I rough in the outline of the hair and the oval of the head. I add the eyebrows, which are straight, two smudges for the eyes, and a vague indication of the eyelids. The nose and mouth are merely quick indications of their general location.

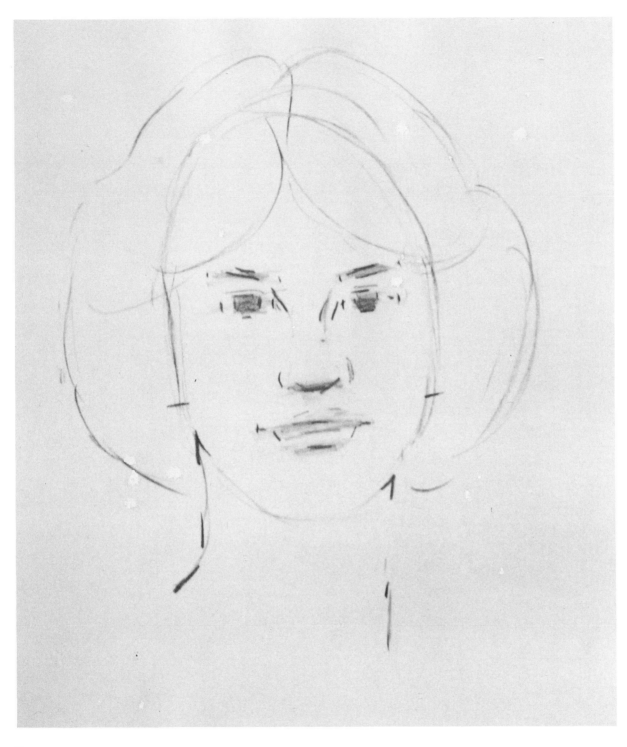

Step 2

I mark off the dimensions of the features. The brows are marked for inner boundaries and width. I leave the ends of the brows until later because they're in shadow. I notice that the right eye seems to face front, but I don't let this influence its location. I note the position of the nose's shadow and the lower part also. I mark the dimensions of the mouth plus the bottom of the ears and the neck.

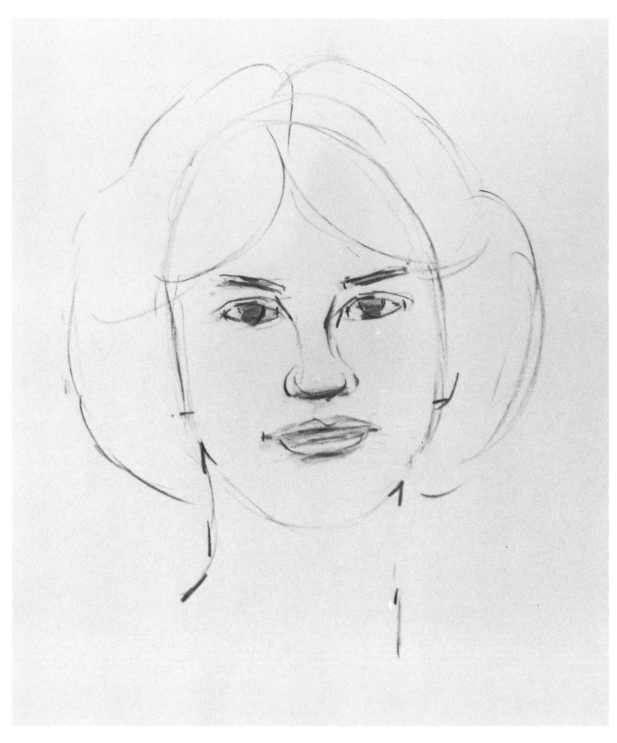

Step 3

With the dimensions of the features established, I now fill in their outlines. The eyebrows are straight and narrow; I draw only the main part now. I get the shape of the eyelids and the pupils. The eyes are large but set in the normal position, one eye-space apart. I outline the shape of the nose. It's at an angle mainly because her head is slightly turned. The underpart doesn't turn up much. I roughly outline the mouth. The ears only show a little at the tips; there won't be much to do with them.

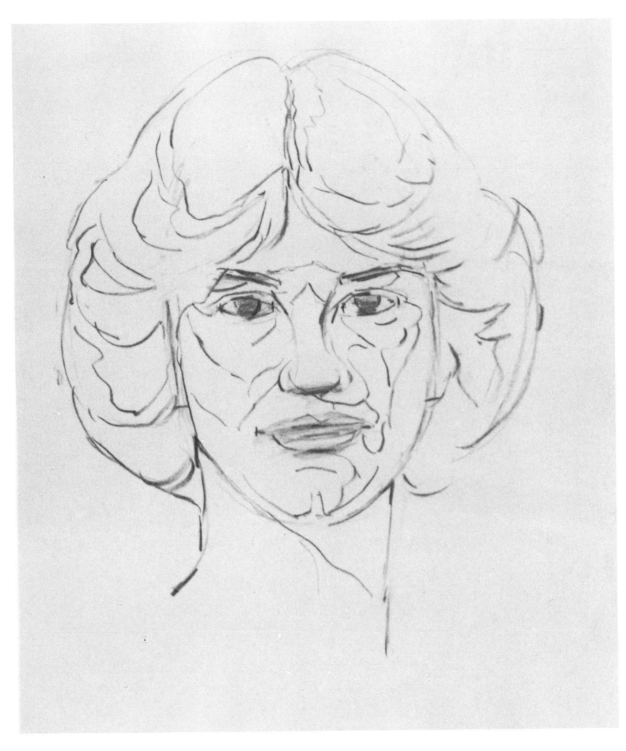

Step 4

This drawing seems to be a lot of confusing lines, but as you study them you can see that the hair makes it so. There's a lot of form in the hair and it's important to locate the tones that create it. I roughly outline the changes in value. As I do so, I erase the previously made guidelines for the skull. There isn't much of a contour change on the forehead, only at the bridge of the nose. I indicate the forms around the eyes and around the cheeks and jaw. I also show the outlines for the cast shadows of the nose and head.

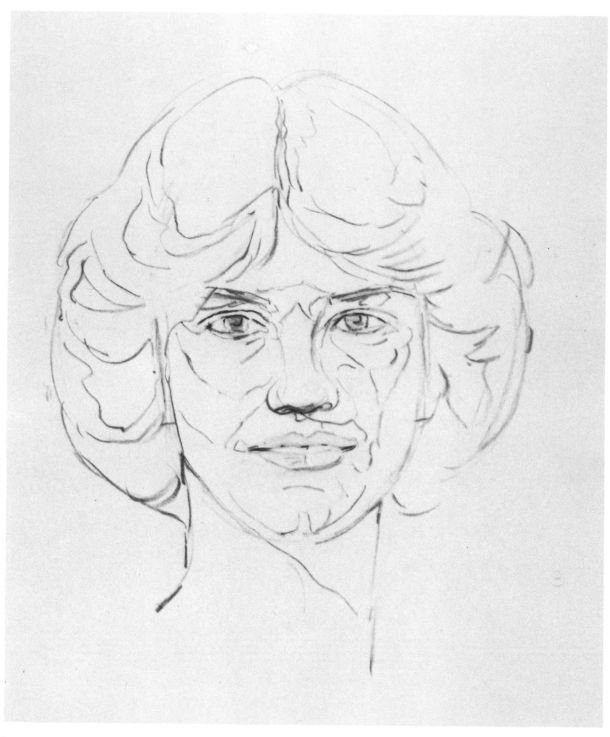

Step 5

I erase some of the smudges in the features, being careful not to lose the established drawing. I outline more clearly the contours around the features and improve the construction of the features themselves. Notice the careful adjustment of the size relationship of the eyelids and openings.

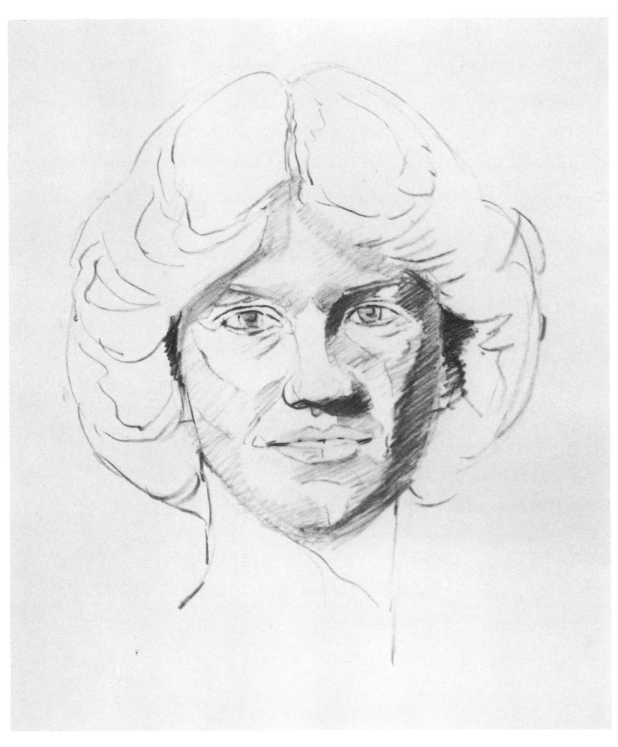

Step 6

I begin the toning process with the values on the face and the shadows cast on the forehead by the hair. In order to get my bearings in tonal relationships, I put in the blacks at both sides, where the hair is in deep shadow. I can now use these darks to get the correct value of the shadow tone on the side of the face, through comparison. I'm still using the soft, vine charcoal. (Later, when I get the tones clearly set, I'll use the charcoal pencil to make them firmer.)

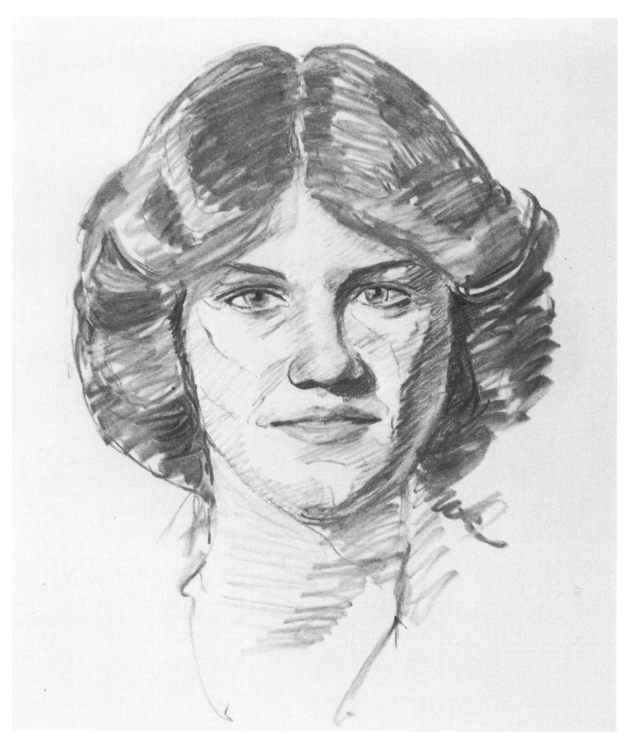

Step 7

I work in two areas, the hair and the features. First, I take the vine charcoal and roughly indicate the hair in two or three values. I also quickly show some of the neck tones and a little of the blouse. I work into and around the features and do some preliminary modeling. I get their general shape and value.

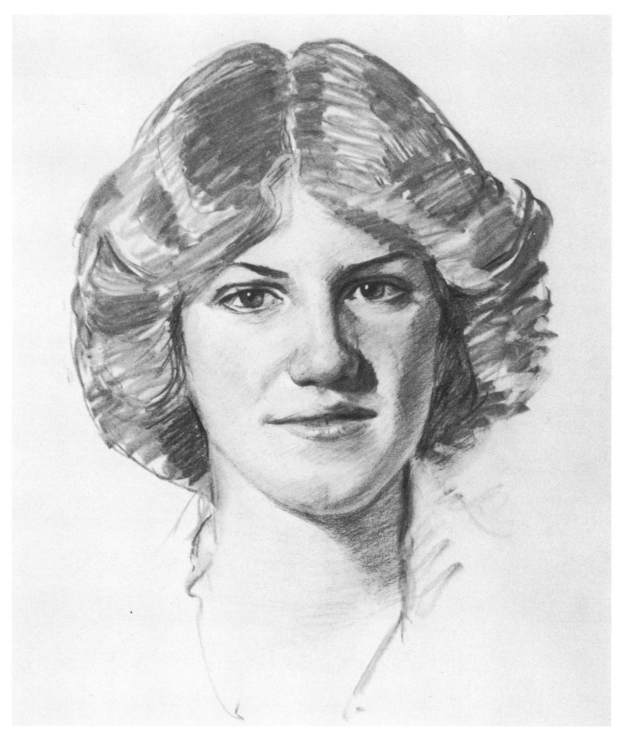

Step 8

I go over the entire face, smoothing and blending the tones. I use a foam rubber makeup sponge to rub down the tones, working carefully so they don't rub off completely. (If they do, I use a 2B charcoal pencil to shade them back in.) I blend in the edges along the cheeks and around the jaw. I get the correct color feeling to the eyes by placing the correct value in the corneas. I shade in tones to get the roundness of the eyeballs. I soften the tones on the nose, straighten the shadow side, and darken the side plane there. I indicate the nostrils and add highlights to the nose by erasing the charcoal. I darken the mouth where the teeth show and also at the shadow side on the top lip. I pick out highlights on the lower lip with a kneaded eraser and add light textured lines next to them.

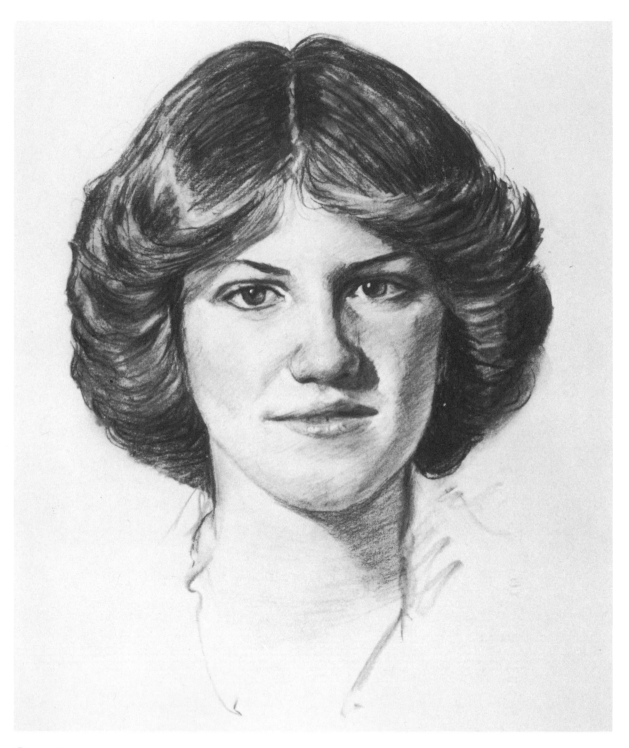

Step 9

I'm primarily concerned with the hair in this step because the face has progressed far beyond it. I take the charcoal pencil and go over the entire hair area. Notice that I follow the direction of the strands and make some lines sharp, like single hairs, while others are treated like bunches of hairs, made with wider pencil strokes. I shade her coiffure so that the effect is of fluffs of hair at the top and sides coming straight out, then receding backward and down the sides. I make the edges of the hair vary in softness, adding a few stray hairs here and there.

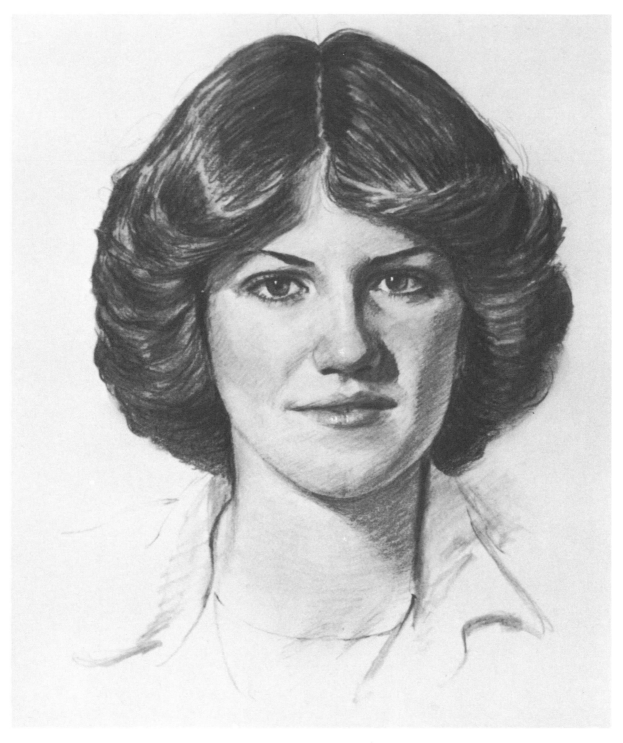

Step 10

I do more work on the hair again. I darken some areas of it, for example, next to the part at the top, and I tone down a lot of the highlights. I also make some minute final adjustments on the features. The pupils, especially the left one, are made more definite. I arch the crease above the left eyelid next to the nose some more and drop that edge straighter. I darken both upper lids and then add eyelashes. The nose is straightened more and the tones made crisper and smoother at the edges. I mold the lower lip a little more completely and, finally, add more to the blouse.

Carbon Pencil and Charcoal on Gessoed Chipboard

The ground for this 20″ x 19″ (51 x 46 cm) drawing is an acrylic gesso-covered (both sides) chipboard. The gesso is brushed on, leaving a certain amount of texture when it dries. I proceed with soft vine charcoal for the linear work, but to render the tones, I sprinkle powdered charcoal into benzol (rubber cement thinner) floating on the drawing (which is lying flat). I then manipulate the charcoal for the basic tones with a bristle brush that I usually use for oil paint. I finish the drawing with soft vine charcoal, carbon pencil, and a kneaded eraser to get the accents and highlights, blending the tones with my fingers and a foam rubber pad. The sitter is a lively, creative, and intensely interesting artist. The splashy, dashing use of powdered charcoal gave me the opportunity to express my feeling for him.

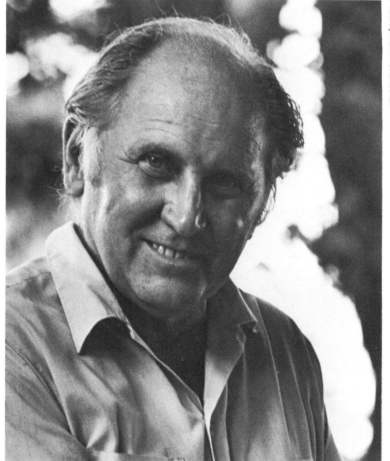

Photo by Mark P. Chamberlain

Photograph

Frank Licciardi, my next sitter, is a longtime close friend who does beautiful portraits himself. I feel somewhat self-conscious working under the eyes of a professional, whose work I admire, not that he'd be critical or try to influence my way of working. But even though I feel tense about the drawing, I know that this careful step-by-step procedure will achieve his likeness. Beyond that, I can only hope that my personal feelings for him and knowledge of his personality and character will make this portrait more than a photographic reproduction of his likeness.

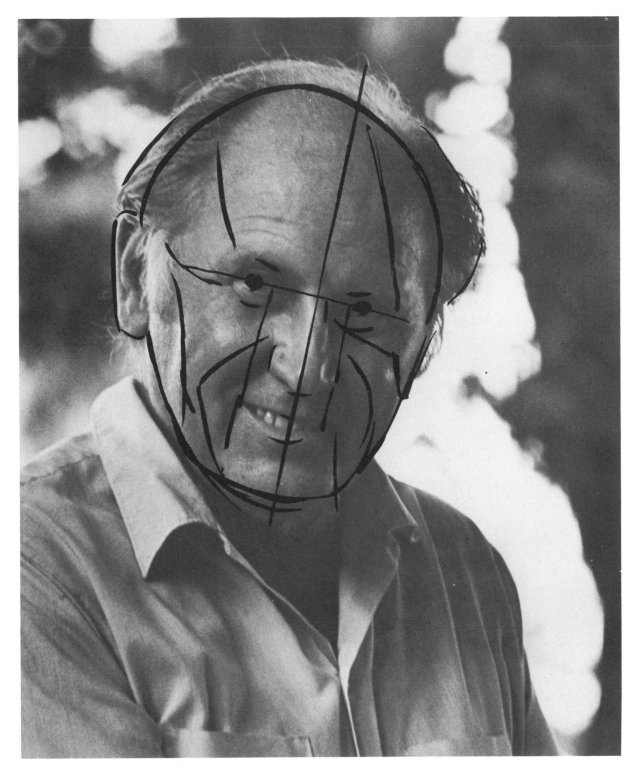

Analysis
The head is an average oval shape. Since the axis of his head is tilted quite a bit, it's important to always measure everything against that axis. For instance, the eyeline is not quite at right angles to the vertical line, but rises somewhat. In this illumination, the forehead planes slant back on both sides. The smiling face makes a bowl shape around the mouth. The corners of the mouth line up under the tearducts.

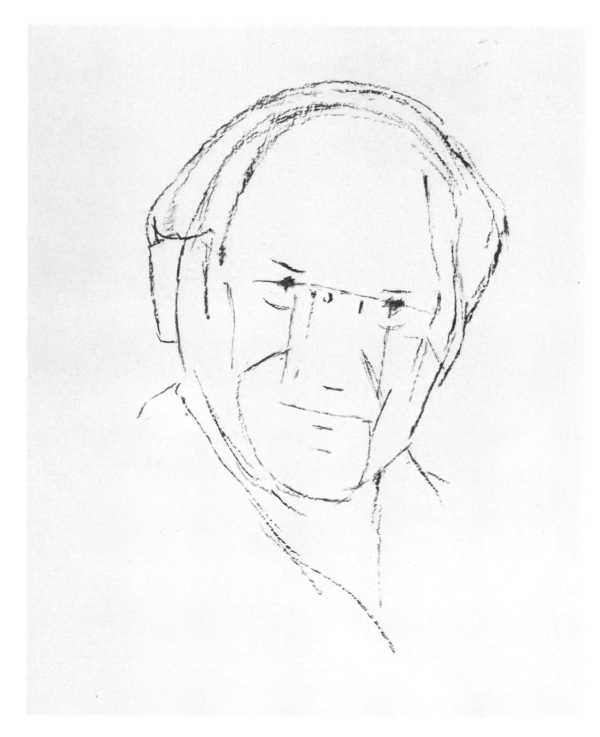

Step 1

To start, I use a piece of vine charcoal to rough in the shape of the head and hair, and to loosely indicate some basic contours, such as those of the planes coming down from the forehead and into the cheeks that are pulled up by his smile. I place the features and establish the same relationship of the eyes to the mouth as shown in the analysis of the photograph. I also note his relaxed position, which raises the shoulder area higher than usual.

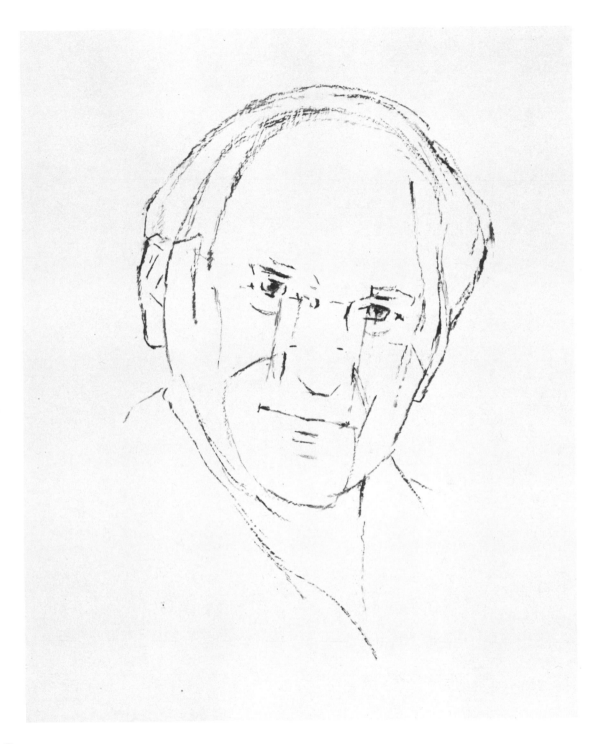

Step 2

I mark off the boundaries and the spaces that the features will fill. I can be quite definite about some of them, such as the lower boundary of the eyebrows, the lids, and the circumference of the corneas. I establish a more positive relationship between the eyes and mouth. The inner corners of the mouth line up with the inner edge of the eyes, but I am careful to keep the tilted lines parallel. Capturing his likeness depends on getting the critical position of his eyes in relation to those lines. For instance, the left eye is slightly above the horizontal axis of the eyes. I now erase most of that line.

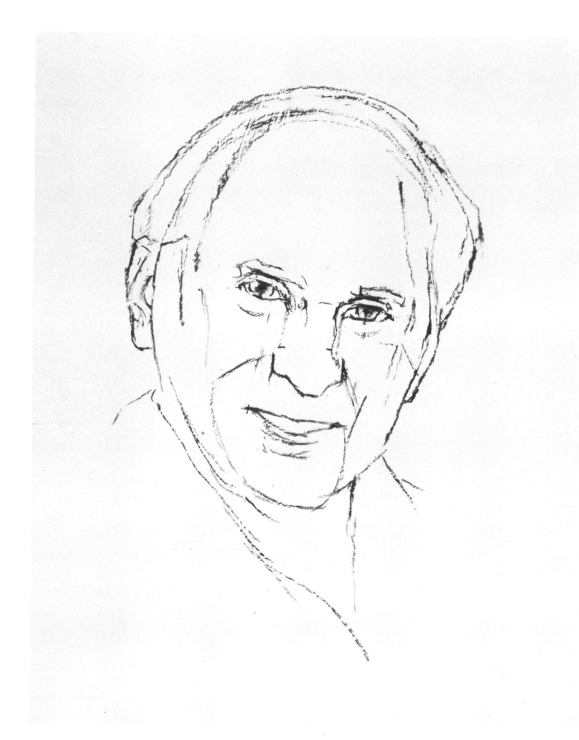

Step 3

I'm getting the shape of the features at this stage. The eyebrows are hard to see but at this point it looks like the right one appears to take up a smaller area than the left. I record the shapes around the eyes, including the lids, and include just a suggestion of the fold of skin on the cheek. The right lower lid seems a little straighter; it doesn't dip as much as the other one. Notice the basis for establishing the lines from the tearducts to the wings of the nose. The differing positions on either side of the nose is due to the turning of the head. The edge of the nose on the shadow side shows the distinct ending of the bone structure, which is part of his individuality. I also note the rising of the lower lip on the right.

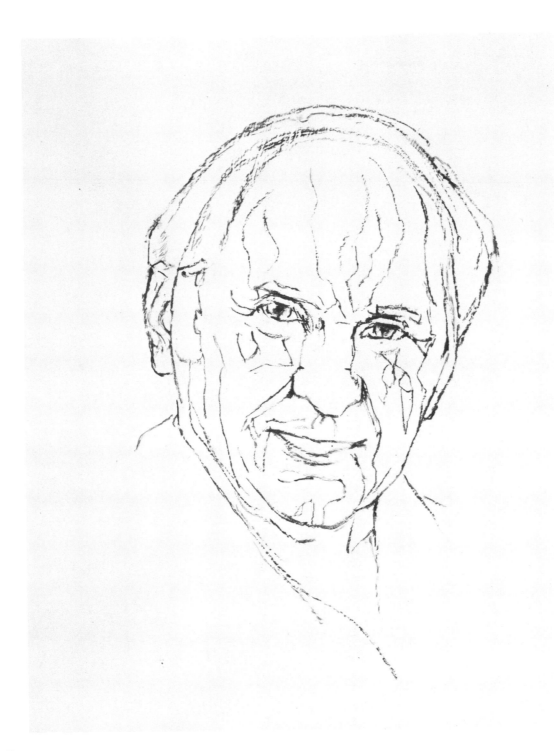

Step 4

There are lots of contours across his face because of the lighting. Various planes are lit by the main light, which rakes across them from the left side, and also by a strong reflected light on the right. The raising of the cheeks as he smiles creates deep shadows around the nose and also adds new planes on the cheeks. High on his cheeks there's a dimpling effect, part of his individual likeness, which causes little undulations. I outline them, especially on the right cheek.

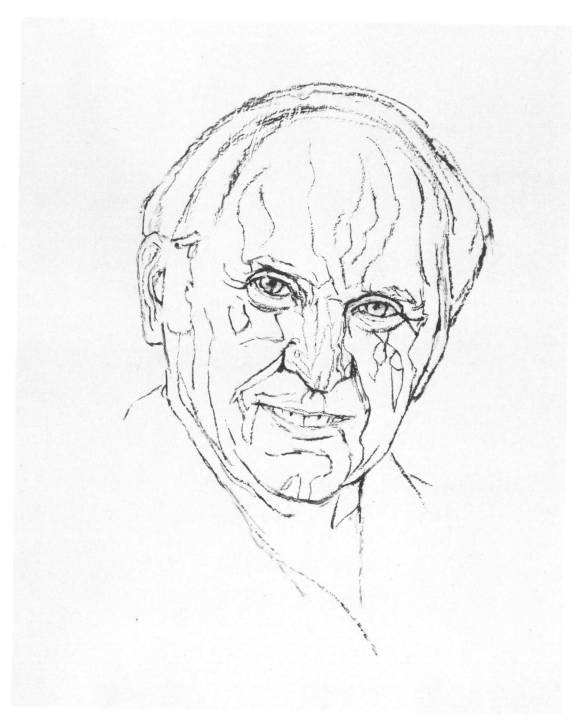

Step 5

Now I sharpen the drawing of the features and outline possible contours in them. The eyebrows can be just lightly outlined because what I can see of them can be developed later in the toning stage. I'm now being definitive in the drawing of the lids, corneas, the crinkling at the outer corners, and lower lids. The nose has many subtle planes on it, which I observe in the photograph. The double lighting adds even more planes on the right. I show the separations between the teeth and attempt to position them correctly in relation to the nose. For example, the middle separation falls under the nose where the left nostril first starts to angle up.

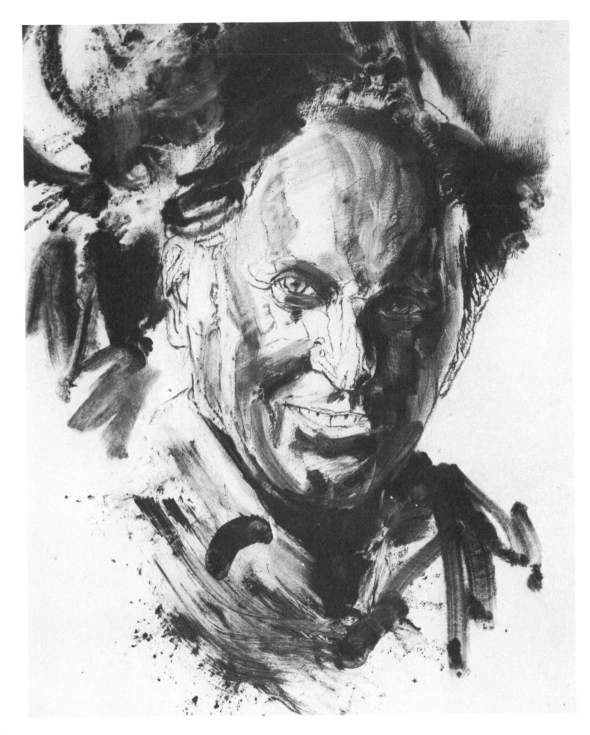

Step 6

This seems like a very dramatic step, as if I've done a lot, but actually it goes quickly. I pour benzol (rubber cement thinner) over the drawing, which is laying flat. Before it dries I sprinkle powdered charcoal approximately into the areas I wish to make the darkest. Then I take a bristle brush I use for oil painting and swish it around, painting into the face as I come right down through the shadow side. Then I wipe the brush with a paper towel, leaving enough charcoal on it to paint the lighter values on the light side of the face. If a value is too dark, like the one in the middle of the forehead, I simply rub it off with my fingers. However, some of the blackest smears, such as the arching shadow of his collar, are also done with my finger. Even though benzol evaporates fairly quickly, there's plenty of time for this brushing and finger-painting technique.

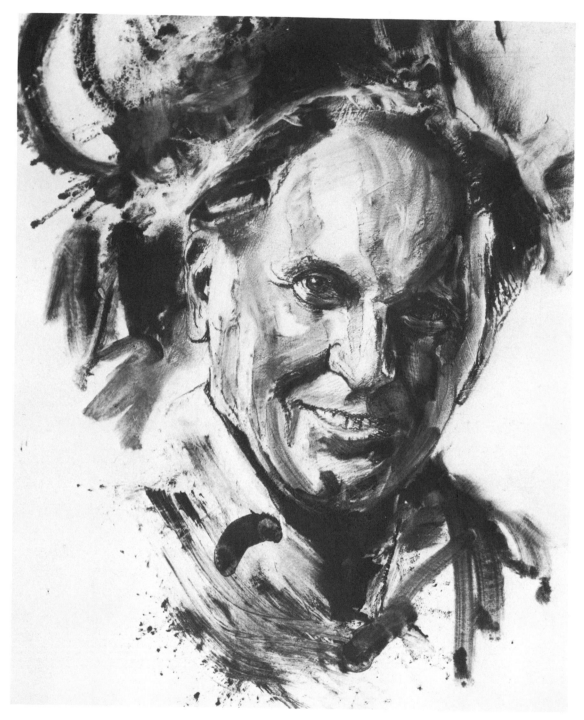

Step 7

Now I need more precise control, so I go into the features with vine charcoal for gray tones (modeled with a stomp or tortillion), charcoal pencil for darkening lines, and compressed charcoal for larger black areas. Most of the eye areas are in shadow; even the whites are low keyed. I put in tone to get a value as close as possible to the color of the irises, and I blacken the pupils. I model the varying tones on the upper and lower lids. Next, I fill in the tones in the areas outlined on the nose, rubbing them with the stomp. I begin to get the effect of the teeth receding into the shadow, adding more of the separations between them, and getting some roundness to the lower lip. I develop the ears somewhat here and start working on the halation around the hair, due to a partial backlighting.

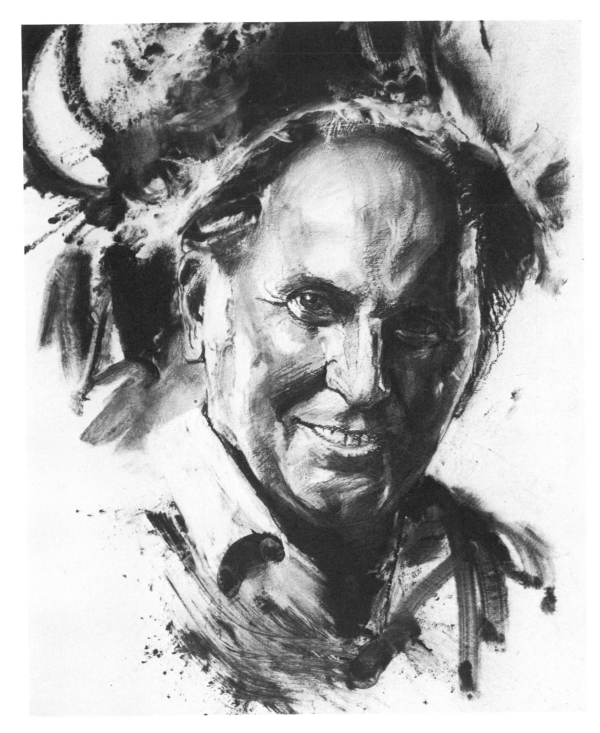

Step 8

Now I smooth out the facial contours and recover the drawing back where I've lost it in the shadow, especially around the mouth. I smooth out the shadow tone above the right eye. With a kneaded eraser, I make some variations in the tones on the right side of the face, which is lit by the reflected light. The shadow tones on the cheek are pulled together. Over and down the other side I add more shadow tones. I make the spots at the dimpled places on the cheek. On the light (left) side, starting at the top of the head, I blend the tones into the hair to get the roundness of the head. I also blend the tones at the temple with a stomp and pull a little tone across the highlight on the forehead. The tones around the cheek are now smoothed somewhat and the shape of the jowls is corrected. Finally, I remove some charcoal on the left to indicate the collar.

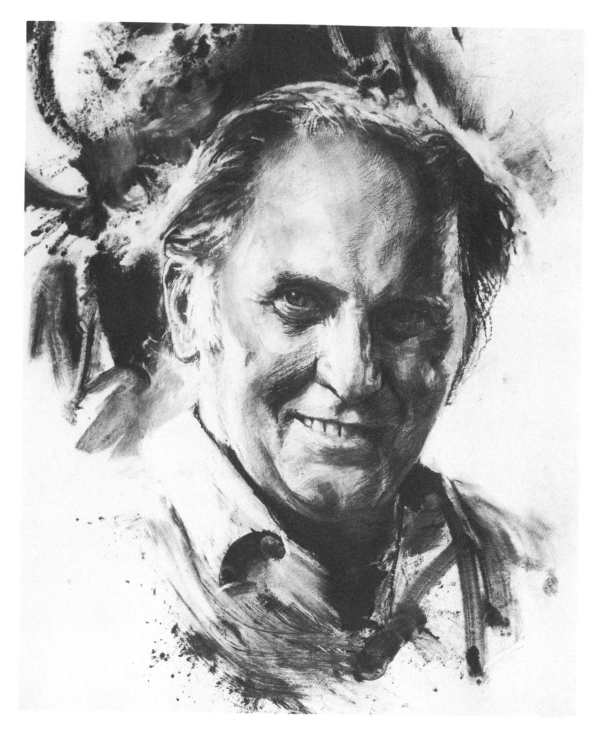

Step 9

Using both the kneaded eraser and a hard ink eraser, I pull out light tones on the hair. I have to reshape it, raising it at the left and cutting it into the shadow side at the upper right. Around the temples on the left, I lighten the mass of hair and work in gray tufts where it starts merging with the sideburns. I blend the forehead tones into each other more and I work in the "S" curved shadows that are a characteristic of his forehead. Going over the whole face, I continue adjusting values by blending. I soften the tones at the bridge of his nose, at the turning point of the lower left eyelid, on the right eye, on the light side of the nose, and on the teeth. I also darken the black triangle in the left corner of the mouth, then pick out highlights along the light edge of the teeth, careful not to make them too detailed and outstanding.

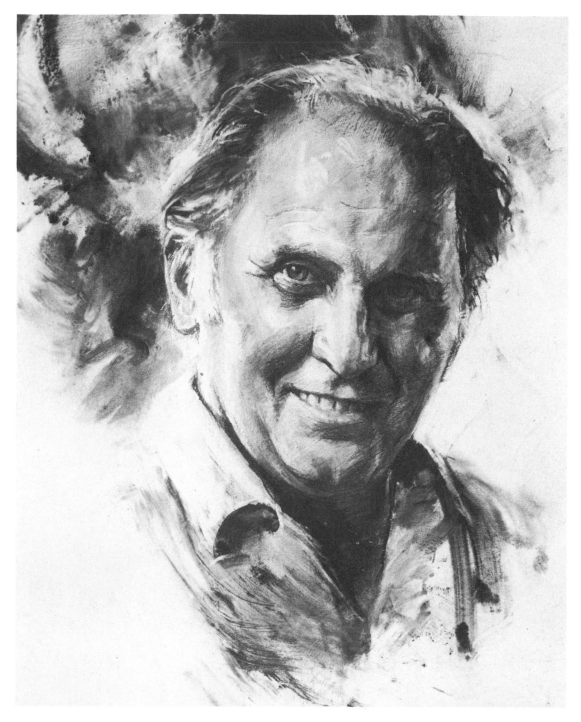

Step 10

I feel that the facial tones are too contrasty overall, so I take a foam rubber powder puff and lightly brush it over the whole face. You'll probaby say that I'm going to lose all of the darks and highlights. That's true, I will, but the unity this brushing gives the whole tonal plan is worth the trouble of going back and restating the accents and highlights. I discover that the left eye has shifted a tiny bit to the right, so this restating also gives me an opportunity to place it correctly. I also feel I can get more of a likeness if I raise the upper lip line slightly at the right. These small changes improve the drawing considerably. Thus I can now concentrate on additional touches such as the wrinkles on his forehead and the variations in the hair. Finally, since the background is competing too much with the face, I soften much of it and clean up lots of distracting areas on the shirt.

White Conté Pencil and Carbon Pencil on Gray Charcoal Paper

This is a repeat of the technique used in the demonstration that begins on page 102. I'm using a white Conté pencil and a BBB Wolff's carbon pencil on gray Strathmore charcoal paper, 24" x 19" (61 x 48 cm). I never fix the vine charcoal drawings. I don't seem to have any luck in keeping the original tones. But if you do like to fix your drawings, this combination of mediums fixes well and the white comes back to the original value when it dries. This lovely lady has a vivacious, glowing face and it seems that using lots of white pencil on gray paper would bring this out very easily.

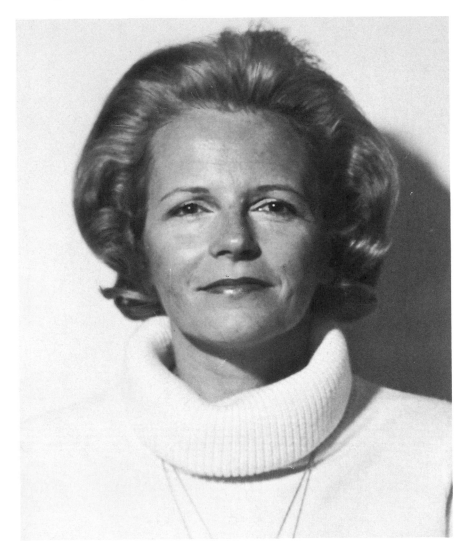

Photograph
Terry is a vivacious woman with ash blond hair that used to be even lighter. Even though you normally associate a definite hair color with certain persons, it doesn't actually determine their individuality. If they were to change their hair color, as this person did, your impression of them may be altered, but you'd still recognize them. Their appearance changes, but not their personal likeness. Since I'm recording the hair color here only in black and white tones, I want you to notice that even blond hair has a complete range of values from black to white.

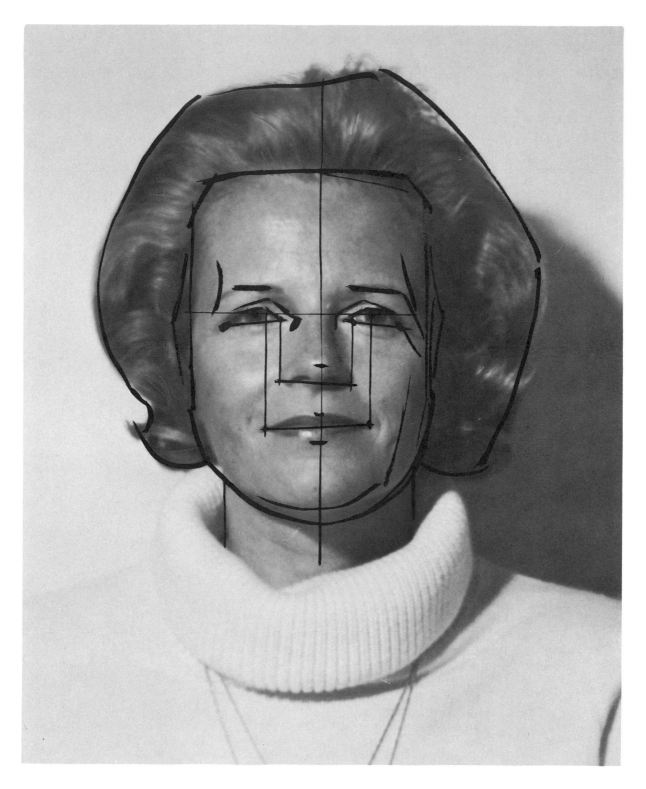

Analysis

The first impression is that the upper part of her face has a rectangular shape, but upon closer observation, you see that the hair is really framing it in a manner to give that feeling. In this straight-on view, the eyes line up evenly across, though they have a tendency to slant down at the outside. The upper lids are quite wide on the inside, and the right eye is open wider than the left one. The most individual part of her face is the opposition of the horizontal axis of the nose and mouth. The mouth is set slightly to the right (check this by dropping plumb lines from the eyes).

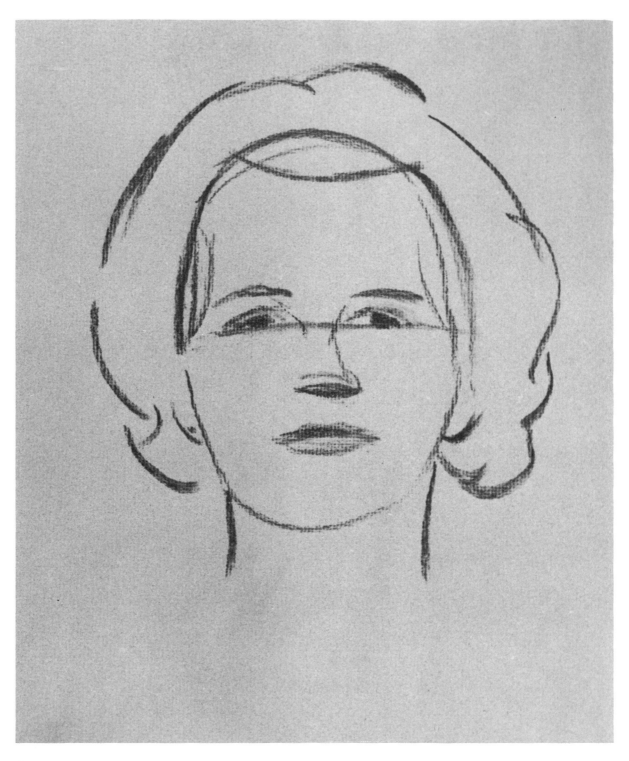

Step 1

I'm starting the drawing on gray pastel paper with vine charcoal. I make the oval of the skull first and notice that a certain amount of character shows up the way the longest part of the vertical axis is to the left. The eyeline is fairly straight across but the right eyebrow seems a little lower than the left. The mouth tilts up slightly on the right. I make an indication of the indentation at the temples. I also show the outline of the outside edge of the hair and the lower line across the forehead.

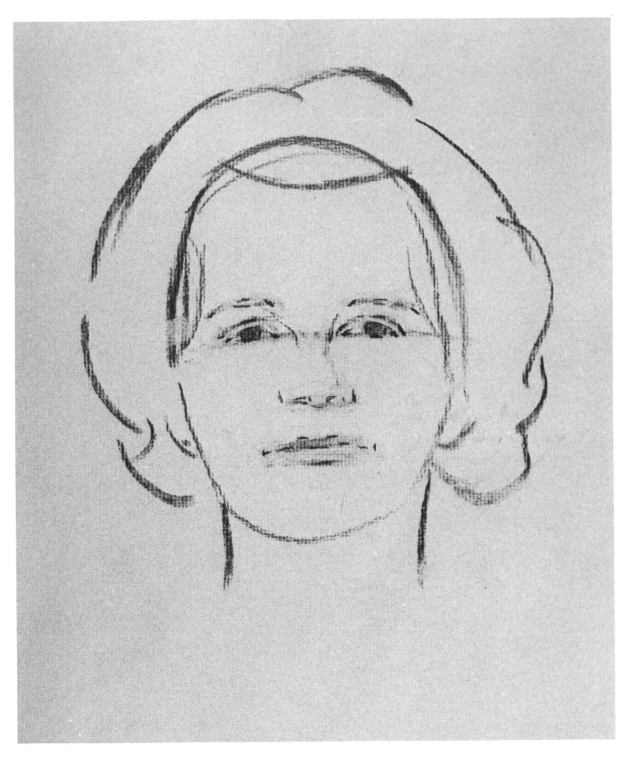

Step 2

Marking off the boundaries of the features, I find that the right eye is open a bit wider than the left one. The outer corners of her nose line up with the tearducts of her eyes. However, as I check that carefully, I find that the tearduct on the right is a little closer to the center of the head. I locate the dimensions of the mouth, which is centered under the eyes. Only the tips of the ears show in this portrait.

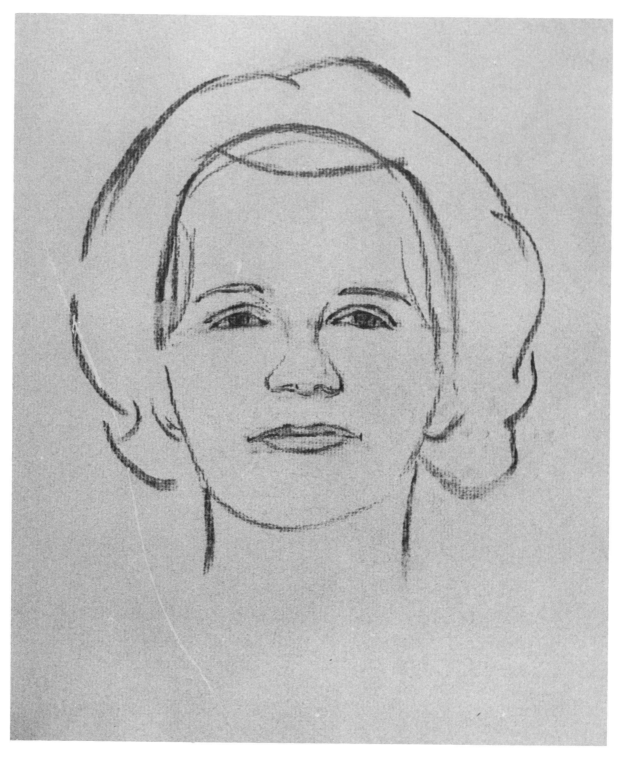

Step 3

Now I fill in the general shapes of the features. Both eyebrows are very thin, but the left one is a little thicker. I draw the eyes and notice the difference between the two: Her right one is slightly larger, opens up more, and seems to have more white showing at the left-hand side. I outline the nose and note that it's characteristic of the whole lower side to swing somewhat to the right. In sketching the mouth I find that the right half of the upper lip arches higher. You should be careful not to miss a subtlety like that.

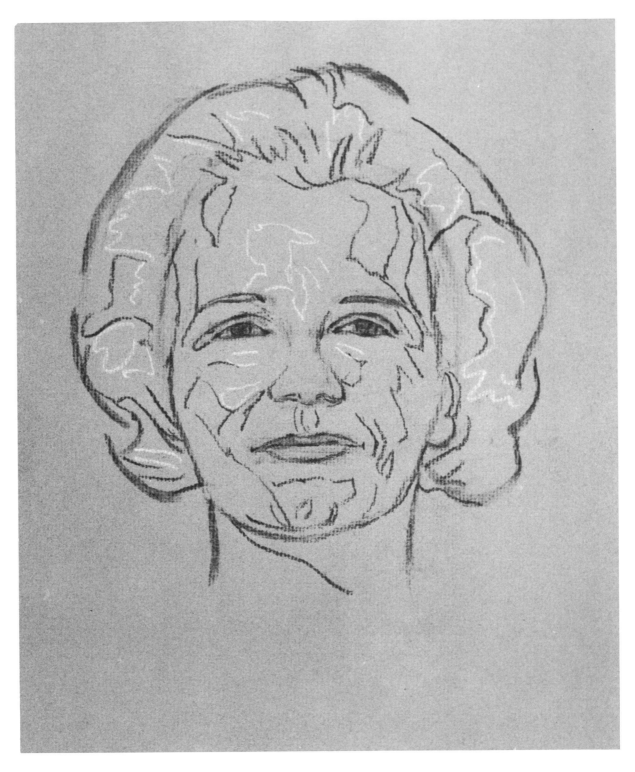

Step 4

In this step I outline the changing forms using charcoal mostly. However, in the areas where there'll be highlights, I use a white Conté pencil. These highlight areas won't all be the same light values but they'll all be lighter than a middle tone. I don't make the ones on the hair too definite, since they won't have hard edges. I'm only making an estimate of their position. But I make the ones on the face more definite. I outline in black the changes in planes across the forehead, center, and lower part of the face. Where the line is broken it means I'll have to blend the neighboring values together.

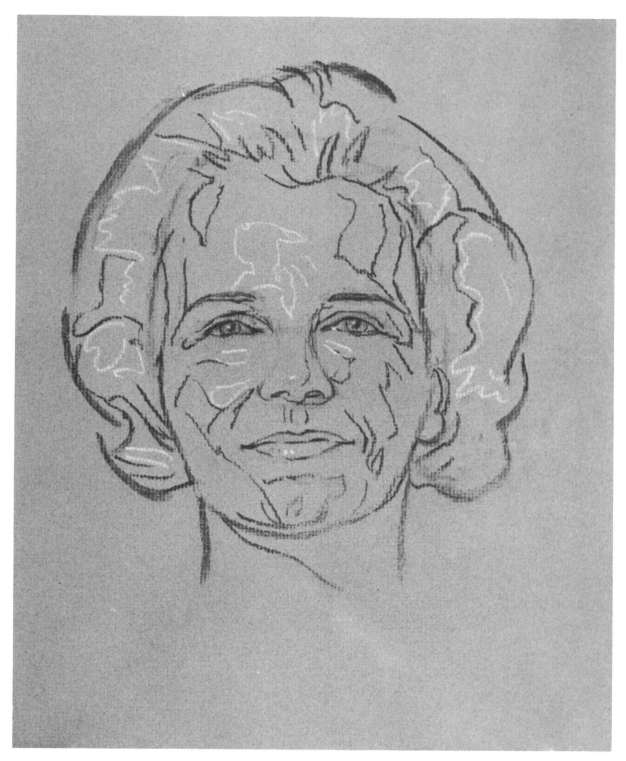

Step 5

I adjust the drawing of the features. I note that the eyebrows are different; the right one is more angular. I also fix the shape of the upper eyelids more accurately. Notice that the left one gets quite wide at the inside. The right eye opens more, reducing the size of the eyelid. I outline the shadows on the nose, including the cast shadow, which is small. I put in a white dot for the highlight to start me thinking even now about the form of the nose. I clean up the lines denoting the mouth, making the lines more distinct, and pay careful attention to the separation line. It arches more on the right as well as the boundary of the top edge. I also use white to show the position of the lightest part of the lower lip.

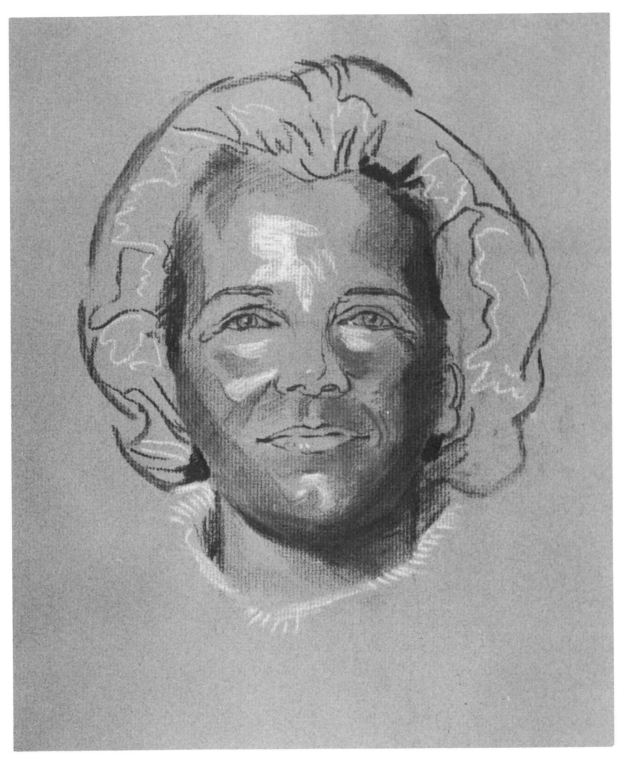

Step 6

I start shading with charcoal, getting three definite planes on the shadow side of the fore-head. Two areas on the left side of the forehead are the same value. I take the white pencil and sock in the highlight area as one strong mass. On the sides, I render a fairly dark gray on the right, the shadow side; while on the left, the light side, the value where the cheek turns is a medium value gray. Several halftone areas meet as I put in values across the cheek, mouth, and chin. I put in strong whites here also, for highlights. I sketch in a dark value on the right cheek where it goes into the side of the nose. I do some toning on the neck and, with white pencil, start the sweater.

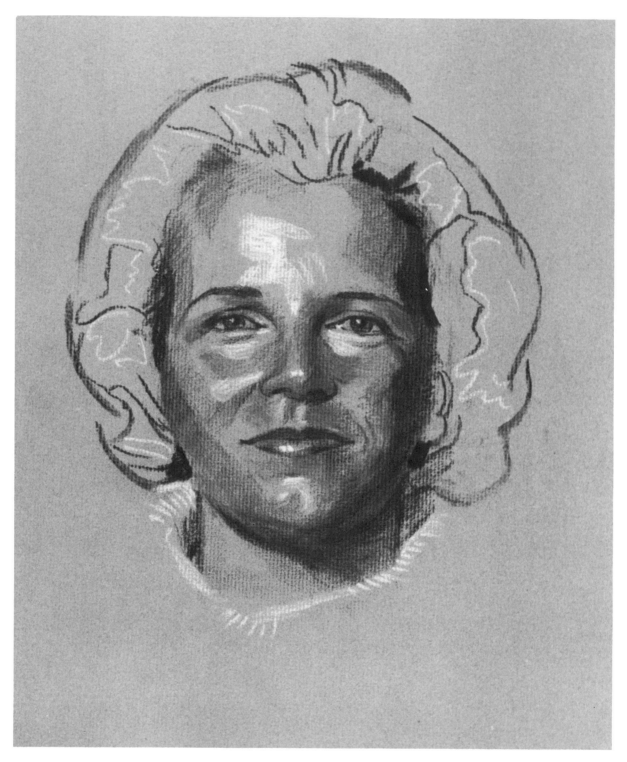

Step 7

I begin to render the tones of the features with the eyebrows, getting the variations in values across their length. Where their direction changes, the tone changes. Now I put in the tones on the eyes, showing the extremes of values from the black pupils to the brilliant white catchlight. (I use that highlight in the early stages to help get a likeness.) I render the tones on the nose, but hold back on the accents for now. I model the mouth with the dark tone that runs along the upper red part and only suggest the lower boundary and vertical textural lines.

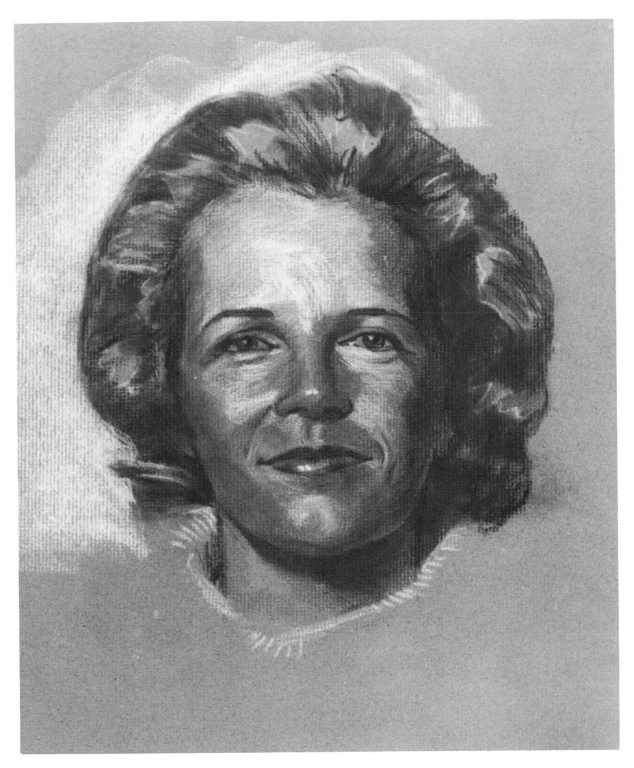

Step 8

I work a lot of tones into the hair, trying to reduce the tonal variations to three values. In some places, where the black mixes in the adjacent tones, it becomes four. The areas I outlined in white, particularly in the hair, will be left mostly gray paper with a few flicks of pure white. This will all have to be softened. Notice that my pencil strokes always follow the direction of the strands, though I may sometimes blend some spots by rubbing across the strokes. Her hair color is ash blond, but as I said earlier, it requires a full range of tones, from the deepest black to white, to express it. The large areas of light tones give it the blond effect. I add white chalk to the background for variety.

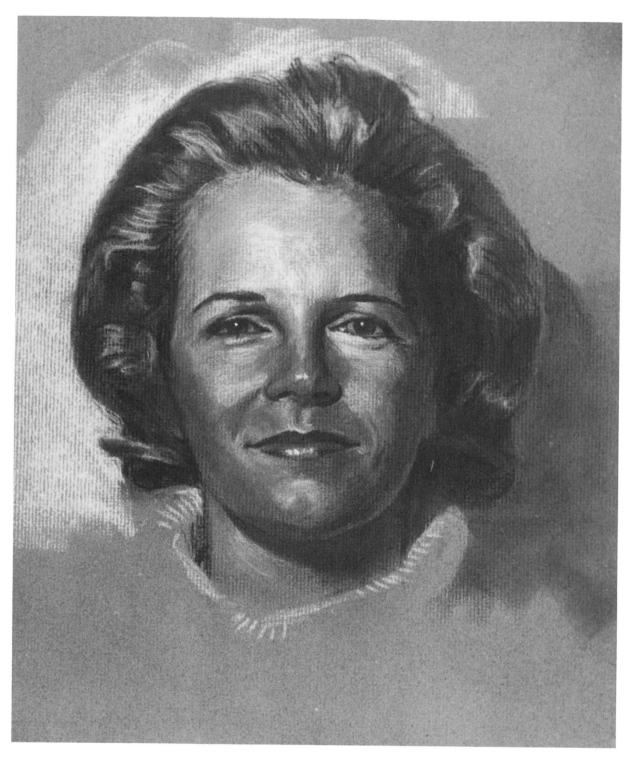

Step 9

I do a great deal of work in this step, particularly in the hair. I make the many individual forms within the hair more cohesive. If you study each section you'll see that they have a roundness with highlights, halftones, and shadows, and that they interrelate by casting their shadows on the roll or curl next to it. I make all the edges soften into the background by blending with my finger. I suggest some individual hairs in both black and white. I also render the features more precisely, getting the exact tonal values and softening and accenting places. I also pull together all of the tones in the face by blending and softening transitions between the white and dark areas.

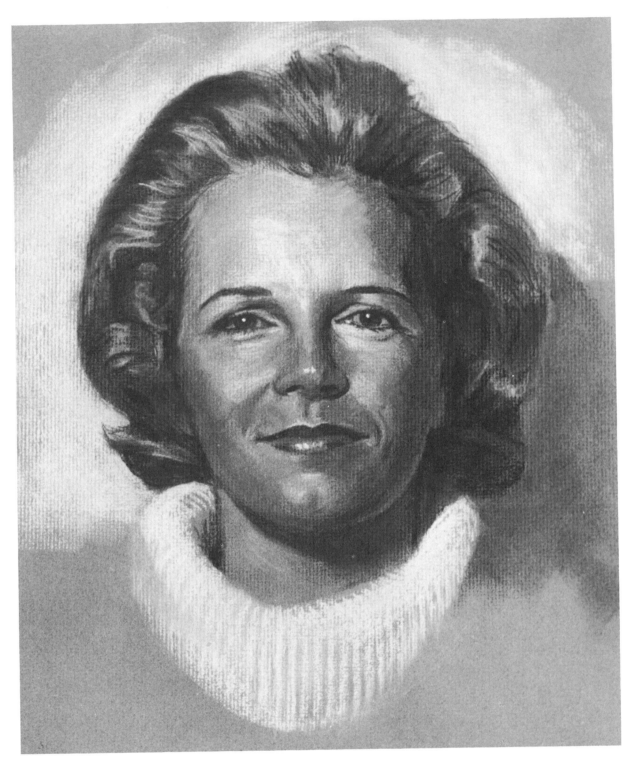

Step 10

I feel that there's a hardness to the tones on the face, so I rub all of them down, especially on the nose and around the mouth, where the grays are too heavy. I rub the highlights too, to help lose that shiny, metallic look. However, I want to keep the glowing quality of her skin. I add eyelashes and strengthen the catchlights in the eyes. I now add the effect of the turtleneck sweater with white pencil only and work up the background to include a cast shadow.

Bibliography

Farris, Edmond J. *Art Students Anatomy.* New York: Dover Publications, 1961.

Graves, Douglas R. *Drawing Portraits.* New York: Watson-Guptill Publications, 1974.

Graves, Douglas R. *Life Drawing in Charcoal.* New York: Watson-Guptill Publications, 1971.

Hogarth, Burne. *Drawing the Human Head.* New York: Watson-Guptill Publications, 1965.

Loomis, Andrew. *Drawing the Head and Hands.* New York: Viking Press, 1956.

Ormond, Richard. *Sargent: Paintings, Drawings, Watercolors.* New York: Harper & Row, 1970.

Perard, Victor. *Drawing Faces and Expressions.* New York: Grossett and Dunlap, and London: Pitman Publishing, 1958.

Pitz, Henry C. *Charcoal Drawing.* New York: Watson-Guptill Publications, 1965.

Richer, Dr. Paul. *Artistic Anatomy.* Translated and edited by Robert Beverly Hale. New York: Watson-Guptill Publications, 1973.

Index